Frame-by-Frame Stop Motion

Frame-by-Frame Stop Motion

The Guide to Non-Traditional Animation Techniques

Tom Gasek

First published 2012 This edition published 2013 by Focal Press 70 Blanchard Road, Suite 402, Burlington, MA 01803

Simultaneously published in the UK by Focal Press 2 Park Square, Milton Park, Abingdon, Oxon OX14 4RN

Focal Press is an imprint of the Taylor & Francis Group, an informa business

Copyright © 2012, Taylor & Francis. All rights reserved.

No part of this book may be reprinted or reproduced or utilised in any form or by any electronic, mechanical, or other means, now known or hereafter invented, including photocopying and recording, or in any information storage or retrieval system, without permission in writing from the publishers.

Notices

Practitioners and researchers must always rely on their own experience and knowledge in evaluating and using any information, methods, compounds, or experiments described herein. In using such information or methods they should be mindful of their own safety and the safety of others, including parties for whom they have a professional responsibility.

Product or corporate names may be trademarks or registered trademarks, and are used only for identification and explanation without intent to infringe.

To the fullest extent of the law, neither the Publisher nor the authors, contributors, or editors, assume any liability for any injury and/or damage to persons or property as a matter of products liability, negligence or otherwise, or from any use or operation of any methods, products, instructions, or ideas contained in the material herein.

Library of Congress Cataloging-in-Publication Data

A catalog record for this book is available from the Library of Congress

British Library Cataloguing-in-Publication Data

A catalogue record for this book is available from the British Library.

ISBN: 978-0-240-81728-6 (pbk) ISBN: 978-0-240-81729-3 (ebk)

Advance praise for Frame-by-Frame Stop Motion

"Tom's extensive experience as a stop motion animator, combined with his knowledge of the field and his natural teaching ability, make this book a clear, well-organized, and empowering introduction to stop motion animation. This book will be an invaluable resource for student and teacher alike."

> - Steven Subotnick, animator, educator, and author of Animation in the Home Digital Studio

"In the digital age it pays to remember that innovative ideas can still be inspired using even the most basic techniques. This book is a timely reminder that a rewarding process depends as much on ingenuity as it does on facility."

- Dave Borthwick, animation director, Bolex Brothers

"A must-have book for any animator's library. Frame-by-Frame is a reminder of all the magical possibilities animation has to offer and all you need is a camera and an idea."

- Jim Capobianco, filmmaker, "Leonardo"

"This book is a wonderfully inspiring, accessible and thorough guide to a number of techniques that have seldom been written about or charted before. It is an essential manual for any student, professional or creative person who has ideas and wants to be encouraged with a sense of 'I could do that'—and wants to get their ideas out there. I just wish this book had been written when I was a student of animation (I still am, so I will buy it anyway)."

- Nick Park, Academy Award winner and creator of Wallace and Gromit

Dedication and Acknowledgments

As in any large endeavor, many people are always involved. Like filmmaking itself, a team effort is critical to the success of any book, and *Frame-by-Frame Stop Motion* is no exception. I have written this book from my own point of view and acknowledge that it is only one point of view. I was fortunate to have two friends and colleagues review each of my chapters and add their comments and observations. Many years ago, Bryan Papciak, Jeff Sias, and I used to work together in the stop-motion industry at a studio called Olive Jar in Boston. We came to appreciate our collective contributions to many projects, and it seemed natural to have them involved in this process. I am eternally grateful for their input. I am also grateful for the positive and encouraging attitude of my editor, Katy Spencer at Focal Press.

The critical elements to this text are the many contemporary artists and filmmakers that contributed comments and images to this study of alternative stop-motion techniques. This includes Terry Gilliam, Jan Svankmajer, PES, Blu, William Kentridge, Dave Borthwick, Nick Upton, Dave Sproxton and Aardman Animations, Jan Kounen, Caroline Leaf, Evan Spiradellis, Jim Blashfield, Joan Gratz, Joanna Priestly, Ken Murphy, Miki Cash, Eric Hanson, Tom Lowe, Yuval and Merav Nathan, Chris Church, Juan Pablo Zaramella, Jeff Sias, Bryan Papciak, Daniel Sousa, Eugene Mamut, Joe Lewis, Jamie Caliri, Adam Fisher, Monica Garrison, J. P. Crangle, The National Film Board of Canada, Lindsay Berkebile, Jordan Greenhalgh, Jason McLagan, Rachel Fisher, Marlee Coulter, Stevie Ward, Clare Kitson, Nick Park, Roxann Daniel, and the School of Film and Animation at The Rochester Institute of Technology. Many more artists and filmmakers are practicing these techniques than I was able to cite or interview. These frame-by-frame techniques are as varied as the artists who practice them, and I was able to touch on only a few approaches. I tried to incorporate principles and practices that are common to most of these techniques, but I am sure that I left out a few. My aim is to open up the door a bit wider to handmade animation approaches. These approaches have been evolving since technology continues to expand, and this makes these techniques as viable as ever. All one has to do is scan the web and see what is out there; suddenly you realize that this is a vast and potentially exciting area of filmmaking. The old saying "what is old is new" applies to this book, but again, technology has made these approaches to single-frame filmmaking much more accessible, and I hope many new filmmakers are able to explore this area of animation. The book can serve as a guide.

So I dedicate this book to all the new filmmakers and established filmmakers that want to expand their means of expression through frame-by-frame animation.

Drawn illustrations by Brian Larson.

Photographic illustrations by Tom Gasek and artists cited in each chapter.

Contents

Introductionxiii
Chapter 1: What Are the Possibilities?1
Creating Magic 1
Silent Films and Beyond
Stop Motion and Its Various Faces
Chapter 2: Shooting Frame by Frame
Technique to Serve the Idea17
Preproduction
Equipment and Setting Up25
Chapter 3: Pixilation
Take Advantage of the Medium31
Who Is the Director?
Humor
Shooting on Twos, Fours, and More38
Variations on Pixilation40
The Moving Camera46
Chapter 4: Time-Lapse Photography
Expand Your Awareness51
The Intervalometer
Understand Your Subject55
Understand Your Subject55
Understand Your Subject

Chapter 6: Objects, People, and Places	81
People, Objects, and Rigging	81
Organic and Nonorganic Objects	84
Shooting Safe Zones	85
Chapter 7: The Multiplane Downshooter	91
A Stand of Your Own	
Lighting for the Downshooter	93
Clay, Sand, and Three-Dimensional Objects	97
Cutouts	
Background	104
Chapter 8: A Sense of Drama	109
Live Action and Single Framing	
Subtle and Broad Performance	112
Reference Film and the Cartoon	114
Look in the Eyes	115
Chapter 9: Rhythm and Flow	
Let the Music Lead	
Patterns of Movement	123
The Beat Goes On	126
Chapter 10: Collage (The Digital Advantage)	129
Planning a Collage	129
Match Lighting and Rotoscoping	131
Clean, Clean, Clean	133
The Chroma Key	135
Chapter 11: Massaging Frames in the Edit	139
Working the Frames	139
Impossible Perfection	143
File Management	144
Playback	145
Chapter 12: Exposure to the Market	
Now What?	150
Record and Archive the Process	
Websites and the Internet	
Film Festivals	153
Ownership	155
A Few Thoughts	

Exercise 1: The Traveling Head 161
Exercise 2 : Rotating Human Subjects 165
Exercise 3: 2-D/3-D Handball 169
Exercise 4: Animated Light Loop: The Bursting Star
Exercise 5: The Dropping Heads (Cutout) 179
Exercise 6: 3, 2, 1—Countdown 185
Exercise 7: Love at First Sight 189
Index 195

Introduction

Why This Book?

Stop-motion animation has been a passion and calling of mine for 30 years. My undergraduate studies were in Design at the Rochester Institute of Technology (where I now teach), and animation came into my life quite by accident. In my last two years at RIT, a new teacher, Erik Timmerman, decided to start an animation course, the first at RIT. Having been raised on cartoons with a love from Rocky and Bullwinkle to Gumby, I felt compelled to take this course. Upon my graduation, two years later, I was on my way to Hollywood to collect a Student Academy Award along with my partner Malcolm Spaull for our stop-motion version of Lewis Carroll's *The Walrus and the Carpenter*. Animation became my career path with design playing a supporting role.

Animation's great appeal for me is that it incorporates many disciplines I love. They include storytelling, drawing, sculpting, photography, lighting, acting, sound, editing, and much more. Stop motion felt most natural to me. The National Film Board of Canada inspired me in my college years. The variety at the NFBC was rich, and the concepts and films were exciting. I studied these films and practiced much of what I observed in them. This was the best way to learn. When I started animating in school and later professionally, I had to learn by experience with no video assist or instant feedback. I could learn of a mistake or miscalculation in my animation only after I completed a whole shot and after the film came back from the processing lab. Those mistakes were never repeated and the learning was deeply ingrained. Shooting on film was the approach I used until about six or seven years ago, when digital still cameras started to emerge as the best, most accessible and affordable option for stop-motion animation. "Frame grabbers" and computers, which give you instant feedback, have been around a bit longer and helped ease the anxiety level of the animation process. I could go home at night after a full day of animating and know that my animation was working well. I have been sleeping a lot better in the last 10 or 15 years.

The majority of my animation has been in the model or puppet area. I produced animated shorts of my own like *Off-Line* and worked with wonderful directors like Nick Park, Henry Selick, Will Vinton, and Art Clokey, among others, but it has always been in model character animation. Since I have been teaching, over the last five years, I have encountered many students who have a great interest in producing animation but do not draw or sculpt very well. Even students who create models in the computer often lack some of the basic skills that make a good designer, but the drive and ideas are still there waiting to be tapped. Since I have lots of experience in puppet animation,

I teach a class in more traditional puppet or model stop motion, but about four years ago, I decided to create a class utilizing other stop-motion techniques, like pixilation, time-lapse photography, and downshooting. This appealed to many students, and my class soon filled with live-action and photography students looking to expand their knowledge and style in filmmaking. The class also appealed to traditional animation students with and without drawing and sculpting skills. I soon realized that there was a gap and interest in this area.

I started cobbling together a class that covered these areas, and I researched the marketplace. I had utilized some of these techniques in my own films, but I wanted to see what was being produced now. I constantly scanned the web and found that there are many pixilated films by novice filmmakers. This showed me the interest level, but these films were rather predictable and dull. Yet, some absolutely amazing examples of these techniques were being shot around the globe. I could not find a complete source for teaching my class, so I decided to approach Focal Press with a complete proposal, explaining these techniques and how they can be maximized. By interviewing practicing professionals and students and explaining some of my own work, I felt I could offer a guide that would help the novice or intermediate-level filmmaker. Pixilation, cutouts, and time-lapse photography are relatively easy techniques to prepare for, but they can be deceptive in their apparent quick and easy approach. By applying more traditional animation techniques and using many appropriate tools, these accessible alternative stop-motion techniques can be quite effective. This is what I explore in Frame-by-Frame.

Tom Gasek

CHAPTER 1

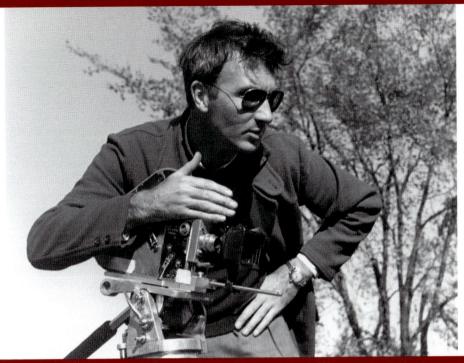

What Are the Possibilities?¹

Chapter Outline

Creating Magic	1
Silent Films and Beyond	2
Stop Motion and Its Various Faces	-

Creating Magic

Humans are social creatures that have an innate need to share experiences and stories. Ever since humankind started communicating, stories, real and unreal, were shared around the communal circle. The tribe gathered together and a tale was told that revealed information, lessons, provocative thought, and emotional empathy. Often the more fantastic the story, the more entranced the audience became and the stronger the message. This might be the job of the shaman or chief, but soon everyone had stories and experiences to relate. Eventually stories became enhanced from the oral tradition through props and other means of visual storytelling. In just over the last hundred years, filmmaking became a powerful vehicle to relate stories and capture an audience's imagination. Sight and sound are our most primal senses, and filmmaking taps into these receptors. Soon filmmaking started to expand its repertoire, and the "fantastic" became a possibility in storytelling.

¹Opening image is of Norman McLaren directing *Neighbours*. © 1952 National Film Board of Canada. All rights reserved. Photo credit: Evelyn Lambert.

Single-frame filmmaking has been around as long as film itself. The idea of fooling or tricking the eye has always been fascinating to people, and the manipulation of live-action filming was the origin of this technique. Imagine the early days of filmmaking, when audiences were seeing projected images on a screen, images that appeared to be alive and real, for the first time. That was magic in itself. When filmmakers became a bit more sophisticated, stopping the camera in mid-shoot and removing an object from in front of the camera then continuing to film, the results were genuinely magic. As film started to mature, artists and practitioners began to see the endless possibilities that this new medium offered. This stopping the motion of filming and adjusting images, cameras, and events is the predecessor to special effects and animation.

We are talking about stop-motion photography, which has evolved into many variations. The most common form of stop motion recognized today is model or puppet stop motion. In this, figurative models are made and animated frame by frame to create a narrative or experimental approach. Examples of this form are seen in films and on television. Feature films like Jiri Trnka's *A Midsummer Night's Dream*, Nick Park and Peter Lord's *Chicken Run*, and *Coraline* directed by Henry Selick all exemplify this popular approach to figurative puppet stop motion. Television has also laid claim to this form of animation with popular programs like *Pingu, Gumby*, and the Rankin Bass Christmas special, *Rudolph the Red Nosed Reindeer*. These, among other titles in this genre, are well loved and considered more in the realm of traditional stop-motion puppet animation.

The nontraditional or alternative use of stop motion utilizes people; objects; various materials like sand, clay, paper; and often a mixture of these and other elements as the objects to be animated. The most common of the nontraditional alternative stop-motion techniques is known as pixilation. This term is attributed to the Canadian animator, Grant Munro, who worked at the National Film Board of Canada with Norman McLaren in the 1940s, 1950s, and 1960s. Both McLaren and Munro were major contributors to this art form. In pixilation, usually, a person is animated like a puppet or model. There is a limited amount of registration in this approach to stop motion, so the result is a rather kinetic, bewitched, fragmentary movement that appears pixilated or broken up. It has nothing to do with the modern day term related to low-resolution digital images. Time-lapse photography and downshooting (animation on a custom animation stand, also known as multiplane animation) are two other forms of nontraditional alternative stopmotion animation. We explore each of these approaches and more in the following chapters.

Silent Films and Beyond

This interest in the manipulation of filming and single-frame adjustment started as soon as film arrived on the scene in the late nineteenth and early twentieth century. The Lumiere Brothers are considered the first to successfully shoot and project films for audiences.

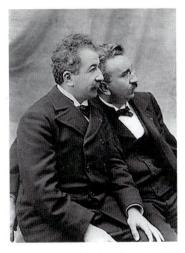

FIG 1.1 Auguste and Louis Lumiere, circa 1895.

Their work was amazing to the French and, ultimately, international audiences of the late 1890s. Everyday scenes of that era were well recorded and documented the factories and streets of Lyon, France. Once audiences became accustom to the novelty of moving images, the experimentation began. Several artists took the filmmaking technique much farther than Auguste and Louis Lumiere, the most significant of which was Georges Melies.

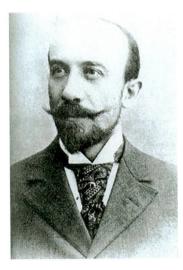

FIG 1.2 Georges Melies circa 1890.

The Parisian-born Melies was often referred to as the *Cinemagician*. His work with film was influenced by his experience as a stage magician. Melies learned how to use multiple exposures, dissolves, time-lapse photography, editing techniques, and substitution photography, in which the camera is stopped and the subject changed, to create a magical effect. These silent films created

in the late nineteenth and early twentieth centuries were like magic shows that featured special effects. This kind of filmmaking was the precursor to several different branches in the tree of stop motion, including modern day special effects, puppet or model stop motion, and pixilation and its various forms. Melies's *The Conjuror*, filmed in 1899, is a clear example of the relationship that he made between magic and his filmmaking.

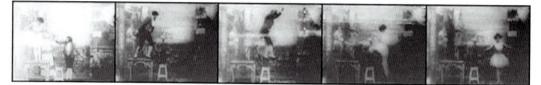

FIG 1.3 The Conjuror, 1899.

He covers a woman with a cloth and pulls it off revealing that the woman has disappeared and reappeared on an adjacent table. He then, through what appears to be magic, continuously switches positions between him and the woman, using smoke and confetti to enhance the effect. This is most likely attained through editing the film and re-enacting the action with different elements. The continuous movement of the actors helps create a smooth transition from one person or object to the next. The editing process was the first technique used in the manipulation of imagery, but before too long, frame-by-frame manipulations shot in the camera became the most effective way to have ultimate control on the film's outcome.

Another French contributor to stop motion and pixilation was Emil Cohl. His 1911 film *Jobard ne peut pas voir les femmes travailler (Sucker Cannot See the Women Working)* utilized real people and is one of the earliest pixilated films known. Unfortunately, many of Cohl's films have been lost due to fire and neglect.

The Edison Company, founded by Thomas Edison, created some of the first motion pictures in the United States in his infamous "Black Maria" studio in West Orange, New Jersey, in 1893.

FIG 1.4 The "Black Maria" studio, circa 1893. Courtesy of the Black Maria Film Festival.

Similar to the Lumiere Brothers, Edison's first films reflected everyday life and activities. Edison also attracted audiences and talent, like the first established American stop-motion animators, James Blackton and Willis O'Brien. Both artists favored model or puppet animation. O'Brien produced special effects films like the 1915 *The Dinosaur and the Missing Link: A Prehistoric Tragedy* and eventually the 1933 *King Kong.* Artists were moving away from the obvious tricks of dissolves, position replacements, and editing techniques to techniques that were the beginnings of special effects and model animation. Pixilation took a back seat. Even artists like Charley Bower favored models, as is illustrated in his 1930 *It's a Bird*, where Bowers has a bird eating metal materials and a car appears to be destroyed frame by frame as the film is run in reverse. This gives the appearance of the car assembling itself totally unassisted.

It is worth noting the Russian-born Polish animator, Ladislas Starevich, in 1910, was creating documentary films for the Museum of Natural History in Kovno, Lithuania. The final film in a series focused on the fighting of two stag beetles. Since these beetles would become dormant when the movie lights were on, Starevich decided to use dead beetles and attach wire with sealing wax to their thorax in place of their legs. This innovative thinking started a whole new approach to stop motion, which ultimately led to much more developed model animation.

In 1929, Russian director Dziga Vertov created a silent documentary film called *Man with a Movie Camera*. In this film, Vertov documents the lives of urban citizens in Odessa. The film, which was edited by his wife and partner, Elizaveta Svilova, features many of the techniques that we will discover in the following chapters. Not only does Vertov use freeze frames, double exposures, reverse playback, fast and slow motion, dynamic camera angles, and editing techniques but also stopmotion approaches to reveal a rather frenetic and modern existence. It is worth viewing this wonderful documentary film for its historical and aesthetic approach.

Stop Motion and Its Various Faces

Not until 1952 did the technique of pixilation become utilized in a film that struck an international chord. Norman McLaren's *Neighbours*, which featured Grant Monroe, mentioned earlier as the person who coined the term *pixilation*, put this technique back in the public eye.

FIG 1.5 Neighbours, directed by Norman McLaren. © 1952 National Film Board of Canada. All rights reserved. Photo credit: Evelyn Lambert.

McLaren's use of animated people and objects, dramatic action, and art direction made the technique perfect for this film. The battle between neighbors, in an extremely territorial fashion, has great humor but also a dark tone that delivers a message in an effective manner. Pixilation continued to grow after McLaren's continued use of this technique. One of the most notable and inspirational masters of this technique is the Czech surrealist Jan Svankmajer. Although Svankmajer used puppets on occasion he also used everything else from humans to meat to household furniture as animated objects. His concentration on textural imagery and suggestive conceptual filmmaking made him stand out from all other filmmakers. His 1971 film *Jabberwocky*, based on a poem by Lewis Carroll, features a cabinet running through a forest, dancing clothes, maggot ridden apples, distraught dolls, and flipping puzzle parts.

FIG 1.6 A series of stills from the cabinet in Jabberwocky, directed by Jan Svankmajer 1971. Courtesy of Jan Svankmajer. Photos © Athanor Ltd Film Production Company, Jaromir Kallista, and Jan Svankmajer.

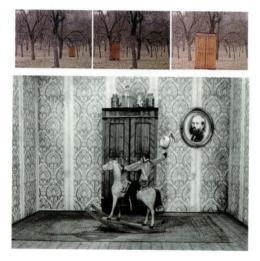

Although Svankmajer uses puppets, he mixes his animated subject matter so wildly that the photographic, textural, fast-paced editing leaves an audience feeling rather assaulted. Animators like the American Mike Jittlov, with his pixilated 1979 film *Wizard of Speed and Time*, and French-born Jan

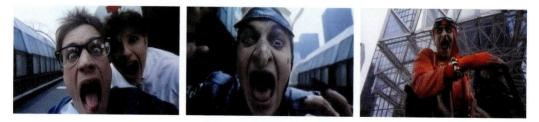

FIG 1.7 Stills from Gisele Kerozene, Jan Kounen, 1989.

Kounen continued using the pixilation technique with obvious influence from their predecessor, Norman McLaren. In Kounen's 1989 *Gisele Kerozene*, the use of dramatic facial makeup and costuming remind us of the faces of McLaren's two neighbors as they start to get deeply into their fight.

Kounen even used classic Warner Brothers cartoon animated motion when he animated people smashing into walls. Wide-angle lenses are used for exaggerated effect. Pixilation is starting to mature. The technique is no longer just a humorous or gimmicky style but a technique that can be chosen as a cinematic device. Dave Borthwick's 1986 feature film *The Secret Adventures of Tom Thumb* is a fascinating and dark film that expands the pixilation technique with a very distinctive story. Nick Upton is Tom Thumb's father, and he plays this role with a McLaren sense of exaggeration. This English actor holds his jaw out to maintain a particular look and refines the element of acting associated with this physically challenging technique. Controlling facial and body involuntary actions, often for hours and hours of shooting time, requires extreme control and awareness; and Upton does this quite well.

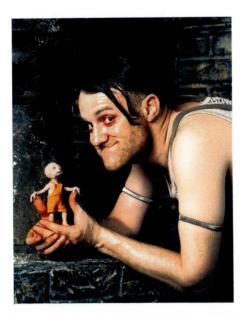

FIG 1.8 Still from *The Secret Adventures of Tom Thumb*, Bolex Brothers, 1986 (Nick Upton with an exaggerated face). Photo by Nick Spollin. *Courtesy of Dave Borthwick*. © *Bolex Brothers*, 1989.

Finally, it is worth noting the Peter Gabriel music video *Sledgehammer*. This 1986 groundbreaking animated short, produced by Limelight London and directed by Stephen R. Johnson, features the work of Aardman Animations, the Brothers Quay, and Peter Gabriel lip syncing or mimicking the words to this wonderful piece of music frame by frame and interacting with everything from fish to fruit to people to clothes and the woodwork itself. Most of these examples, including *Sledgehammer*, were produced and shot directly in the camera. Very few postproduction effects were added, which points out the clever and innovative approach these filmmakers used. This direct application of effects shows a resourcefulness that offers a unique look and costsaving production.

FIG 1.9 A still from the 1986 music video Sledgehammer, written and recorded by Peter Gabriel. Courtesy of Real World Music Ltd., Peter Gabriel Ltd., Real World Productions Ltd., and Aardman Animations. © Real World Productions Ltd. and Peter Gabriel.

Pixilation has become quite popular in film and animation programs across the country and the world. The technique is relatively inexpensive to produce and very direct in terms of the outcome. It does require proper planning like any effective use of animation, but you can get fast results and learn a lot of animation techniques by just grabbing a camera, stopmotion animation software, and objects or friends. On a professional level, there is more pixilation and mixed media out in the mainstream of our society than ever before. An example is *Her Morning Elegance*, directed and produced by Yuval and Merav Nathan, an Israeli couple that works in various animated techniques and genres. This music video is shot with a static camera mounted directly above a bed. A woman, a man, and objects are shot frame by frame in a controlled environment in a very stylized manner, depicting walking, movement in a subway, and swimming underwater all on top of the bed. The static background sets off the animated motion of the people, cloth, and various objects in a very satisfying manner.

FIG 1.10 Still from the music video, *Her Morning Elegance*, directed by Oren Lavie and Yuval and Merav Nathan. Photographer: Eval Landesman, 2009.

Two other extensions of pixilation are seen in the work of Blu and PES. Each artist uses pixilation but in very different ways. Blu works outdoors, painting walls and animating figures and objects on cityscapes. His camera work is unregistered and quite active but the dominant drawn figures in the frame maintain the focus of each shot as in his 2008 film *Muto* and his 2010 film *Big Bang Big Boom*. PES works with objects in a very controlled manner, creating events and environments out of everyday objects, as in his 2008 film *Western Spaghetti*. In this animated short, the simple use of candy corn vibrating frame by frame on a stove top, mimicking gasfueled flames, sets the style that unfolds in this cooking experience. PES animated stuffed chairs having sex on a roof in New York City in his 2001 film *Roof Sex*.

FIG 1.11 Chairs on a roof in *Roof* Sex, PES, 2001.

Time-lapse photography is a form of stop motion shot in a controlled and consistent manner. The effect of the time lapse is that it speeds up time and events so the viewer can study an event from a different point of view. This perspective and different temporal perception can give us a more expanded understanding of our world and ourselves. One of the most common uses of this technique is the blossoming of a flower sped up to ten or more times the actual event. Anyone can see an hour of real time go by in just 1 second. So much more can be achieved with this approach to stop-frame photography. Not only can events be recorded at an accelerated rate but animators can use this technique to pixilate objects and people. It is critical that the time-lapse camera have an intervalometer, or timer, associated with the camera so the shutter can expose the film or digital image sensor at an even rate. The even exposure rate or shooting interval of the camera reveals the natural rate or evolution of an event in nature sped up and compressed into a short viewing time.

Once again, George Melies was a pioneer in this area. His continued experimentation with film found him exploring time-lapse photography as is seen in the 1897 Film Carrefour De L'Opera (Film Crossroads of the Opera). Other early uses of time-lapse photography were associated with science. Biology and various phenomenon of nature became the prime focus for this technique. The technique has the benefit of speeding up slow action and motions, giving the viewers a better understanding of how nature works. The Russian-American Roman Vishniac used it in the early twentieth century, and his interest in nature included microscopic photography and the movement of living creatures. The work of John Ott in the 1930s, 1940s, and 1950s became a technique landmark. Ott, an American banker by trade, was fascinated with the growth of flowers and how nature and light affected them. He cobbled together enough photography equipment controlled by an intervalometer and put his lens on various plants in his own greenhouse. His expanded knowledge of how plants grow and are affected by the environment led him deeper into this technique of stop-frame photography. He created an early motion-control machine that moved the camera increment by increment, frame by frame as the camera captured a plant's progress over a long period of time. This movement of the camera from position A to B added a poetic element to the more scientific locked camera positions.

This inspired many filmmakers for years to come, including the rich and refined time-lapse photography of the British filmmaker David Attenborough, as illustrated in his 1995 film, *The Private Life of Plants*. Many sequences in this film focus on plant flytraps. The time-lapse photography of the growth and feeding habits of these plants rival any science fiction film ever made. Yet, nature provides these creatures and time-lapse photography allows us to view them with an expanded point of view.

The British Oxford Scientific Film Institute, in the 1950s and 1960s, went a long way to refining the scientific use of time-lapse photography and inspired many filmmakers and scientists like Attenborough and Ron Fricke. In the early 1980s, American filmmakers Godfrey Reggio and Ron Fricke created a feature film based

FIG 1.12 Dr. John Ott, circa 1950.

Photo by A. Taradel

around the revealing qualities of time-lapse photography. Called *Koyaanisqatsi*, most of the film was shot in the "four corners" of the western United States and New York City. The use of time-lapse photography is so effective that clouds can be seen as rushing currents of water and people traversing streets in New York look like pulsing blood in the veins of an urban environment.

The perspective of this film is so unlike anything we are used to seeing that it is easy to understand the message these filmmakers are creating without a word of dialog or narration. Technically this footage is superior, utilizing motion-control cameras, varied shutter speeds, natural and artificial light, and dynamic composition. The sound work of Philip Glass helps place this film in a category of its own that is unique, beautiful, and powerful. Time-lapse photography continues to be used in all sorts of commercial and educational venues. It is an effect that represents the complementary side of highspeed photography. Instead of slowing down events, it speeds them up and presents a whole new way of observing any event.

The last alternative stop-motion technique that we cover has many subcategories of its own. The one element that unifies these various subcategories is the way they are shot. Materials like sand, beads, candy, paper, photographs, and an infinite list of objects can be manipulated under a mounted camera on an animation stand, or downshooter. This is also referred to as a *multiplane animation stand*. All these elements can be shot in a horizontal fashion, but with a downshooter, they are treated like animation cels or drawings on a traditional animation stand. When shot this way these objects can be free of the constraints of gravity. The most developed

and popular use in this area is "cutout" animation. This involves drawings, photographs, and other two-dimensional objects joined together with rivets, string, wax, or other hinging devices to simulate animated movement. Although this leans much more in the two-dimensional world, like drawn animation, technically speaking, it is a form of stop-motion or frame-by-frame manipulation. The German artist Lotte Reininger created one of the earliest examples of this form of stop motion. *The Adventures of Prince Achmed* was a feature film produced in 1926 using flat opaque materials like lead and cardboard. These forms were shaped and constructed to move on a flat piece of glass with lighting that came from behind the cutouts. This created a silhouette effect that was enhanced with some limited color and various background materials to give a painterly look.

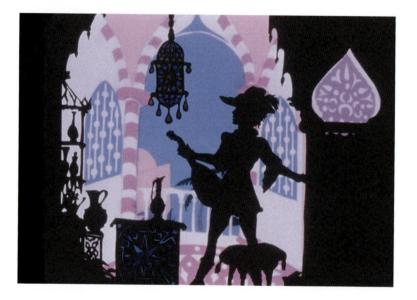

Cutout animation was one of the most popular techniques of animation, after drawing, for the first part of the twentieth century. It was a way to display a fair amount of detail without having to draw that detail over and over again. The Japanese utilized this approach through artists like Noburo Ofuji and Kihachiro Kawamoto. Applying individual and cultural techniques and styles to cutout animation added to the depth of this approach. Kawamoto traveled to Czechoslovakia in the early 1960s to work with Jiri Trnka in Prague, but Trnka encouraged him to pursue his own cultural history and create stories and artistic applications that were relevant to Japanese culture.

Cutout animation was a fairly popular technique, practiced by animators that worked in different mediums, including model stop-motion animation, and traditional cel or drawn animation. Auteurs in Argentina, England, Russia, Czechoslovakia, the United States, and other countries animated using backand front-lighted cutouts, cardboard, lead, translucent color papers, illustrations, and engravings, among other materials. The films produced using cutouts

FIG 1.13 A still from Aucassin and Nicolette, by Lotte Reiniger. © 1975 National Film Board of Canada. tended to be figurative in nature and often had cultural and ethnic themes. The relatively low cost of producing this technique allowed independent filmmakers and financially challenged countries to compete on the world stage in animation. The late twentieth century had several successful applications of cutout animation. Most notable was the Russian Yuri Norshtein and his film *Tale of Tales*, produced in 1979. This is a haunting tale of a family, community, and the effects of war. Norshtein uses drawings and cutouts, superimposed layer on layer, to create a very dreamy and often frightening memory full of atmosphere. This is a very controlled and time-consuming technique, and Norshtein is one of the masters. He continues to work today on a feature called *The Overcoat*, which has been over 20 years in the making.

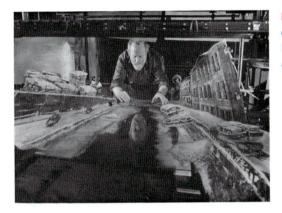

FIG 1.14 Yuri Norshtein working on *The Overcoat*, © 2000. Photograph by Maxim Granik, courtesy of Clare Kitson.

Other contributors to cutout animation include Terry Gilliam's work in the British television series *Monty Python's Flying Circus*. Gilliam, an expatriate American artist, cobbled together strange, surreal, and entertaining animated shorts for the series featuring drawings of his own and a large collection of Victorian illustrations and photographs animated together in the cutout approach. They were so offbeat and unusual that his animation became a signature part of the Flying Circus series.

FIG 1.15 Two-legged portrait of Teddy Roosevelt. Courtesy of Roger Saunders. © Python (Monty) Pictures Ltd., 1969.

In more recent history, several American television shows started out as cutout animation but evolved into computer-generated images that simulate the cutout approach. *South Park*, created by Trey Parker and Matt Stone, was first conceived in cutout animation but became too difficult to produce in volume using this technique. Many more pieces of animation for television and the Internet mimic the cutout look but use computer animation for efficiency, including *Blue's Clues*, JibJab, and *Angela Anaconda*.

These examples of cutout animation primarily use flat illustrated or photographic elements but a downshooter can also manage to hold more dimensional objects like beads, candy, clay, sand, or any other object that can fit between the shooting surface and the mounted camera. An example of this approach is from the 1988 film *CandyJam*, directed by Americans Joan Gratz and Joanna Priestly. It features the work of animators from around the world and is themed around candy. Several of the animators animated candy on a glass surface in patterns and figurative forms. The wonderful mix between flat and dimensional styles helps make this rich in texture and style.

Sand on glass is another popular downshooting technique mastered by the American-born Caroline Leaf. Although Leaf was born and educated in the United States, she is associated with the National Film Board of Canada, where she produced numerous films over the 1970s and 1980s and into the twenty-first century. Sand is manipulated on a flat glass surface with the camera mounted directly above the glass. The lighting comes from below the glass and the sand blocks the light from the camera, leaving a silhouetted image. The thinner the layer of sand, the more light comes through, giving the image a feathered look. There are many variations on this technique, and Leaf employs them well.

FIG 1.16 A still from *The Street*, directed and animated by Caroline Leaf. © 1976 National Film Board of Canada. All rights reserved.

We have only touched on a bit of the history and highlights of these alternative stop-motion techniques. Filmmakers have always been fascinated with the potential of creating images frame by frame to create illusions and fantasy. Although the majority of animation artists followed a more figurative and narrative approach to animation and stop motion in particular, many successful examples show less traditional, alternative uses of the medium in the nonfigurative areas. Today, artists are revisiting some of these older techniques and putting a new spin on them, with fresh ideas and technology. A real image captured by a camera has a unique and genuine appeal that is hard to deny. Computer imagery is full, fluid, and guite refined, but the imperfection and anomalies of the photographic expression of an object or person are what strikes us to the core. The process of shooting photographic frame-by-frame films requires a certain skill set that is unique to these techniques. All the innovators mentioned in this chapter have been groundbreakers. They had to take risks to experiment and use what they discovered in their process and expand on those discoveries. Many, like Dziga Vertov, were not so readily accepted in society, but their passion and drive to discover new means of expression in their filmmaking drove them forward in their frame-by-frame approaches. Pixilation, time-lapse photography, and downshooting are techniques that exemplify this approach, and we explore them in more depth in the following chapters. The possibilities are expansive.

CHAPTER 2

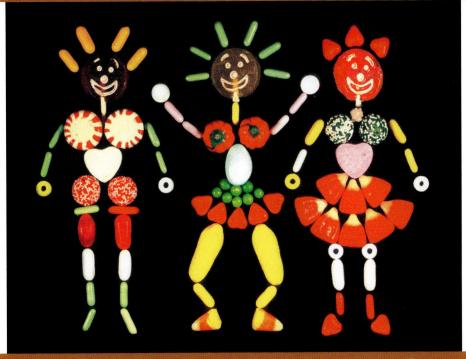

Shooting Frame by Frame¹

Chapter Outline

Technique to Serve the Idea	17
Preproduction	
Equipment and Setting Up	25

Technique to Serve the Idea

"A lot of people are trigger-happy—they just want to be shooting/ animating all the time, because it makes them feel like they are being productive. But in reality, you are just wasting creative energy if you haven't done the hard work on your ideas. And it is hard work. There are days when you smash your head against a wall trying to work something out. I spend a lot more time refining my ideas than I actually spend shooting.

"To me, understanding that your ideas are what make you unique is the most important thing. There are many people who can shoot or animate well. That's not the rare thing. A good idea is the rare thing."

PES

¹Opening image is from the 1988 film *Candyjam*, directed and produced by Joanna Priestly and Joan Gratz, © 1988.

I am always torn between the excitement of jumping directly into the production of an animated idea and approaching an idea with a better thought-out plan. Getting your hands on a camera, simple capture software, and shooting a scene spontaneously can be fresh and exhilarating, until you run into your first challenge or problem. This is especially true when shooting frame-by-frame pixilation of human subjects. Any animation is hard work, and you do not want to waste anyone's time and energy. Creative ideas need to be drafted and carefully honed to impress any audience these days. We are a visual storytelling society, and much more discerning about filmmaking language than any time before. Having a good idea and an interesting way of telling it gains and holds an audience's attention, and that is good communication. This planning phase, known as preproduction, is your road map or core idea that gives you direction. It also changes, and that is not a bad thing. There is room for the spontaneous approach, mentioned earlier, in this process, and we come across the subject again later on.

The first step in any film is the idea. What do you want to say? What idea, story, or visual art do you want an audience to receive? Who is your audience? Do you even care that an audience sees your work? There are many filmmakers who have no care for what an audience thinks. These "artists" want only to explore their own vision as best they can to their own satisfaction. This approach requires more risk if you are approach filmmaking as a means of income. But, some of the most successful ideas come from this original thought process. The great majority of filmmakers do care what an audience thinks and tailor their approach to filmmaking to make a connection with the audience. They yearn for a laugh, a gasp, or a tear in reaction to their film. Getting your ideas down on paper can be challenging. Scriptwriting is not an innate talent that most filmmakers possess. It takes practice, guidance, and crafting. There are many books on this subject so we do not go into this area. Ideas are another matter. I find that the old saying "life is stranger than fiction" rings true. When you draw from your own experiences and the experiences of others you know, you may have a kernel of an idea that can germinate. The effective outcome of this approach is that, if you had an experience and reacted to it in some emotional way, then audiences have a greater access to empathy and your idea, because we all share the human experience. Empathy, not sympathy, is a key ingredient to including an audience. We need to understand a character's emotion, based on our own experiences, but we do not necessarily have to agree with that emotion.

The next step is to take advantage of the process and strengths of animation. Hyperbole or exaggeration and strong images can be used effectively in animation. When real human subjects are not being used as the subject matter, we can address sensitive issues (like sex, death, and the human condition) with human proxies, like animals, aliens, or even everyday objects. You can elicit human emotions and experiences through inanimate objects and get an audience to understand your point. The audience can understand the empathized point and not necessarily feel directly or personally targeted by the subject matter. This is true even in pixilation, the animation of humans, since the movement is unreal or unnatural.

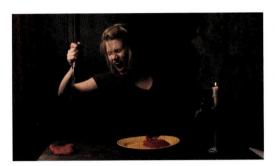

FIG 2.1 Image from Meat!, Lindsay Berkebile, 2010.

FIG 2.2 A production still from *The Human Skateboard* for Sneaux Shoes, directed by PES. Courtesy of PES © 2007.

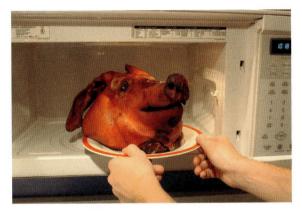

FIG 2.3 Image (pig head) from Off-Line, Tom Gasek, © 2009.

There are many ways to approach ideas, and the subject is a book unto itself. The important thing to remember is what you want to say, who your audience is, and how your idea can be clearly expressed through animation. The great Czech master Jan Svankmajer approaches ideas and process in a less formal way.

"I try to work spontaneously, I let the creative process open to chance and automatism."

Once you have an idea, you need to think about an animated technique that serves the idea or enhances it. For example, a lawyer who is going to demonstrate to a courtroom the events of an alcohol-induced fatal car accident to prove his client's innocence would be best using an emotionless, naturalistic, demonstration with computer-generated images. Imagine what the results would be if the lawyer showed this demonstration in clay animation or even pixilation. The courtroom might burst into laughter and not take the demonstration seriously. That lawyer would lose the case.

What would Gumby or Wallace and Gromit look like in drawn animation? Many of the old cartoons from the 1950s and 1960s are being updated into computer effects and images, and they just do not sit right. Some of this incongruity has to do with the way a film or character was first conceived. Originally, the choice of some techniques may have had to do more with economics than technique to support the idea. Once a technique is established and an audience embraces that film or character, an animator is treading on thin ice to move a beloved idea or character to a new animation approach. Ultimately, it is important to think about films that have been done in certain techniques and why those techniques were used. If you choose to use pixilation, time-lapse photography, or downshooting techniques, then how does that approach affect your final idea and outcome? Terry Gilliam from *Monty Python's Flying Circus* claims:

"I think the limitations of cutouts leads towards comedy or violence. Movements are crude, ungainly, and inelegant. It's hard to be portentous or pretentious with this technique. However, serious ideas can often be communicated very powerfully with humour."

FIG 2.4 Image from Monty Python's Flying Circus, Terry Gilliam. Courtesy of Roger Saunders © Python (Monty) Pictures Ltd, 1969.

Today, cutout animation is composed with After Effects, Toon Boom, or Flash to smooth out the "violent" approach that Gilliam cites. As a result, more and more kids' shows are being produced this way. The movement is much more fluid and subtle. Pixilation has a tendency to also be crude, ungainly, and inelegant by the nature of the process. It is practically impossible to keep a human subject completely still or registered in the same position one frame to the next. The result is a highly active frame that has a bit of a humorous and kinetic appeal. A pixilated Shakespeare would not be a great match (unless humor or parody is what you are seeking).

Time-lapse photography, which requires a consistent exposure of frames over a period of time, has a completely different effect. Events are sped up dramatically so time feels compressed into a short span. When a time-lapse camera is pointed at the sky during an oncoming thunderstorm the results can truly be awesome. Clouds look like waves of ocean water and one can see the power of nature.

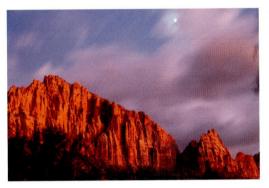

FIG 2.5 Zion Mountains with clouds, shot by Eric Hanson. *Courtesy of Eric Hanson*, ©1995.

When the time-lapse camera is focused on human subjects or animals, the effect can be a bit more humorous. The fast and unnatural movements remind us of early films, when cameras were undercranked and you would see comedic action, like the incompetent Keystone Kops from Mack Sennett

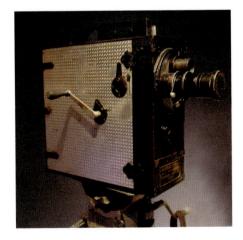

FIG 2.6 An old hand-cranked camera (Museum of the Moving Image).

in the early twentieth century. Cameras used to be hand cranked or driven, so the number of frames that were exposed per second in the camera was fewer than the number of frames projected per second on a screen later. More action was packed into less time, which gave the effect of everything being sped up.

There are many ways to overcome the inherent features of a particular technique, and these adaptations to the technique are one area we explore in the chapters about each technique. It is important to think about what a technique might bring to a film and if it is complementary to the concept of the film. If it is not complementary, then how can you adjust the technique to complement your idea? Once you have your idea and the proper technique, and in our case, we are concentrating on these alternative stop-motion techniques, you need to proceed deeper into preproduction.

Preproduction

Your concept and script need to be translated into visual language for you to know how to prepare for a shoot. This is the storyboard. Storyboarding can be a career unto itself, and some highly talented people work in this arena. The critical job of the storyboard is to force you to think through your idea carefully, map out a plan of production, and help communicate with the people involved in the production. The storyboard does not have to be beautiful. It needs to be practical and communicate your idea visually. If you are creating a film for a potential client, especially one that may not have your visual imagination, then a well-rendered and clear storyboard becomes essential. If you are making a film for yourself or a few friends, who may help you in production, then a "thumbnail" or simple stick-figure rendering of your idea suffices.

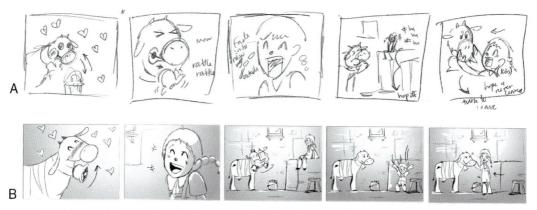

FIG 2.7 Images of "thumbnail" boards. A is a thumbnail and B is a finished storyboard. Courtesy of Janine Carbone, © 2009.

The use of reference material in this phase is a must. What does a gila monster look like? What is the scale relationship between the Empire State Building and an igloo? What color is Mars? If you have no idea then jump on the web and get some photographs and images to become informed. You can then distort this information, but you need to know the truth before you go off on a tangent. Even if you create something that has never been seen before, you still may need some reference for texture, details, or color. Reference material is where it all starts visually. If you do not draw very well and cannot get someone to help, then you might consider creating a photographic storyboard with a digital still camera. This approach requires that you go out and find images you can photograph with your digital single-lens reflex (dslr) still camera, or images in magazines, on the web, or from other visual resources. By using some simple cutting and pasting in a program like Photoshop, you can create your own storyboard that clearly communicates the narrative or ideas you need to show to tell your story. This is especially appropriate for the production of a pixilated film. Between reference material and photographs, you can create a storyboard that reminds you of how you planned the production, and it can communicate your intentions to your small crew.

Drawing is a great skill, one that I would encourage, but if the skill is not available, then there are other ways to lay out a storyboard and move your production ahead. Storyboarding for time-lapse and certain pixilated films may be close to impossible to draw out because it relies so much on the eye of the cinematographer and director when on location. Simply writing down shot ideas in sequence and what you want to accomplish with each shot can be very helpful. You then have to be open to what happens in the field. In time-lapse animation, it is absolutely critical to observe the event that you want to photograph. You need to know how long an event takes to unfold, what the subjects do, how the lighting might change, and how the general environment, like weather, might change before you shoot the final shot. FIG 2.8 Images of a photographic storyboard. A is a simple cut and paste photographic storyboard. B is a finished photographic storyboard with background. You need to scout a location first. If you cannot scout a location or event before you shoot a time-lapse film, then you need to get information about the weather, accessibility of the location, and what sort of traffic crosses through your focused area. This research and environmental anticipation can be done on the web or by talking to people who have been in the area you want to shoot. This is all preproduction, the planning and preparation necessary to execute before you enter the actual production stage. It saves you a lot of time, effort, and helps give clarity to your idea. It forces you to think through the process and solve problems before they arise (which will happen in the field or on the downshooter during the actual shooting). Preproduction does not eliminate all the potential problems but it resolves the majority of them and focuses your vision. Alternative stop-motion techniques are not an exception from all other types of animation when it comes to preproduction.

Many directors and animators like to take the preproduction process one step further. They make a moving storyboard, or what is known as an *animatic*. An animatic puts all the storyboard panels into a timeline and makes a movie of the artwork. It should be timed out to match the final timing of your film. You can make adjustments to the animatic, and it helps determine the final cut of your animated film. Often animation can be pre-edited through this process. The advantage of this is that you do not overshoot the animation footage, which is a very time-consuming, expensive, and potentially exhausting experience. It forces you to look at the overall flow of your film, check for consistencies, and have an idea of the dynamics of your shots all together. It is critical to look at the big picture. Once you capture the final footage, then the corresponding artwork shot for the animatic can be replaced by the final footage. The sound and dialog play an important role in this process.

FIG 2.9 Animatic on a timeline in Final Cut Pro, Courtesy of Tom Gasek, © 2011.

One step I practice and encourage all alternative stop-motion animators to consider is shooting some test footage before the actual production begins. If you are pixilating someone, then try the action yourself in front of the camera and get a sense of the pace, action, and timing. Try your actor out in a test and give the person a chance to practice this arduous technique, so you can see how he or she acts and how you want the ultimate action to look. This is the time to have a bit more confidence with your shots because you cannot make mistakes in a test. Allow yourself the spontaneity that can often birth new and exciting ideas to apply to your film. If you have no one to help you test a pixilated idea, then set your camera to run on a time-lapse interval and test a particular movement on your own. If you plan to shoot a time-lapse event, then take your time-lapse camera and shoot a test of the event and see if you need to consider an adjustment to your exposure or interval between exposures. Cutouts or sand on glass have their own properties, and a trial run will inform your initial animation shots and improve your technique right out of the gate. There is often a tendency to jump right into production shooting, with no time allowed for testing. I cannot tell you how many times I have heard animators complain about their initial shots, because they were learning everything on the first shots and made adjustments in later shots. The desire to reshoot first shots is strong but often schedules do not allow this. Testing can resolve this issue. There really is no reason not to test and experiment before you commit to your final film.

Testing requires equipment, and this is one more issue that needs to be addressed before final production begins. Pixilation and time-lapse animation utilize equipment that is familiar to live-action filmmakers. Cameras, computers, tripods, lights, and grip equipment, like flags, C-stands stands, sandbags, and gaffer's tape, can all be used with these alternative stopmotion techniques. The downshooter requires an animation stand and this crosses over into the more traditional animation realm. All alternative stopmotion techniques have a camera as the primary piece of equipment. After all, we are stopping the camera frame by frame and manipulating the images in front of the camera, whether on a tripod or a downshooter, very much like the first "trick films."

Equipment and Setting Up

For decades, the movie film camera was the primary capture system. Kodak, Bell & Howell, and Mitchell cameras were steady and reliable animation cameras. Other cameras were used, but the key element that made a good stop-motion film camera was known as *pin registration*. Basically, this means that the camera has the ability to place the individual frame to be exposed in the exact same position in front of the film gate as the previous frame through placement pins. This eliminates the weave and bobbing up and down that can occur when films are projected. FIG 2.10 Image of a Mitchell camera with pins.

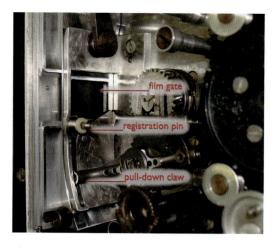

These days, like many things, digital technology has put the animation film camera to rest. The two main digital cameras used are the digital video camera and the dslr camera. There are advantages to each camera, and this is explored in subsequent chapters. Remember that we need the ability to shoot one frame at a time. Digital still cameras are ideal for this approach because they were designed to take single still pictures. Most digital video cameras can be controlled to shoot single frames through the animation software that you need to use. All images that come through a digital camera are digitally registered in size and placement, so there is a steady image when single frames are strung together to make a movie. Having a camera that has "manual" controls is critical for a steady image. Canon and Nikon are two leading brands in the digital SLR arena and Sony and Panasonic are two popular brands in the digital video approach. Many more brands work well and satisfy the requirements needed for alternative stop motion techniques.

FIG 2.11 Image of a Panasonic digital video camera and a Canon digital still camera.

The computer software that makes animation possible and easier to execute is known as capture software. Several different brands are listed on our associated website and mentioned through this book. Dragon Stop Motion and Stop Motion Pro are ubiquitous across the globe. Several features are common to all good capture software. They need to show you a "live" frame coming directly in from your camera. The ability to compare the previously captured frame and the live frame allows you to monitor the amount of movement your subject has registered. It is important to be able to step through all your frames one frame at a time so you can see the sequence of movement, and the software needs to have an instant playback at various frame rates so you can see your final animation. The better capture software programs have many more features that allow you to refine your animation and animation technique. They also work on Apple and PC platforms. Several inexpensive and free capture software programs, like iStopMotion, Framethief, and Anasazi, are available for novice animators, but these programs can have support, technical, and capability limitations and may frustrate the more advanced stop-motion animator. They are great starter programs but are not quite up to the depth of the previously mentioned programs.

FIG 2.12 Image from the "screen grab" of the Dragon Stop Motion interface.

Similar to live-action photography and live-action movie making, all stop motion requires a "grip" package. This may include tripods, lights, flags, electric chords, voltage regulators for lights, sandbags, gaffer's tape, and potentially motion control for moving the camera. We will explore these elements in more detail but it is important to know what is required by your particular script or idea. Naturally, for downshooting, an animation stand is required, but the stand comes in various forms. This can range from a classic Oxberry animation stand right down to a camera on a tripod pointed down at 45° angle toward a tabletop. The Oxberry animation stand is like the Rolls Royce of downshooters. It offers weight, stability, and very accurate, dependable registration systems, like machined peg bars used to perfectly match one cel or drawing to the next. Often Oxberry stands, which are designed for both 16 mm and 35 mm film cameras, are computer controlled with stepping motors that drive the various components of the stand, like the shooting table, the lighting, and the mounted camera. Most downshooting producers custom build their own stand for a fraction of the cost of an Oxberry, and it suits their needs quite well.

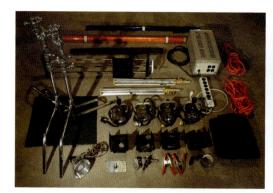

FIG 2.13 Image of grip equipment (lights, flags, voltage regulator, c-stands).

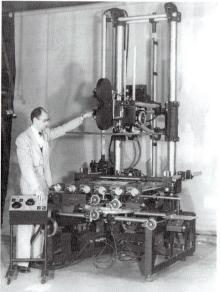

FIG 2.14 Image of Oxberry animation stand.

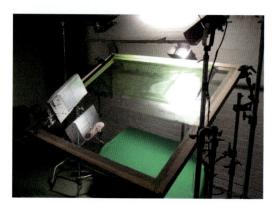

FIG 2.15 A custom downshooter, *Courtesy of Miki Cash*, © Wonky *Films 2011.*

During this preplanning/preproduction process, you need to think through all of your shots and determine the most efficient and effective way to shoot your production. Examine your budget, space to shoot (if it requires a controlled studio environment), and the amount of time you have to shoot.

Let us move into one of the most popular forms of alternative stop motion. Pixilation can be direct and simple when practiced by novice filmmakers or it can be very sophisticated. Of all the various types of stop motion, pixilation can be a bit more spontaneous in production because it is very hard to control humans frame by frame. If you are out in the field, it is hard to control natural light and any peripheral activity. With the proper planning, observation, and application of this technique, the results can be very satisfying and fresh.

Pixilation¹

Chapter Outline

Take Advantage of the Medium	
Who Is the Director?	
Humor	
Shooting on Twos, Fours, and More	
Variations on Pixilation	
The Moving Camera	

Take Advantage of the Medium

"We like the fact that you can feel the real material in the objects. When you choose your medium of work you get another aspect to play with. How would that material express what I want to express? When you animate a paper or a person you actually use a material that everybody has a relation to, and then you add another layer and give this material life in any way your imagination will lead you."

Merav and Yuval Nathan

¹Opening image is a light painting with Christmas lights. © Tom Gasek 2011.

CHAPTER 3

Pixilation is one of the most popular techniques for anyone who wants to jump right into animation with little or no experience. Having a camera is about all that is necessary to begin this process. Naturally, there are more possibilities if you have a well thought-out idea, a computer, capture software, and a tripod, but capturing images on a compact disc in the camera and the ability to sequence those pictures into a movie is all it really takes to shoot a pixilated film. Even an experienced stop-motion animator can pare down his or her equipment to a single camera and create an interesting film. Having some knowledge of how to take advantage of this technique makes a huge difference in the final outcome. The early trick film artists, like Melies, knew how to utilize the unique qualities of single-frame manipulation. We explore some of these "tricks" and advantages of pixilation in this chapter, and it is not just the equipment that we explore but the ideas and execution of your next pixilated film.

What exactly is *pixilation*? Remember that Grant Monroe, who worked with Norman McLaren on *Neighbours*, coined this term. Monroe and McLaren used the human body as the animated subject. Unlike model animation, pixilation, the animation of humans, requires no intensive model building, armature building, or even character designing. Everyday objects like kitchen appliances, cars, books, or any premade physical form can be moved or animated frame by frame, and this would also be considered pixilation, which is a subdivision of stop motion. Animating humans appears to be the most frequently used subject of pixilated films. As you can imagine, the variations are limitless.

If you start to add the elements of design or makeup to people in a pixilated film, then the results can be even more dramatic. This is what McLaren did in *Neighbours* and what was emulated in Jan Kounen's 1989 film *Gisele Kerozene*.

The addition of makeup or costuming enhances the dramatic effect of the film but so can the strong expressions of the pixilated human figures. This is not a delicate and subtle animation technique, because human subjects are always moving. It is virtually impossible for humans to stand absolutely still like a model or an object, so the result is an impulsive energy and vibration.

FIG 3.1 Grant Monroe in Neighbours. © 1952 National Film Board of Canada. All rights reserved. To overcome this effect of internal energy, the expressions of a human subject need to be bold and powerful. The eye is drawn to the strong expression and becomes less concerned about the constant vibration of movement, which can be a potential distraction. Once you understand this principle, you can experiment with variations of expression and constant movement. Lindsay Berkebile, a young filmmaker in the New York area, puts it this way:

"In my film *MEAT*! I took a simple concept and used the stylized movement pixilation provides to my advantage. The movement is exaggerated; the facial expressions are pushed to the limit and place an audience at an uneasy state. The movement, especially in this piece, is very controlled for pixilation. There are a lot of pauses, silent moments, and breaths throughout the film. However, the stillness still has a vibrating life to it, which I feel gives the film a sort of chaotic life amongst silence."

In my own 2009 film *Off-Line*, I wanted to animate a real human arm and hand pressing a microwave Start button. I wanted a slightly affected movement, but I desired a more fluid live-action approach to the movement of the hand. I ended up making a support or rig to hold the human subject's arm so I could control the movement. If the support were not there, then the inward movement of the arm would have been less direct and effective.

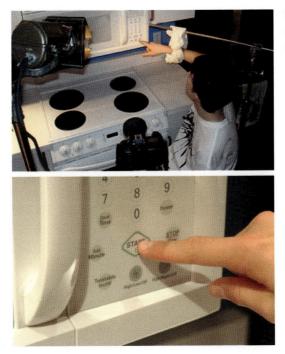

So setting up rigs, using predetermined staging marks, and designing the look of a character through makeup and strong expressions can add a whole other layer to your pixilated film.

Knowing how to use pixilation, especially with human subjects, can really complement the emotional or visual storytelling aspect of your filmmaking. Ultimately, several things are unique to pixilation. Since each frame is taken one at a time with an indeterminate period of time between frames, you have the ability to completely rearrange or manipulate your subject matter and frame. This could come in the form of removing or introducing an object or person from one frame to the next, capturing a movement or position of an individual, like a mid-air jump for each frame, or just bringing inanimate objects to life. These are the same principles that the early trick film artists utilized, and they are just as effective today. These techniques have a unique quality when done photographically, eliciting a sense of magic.

Who Is the Director?

When animating a pixilated film, at least two important roles need to be addressed. One is the person behind the camera, the director, and the other is the person(s) in front of the camera, the actor. At least one of these people must have a basic understanding of animation. The principles of "easing" in and out of movement, accelerated action, secondary motion, anticipation, squash and stretch, and the effects of momentum add a lot of dynamic and interest to any scene. To review these principles, let us look at a few illustrations. When any movement begins, it takes a lot of energy to make an object break inertia. There is an acceleration of movement frame to frame as the object (person) gains speed. The opposite is true when an object comes to a stop. The object decelerates. Think of when you drive a car and how it works. You step on the accelerator, forcing the tires to start rotating and getting up to cruise speed, where the tires rotate at an even rate, giving the car an even speed; then you apply the brakes to slow down the rotation of the tires and the distance you travel before you come to a complete stop. When the tires

FIG 3.3 The basic physics of any movement requires ease-in and ease-out movements with an accelerated increase and decrease in the amount of movement for each frame.

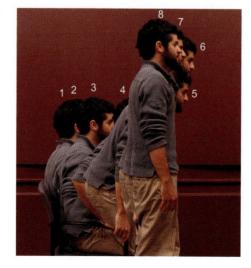

stop turning, the car continues slightly forward with secondary motion and the chassis settles back to its default position directly over the tires. Once this principle is understood, the director or actor can break these rules and create some different effects.

Secondary motion basically means that any appendage or secondary mass like hair on a head or a tail of an animal trails behind the main body of movement. For example, if a person quickly turns his or her head, the hair trails a few frames behind the mass of the head, which is the source of the movement. The head stops, but the hair continues around past the head's stationary position then settles down.

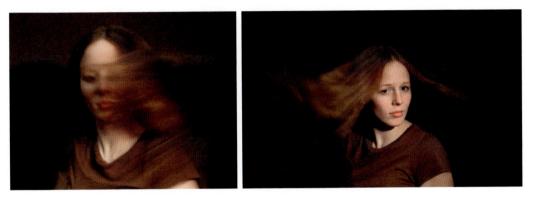

FIG 3.4 Secondary motion of hair as it trails behind the turn of a head.

Anticipation basically means that, to move in a particular direction, you must first move slightly in the opposite direction. This wind-up builds energy and allows the audience to see what is about to happen for a beat before it actually happens. This is exaggerated in animation but often does happen in real life.

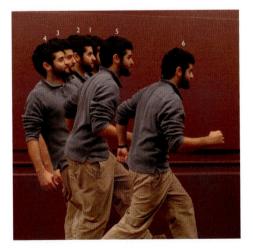

FIG 3.5 The wind-up or anticipation allows an audience time to focus on an object before it moves, and anticipation builds energy just before that action occurs.

Squash and stretch is an exaggeration of the way movement occurs and how weight and form shift within that movement. Again, it is emphasized in animation and can add a humorous element when it is highlighted. These classic principles of animation apply to pixilation as much as any other form or technique of animation. It is limited with the human body, because the body can stretch and squash only within its physical limits, but this principle can still be applied.

FIG 3.6 The human figure can squash and stretch for a humorous effect, but it is limited in its physical range.

All these basic principles should be considered when producing pixilation. Applying these guides to movement must be planned and intentionally created. After all, how can you have a head of hair fly around a turning head when you are shooting one frame at a time and there is no momentum to make the hair fly? Gravity pulls the hair down. In this case, if you want to have hair flying, you may have to consider using hair spray each frame after arranging the hair in a particular position of movement, or some sort of rig weaved through the hair, or clear fishing line to hold the hair while the slow process of shooting single frames occurs. We discuss rigs and special requirements further in the book.

You may decide that you do not want that kind of natural movement and let pixilation be pixilation, with all of its particular attributes. The bottom line is that these are decisions that must be made, and the director is the one who plans the shoot and makes the calls. It is possible to simultaneously be a director and an actor that performs in front of the camera, but there are limitations to this approach. You cannot really see what the camera is seeing, and although you might be able to judge the kind of movement that is required for each frame of an action, you are unable to adjust your position or registration in the frame relative to the previously captured frame. Naturally, you can set up a computer or have your computer attached to a projector in front of you, so you can see yourself as you animate yourself. The problem is that you are concentrating on looking at yourself and not necessarily on what you need to focus on. Also, wireless remote controls with infrared beams could allow you to shoot your camera from across the room, but this takes careful control and aim and might pull you out of position. Finally, you can use a time-lapse feature on your camera, but that requires that you be ready for your next position every frame within that allotted time interval. So, you can be an actor and a director simultaneously, but it is much more effective to have someone behind the camera shooting and calling out to you or actually moving you as the animated (actor) subject.

Humor

"Although pixilation has been explored since Norman McLaren's work in the 1950s, it had tended to be used largely for slapstick effect. Our initial interests were in trying to use the technique in a more subtle and expressively dramatic way.

"The intention was to make a film that looked like live action but [moved] like an animation film. When successful, the technique creates a distorted realism that can very effectively be used to accentuate or exaggerate a character's personality and presence. It was that possibility of manipulating the dramatic performance of a character that led to the use of pixilation techniques in the Tom Thumb project."

Dave Borthwick (Bolex Brothers), The Secret Adventures of Tom Thumb

As Dave Borthwick points out, many pixilated films have leaned into humor and slapstick, primarily because the fast and energetic movement of pixilation tends to strike the "funny bone." Yet, this technique of animating people also lends itself to more serious subject matter. The more control of expression and movement, the more serious the effect can be. As Lindsay Berkebile points out, using holds with as little movement as possible in a human animated subject can emote a sense of quiet desperation or an inner energy and conflict that may reveal another layer of interpretation in an animated performance. The key is in the performance, expression, and overall movement.

In Jan Kounen's *Gisele Kerozene* and in Norman McLaren's *Neighbours*, the action is so broad and absurd that one cannot help but laugh. In *Neighbours*, when one of the battling men, played by Grant Monroe, hits the other neighbor's wife with a picket fence post, throws her baby to the ground, and kicks the baby off screen, we cannot help but laugh despite the dark humor involved. It is so tragic that it actually becomes comedic, and the fast paced action of the pixilation feeds the humor. As Terry Gilliam states, "...serious ideas can often be communicated very powerfully with humour."

Terry Gilliam

A few techniques can be used to help smooth out the action of a performance, allowing for more serious interpretations. It appears that the more time spent between frames adjusting people leads to the potential for more quirky and misregistered movement. This can be very funny looking. But, if the movement of a character is smoother, then the effect can lean more toward serious interpretation. Expression and performance play a key role, but we are concentrating strictly on movement. So, if an actor being shot frame by frame moves slowly and constantly and the camera operator continuously shoots frames, capturing the in-betweens of action at a more even pace, the action will be smoother, mimicking live-action movement. A minimum of time should be spent between shot frames. If the person being shot is moving constantly in a particular direction, then he/she will be better registered in placement from frame to frame than spending minutes between frames adjusting position and losing that registration.

Surprise is always an effective way to conjure up a good laugh. Pixilation allows a filmmaker the ability to change the subject matter or position of the subject within the frame for each shot. This erratic movement combined with unexpected action and subject placement within a frame is fun and surprising. That elicits humor. Quick movement similar to the animation in cartoons, like the work of Warner Brothers director Chuck Jones, can raise a laugh. Treating human subjects like cartoons that whip across a frame, do the impossible (like dancing across a dance floor on their fingers, slamming into walls with no consequences, and other humanly impossible feats) make us laugh and think of these human subjects as unreal. This quick stylized movement is what Dave Borthwick was referring to when he mentioned that a lot of pixilation was relegated to the slapstick world.

Shooting on Twos, Fours, and More

Often pixilation filmmakers mix together smooth and quirky misregistered movement. This adds an interesting dynamic movement to a film. We just explored constant shooting of the single-frame camera, but the mixture of live-action photography and pixilation can be very effective to achieve this dynamic. A great example of the mixture of frame rates is Norman McLaren and Claude Jutra's 1957 animated short, *A Chairy Tale*. McLaren and Jutra would often shoot at half normal live-action speed (12 frames per second) to speed up the action and blend that footage with the more time-consuming frame-to-frame manipulations.

Pixilation

FIG 3.7 Still from A Chairy Tale, Norman McLaren and Claude Jutra, © 1957, National Film Board of Canada. All rights reserved.

Another successful practitioner of the pixilation and live-action mix is Jan Svankmajer. It is blended so well that the viewer easily falls into the magical space that is created with these practical and photographic effects. In the 1994 film *Faust*, Svankmajer cuts back and forth between the live action, pixilation, and clay models of Mephisto.

Jan Kounen did the same thing in Gisele Kerozene and claims,

"I'm no more thinking of stop motion as a genre, but only as a technique; even in *Gisele Kerozene*, there is 20% of real stop motion the rest is shooting continuously at 2 frames a second, or 6 frames."

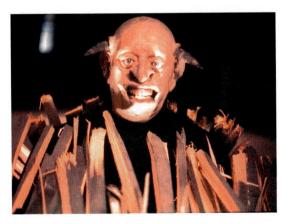

FIG 3.8 The clay head of Mephisto from *Faust*, Jan Svankmajer. Courtesy of Jan Svankmajer. Photos © Athanor Ltd. Film Production Company, Jaromir Kallista, and Jan Svankmajer.

Both McLaren and Kounen were shooting with movie film cameras that allowed them to vary the shooting frame rate. The present day digital still cameras now have the capability to shoot live-action movies and the newer models shoot in high definition. They are starting to include features like variable frame rates; for example, the Nikon D-90 shoots 1 to 4 frames per second and the Canon 7D can shoot 24, 30, and 60 frames per second. Many digital video cameras have this various frame rate feature available, because they were made to shoot live-action video. The digital still cameras are not far behind. Please refer to the associated website to see the latest in camera technologies.

For animators that have no access to this higher-end equipment, using the continuous shooting technique helps vary the look of pixilated film. When you shoot "pure" stop motion or heavy manipulation of the subject matter between frames, you need to consider how many pictures or frames you want to use for every increment of subject movement. Since moving human subjects is physically challenging, it is best to reduce the amount of work demanded of them. I often shoot my human subjects at a rate of 15 frames per second and play back the footage at 15 frames per second. Or, you can just shoot two pictures for every movement of the human subject and play it back at 30 frames per second. This technique, known as shooting on twos, has the same effect as shooting at 15 frames per second (fps) with a playback of 15 fps. Since NTSC (the National Television System Committee) video is 30 frames per second, that is the rate I like to use. This is most common in the Americas and parts of East Asia. In film, the projected playback rate is 24 fps, so many animators shoot two pictures per movement, played back at 24 fps. But, if this film is transferred to video, then there is an interpolation made to stretch those 24 frames into 30 fps by averaging out two frames every five frames of footage. This works well but can be somewhat problematic if you are creating special effects frame by frame in postproduction, where every frame needs to be a clean distinctive image. In this case, images are worked on in the effects area at 24 fps then stretched to 30 fps after the effects work is done.

Variations on Pixilation

Although the animation or pixilation of people is quite popular, so is the combination of people and two-dimensional graphic elements, the animation of light, and the animation of everyday objects. Mixing people frame by frame with drawn animation, graphics, and objects elicits an infinite variation of this genre. The important element that distinguishes this approach is that combining these elements occurs directly in front of the camera and not in a postproduction process. One example of this approach is by filmmaker Jordan Greenhalgh, an independent filmmaker in New York. Jordan made a film, *Process Enacted*, in which he shot his human subject frame by frame with a Polaroid camera then animated the Polaroid photographic prints on a tabletop.

Pixilation

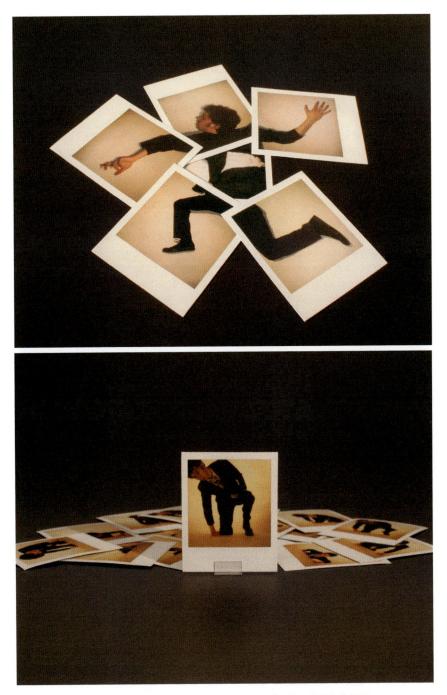

FIG 3.9 Images of multiple Polaroids for *Process Enacted*, Jordan Greenhalgh, © 2007.

This is a time-consuming, difficult process, because it requires twice the amount of animation, once for the human figure and once for the animation of the Polaroid photographs, but the results are fascinating. In this kind of approach, spontaneity of production can be risky, so planning ahead reduces that risk. Jordan states:

"I test shoot every idea. I have to work out the technical kinks. I also storyboard and make animatics to get a feeling for the film as a whole..."

A contemporary, Italian born, graffiti artist/animator, Blu has made several films that feature paintings on buildings that animate across an entire neighborhood or urban environment. His animation is often shot in outdoor environments, where the natural movement of light helps keep his frame active and fluctuating in exposure. He then adds constant movement to his camera in an erratic fashion that infuses an energy and freshness to the image. There is an aesthetic choice to this approach as well as a practical advantage. By moving the camera constantly, the viewer accepts the active camera and consistent jittery motion, which helps mask any unplanned exposure, lighting, or camera placement changes. These changes may occur naturally, due to weather, time, or unforeseen obstacles. This technique, like most stop motion, is difficult and time consuming, and single shots may take days or weeks to complete. He can stop in the middle of a shot at the end of one day and start up again several days later, yet the shift in the image does not stand out. It is impossible to control external conditions for any extended period of time outdoors, so Blu's aesthetic and practical solution works very well. Since the overall frame is so active, Blu creates strong striking graphic images, like in his 2008 film Muto and his 2010 film Big Bang Big Boom. The eye is drawn to the constant morphing and moving image and is not distracted by the highly active overall frame. This contrast and focus of the eye is highly effective. In both films, Blu moves his images from graphic flat painted images to threedimensional forms that may carry some of the painted graphic elements on them as they move through the frame. Occasionally, Blu appears in and out of the frame, revealing some of the process of making the actual film.

FIG 3.10 A series of three shots from Muto showing the movement in composition from one frame to the next. Directed by Blu, © 2008.

Pixilation

FIG 3.11 Shots from *Big Bang Big Boom* demonstrating the use of two-dimensional and three-dimensional elements shot frame by frame. *Directed by Blu*, © 2010.

Light is an element that many contemporary artists are starting to rediscover. Light generally plays a big role in photographic frame-by-frame animation because it gives form to objects and sets atmosphere. Pixilation filmmakers create films both indoors and outdoors with controlled and "wild" lighting, lighting that occurs naturally. The sun is the largest light that we utilize, but human generated lights both in the studio and out in the streets have great potential to be exploited. Painting with light, frame by frame, has begun to expand with today's technology. By using LED lights or even bright flashlights in a dark environment, you can create a light painting. Like the other techniques discussed, you must use a dslr camera that has all manual controls on a tripod. By setting the shutter speed to a long exposure (at least 2 seconds and potentially longer), you can draw streaking light images frame to frame.

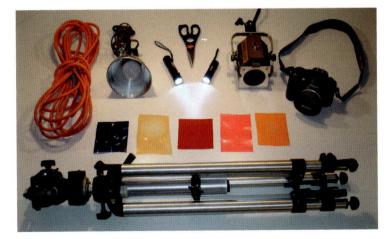

FIG 3.12 Tools required to light paint—camera, tripod, lights (LED, etc.)—and colored gels.

The light(s) must face the camera lens as you draw an outline or image. Since the room is dark, the light painter should wear dark clothes and may disappear from the final image all together. It is also helpful for the light painters to move their position frame to frame to help hide their presence. The light, which is

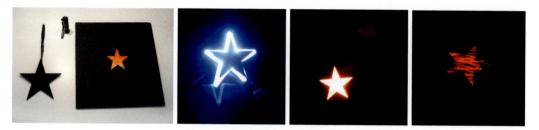

FIG 3.13 Guides for light painting.

bright and moving, leaves a strong streak of color (if you use colored lights) that creates a drawn image on the frame. Some artists create images freehand for every frame. It is important to know the shape being drawn and to be able to repeat it or potentially change that image frame to frame like any animation. You can have a person or cutout of the shape you want to draw as a guide when you light paint, if you need that kind of consistency.

New approaches to light painting include using iPads as the source of light. By predetermining certain shapes and colors, the light painters can move in the dark with their iPads in hand. The iPad image changes frame to frame, and the movement of the painter holding the iPad and a long exposure allows words and more distinctive shapes to be extruded exposure by exposure.

FIG 3.14 An iPad held in the dark to form a distinctive shape.

The final area of pixilation I want to cover is what I call *object animation*. This is very close to model animation and is treated in a similar fashion. The main difference is that the objects have little or no manipulation performed on them. In puppet or model animation, sculpting, armature fabrication, molding, painting, and a whole series of processes are involved before that model is put in front of the camera. In object animation, usually, very little is done to the object. The animation of an object, how it is moved, is the way that expression and storytelling is achieved with this technique.

One of the most successful contemporary artists in this area is an American animator who calls himself PES. Although not trained in animation, PES

worked in the advertising industry in short subject filmmaking (commercials). Some might consider PES a three-dimensional collage artist. In his first successful film, mentioned earlier in the book, PES animated real chairs on the roof of a New York City apartment building. This film, Roof Sex, has a strong sense of art direction in color and composition and the chairs, which bare no human features, are moved in a way that mimics humans consummating. Understanding the effects of movement through testing and reference film allows an animator to reproduce a particular action that may not normally be associated with that object. As humans, we recognize certain actions associated with our species, because we understand ourselves (mostly). Once that motion is transposed onto another object, we identify and find interest and humor. PES has a simple trick that he uses on his website and in his 2009 film, Western Spaghetti. He mimics a flame, on a stove or in a fireplace on top of pretzels (that look like logs) using several different size candy corns and replacing them in front of the camera every two frames. It is so simple but so effective. This technique, which is known as replacement animation, calls for the substitution of one object for another similar but different object. The changing objects create an animated effect. This is one way to achieve squash and stretch in object animation. Replacement animation is one of the cornerstones of all stop-motion techniques. People can be substituted for people, objects can be substituted for other similar objects, and the effect can be magical, as in the PES candy corn flames.

FIG 3.15 Several different sizes of candy corn are used as replacement models, imitating a flame. Courtesy of and © PES.

One simple exercise that anyone can try involves taking any object, like a saltshaker, and moving it around a table in front of a camera, frame by frame. This requires a digital still camera or a digital video camera that is controlled or hooked into a capture software program, like Dragon Stop Motion or Framethief. Dragon works well with the digital still cameras and standard definition digital video cameras work well with Framethief. Mount your camera on a tripod and lock it down with tape or sand bags. Make sure the tripod is on a hard flat surface like a concrete floor. Do not

(Continued)

mount your tripod on a rug because the "give" in the rug could move your camera. Put a simple light on your saltshaker and start moving it around, bit by bit, frame by frame. Shoot two pictures for every move ("on twos"). Capture about 3 seconds of this. Now, find a piece of liveaction film of a person who is very nervous or any other kind of dramatic emotional state. This reference film should be a Quicktime movie, so you can look at it frame by frame. Notice and analyze how the person is moving frame to frame. Once you understand the action on a single frame basis, transpose this movement onto that saltshaker. Try to be as true to the reference film as possible, and even try exaggerating that movement. If you do this successfully, then you will understand the power of controlled animated movement in everyday objects.

If you want to add another layer to this experiment, then try to find a saltshaker that comes in three different sizes. You can substitute the salt shakers, one for another, to get a breathing effect, expanding and contracting.

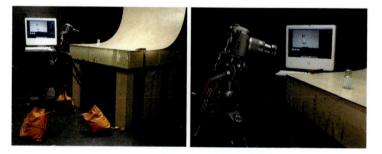

FIG 3.16 Setup for the saltshaker experiment.

The Moving Camera

It would be a mistake not to talk about the ability of the camera to be animated. So far, I stressed the importance of "locking down" your camera so there are no unnecessary bumps or jarring movements. Yet, we discovered that artists like Blu intentionally move the camera every frame for certain aesthetic and often practical reasons. Until recent years, most filmmakers shot in film and the film cameras were heavy and cumbersome. This was especially true of 35 mm cameras, like the Mitchell, that can weigh over 40 pounds.

To produce animated shots with camera moves that simulate live-action camera movements, these heavy Mitchells require large, heavy motioncontrol units controlled by a computer and power drivers. Many of these units are custom-made and many are produced, but all are very expensive

FIG 3.17 A 35 mm Mitchell camera used for animation and live-action filmmaking. *Courtesy of Fries Engineering.*

FIG 3.18 Heavy Milo motion-control system for studio shooting. Courtesy of Mark Roberts Motion Control.

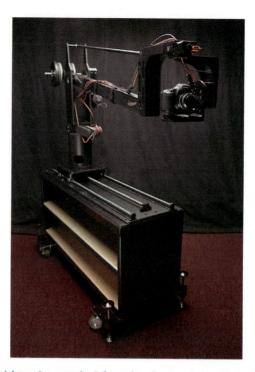

FIG 3.19 Lightweight motion-control unit for outdoor shooting, designed by Joe Lewis. Courtesy of Jamie Caliri.

and difficult to maintain. Some of the lighter units can be used in the field but might not have the accuracy achieved on a hard studio floor with a heavy machine.

These days, most filmmakers that work in stop motion and pixilation shoot with digital single-lens reflex (dslr) cameras, which are small and lightweight. As a result, the large, heavy motion-control units are no longer necessary. Newer, more affordable lightweight systems are constructed from off-the-shelf parts. We explore these in the following chapter about time-lapse photography. The other advantage of these dslrs is that they can be animated directly with no motion control. In my recent film Off-Line, I took my Nikon D-100 and placed it right on my set. By focusing on a particular object in the frame and utilizing my frame-grabbing capture software, I was able to move the camera through the set in a relatively smooth moving point-of-view (POV) shot. I held the camera to the set using "Blu-tack," a soft putty material, as I shot each frame from the computer. You can even use a simple wooden guide to help control the placement of the camera for each frame. There are many ways to be creative with the camera now that they are small and light; and this kind of filmmaking becomes even more accessible to anyone with a good idea and the desire to make a pixilated film and do the work involved.

FIG 3.20 Camera mounted on the Off-Line set, Tom Gasek, © 2009.

One other fun and relatively simple way to get a moving camera/point-ofview shot is to mount a dslr camera to the dashboard of your car and take a drive. If you set your shutter to a longer exposure, you get a streaking effect along the sides of the frame, but the objects in front of you do not streak or smear quite as much. This can be very effective on a nighttime drive, when lights (which streak with a longer exposure, like 1 second) are everywhere. It is critical to make sure that your camera is firmly mounted on the dashboard with tape or some sort of stabilizing base.

By now, you can start to see the possibilities and variations using the singleframe camera and the pixilation technique. I am certain that some variations have not been exploited yet, and there many more that I have not mentioned in this chapter. Ultimately, you will need a camera that has single-frame capability, some capture software, a tripod, and most important, a great idea; then you can start experimenting in this technique, building up a vocabulary of information that will feed into a finished film.

CHAPTER 4

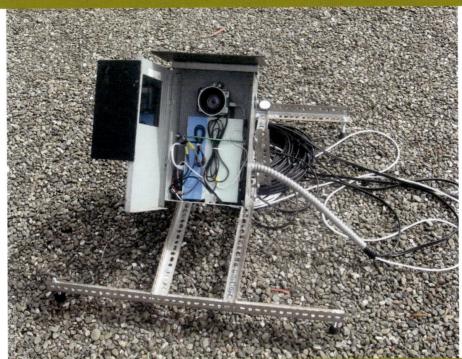

Time-Lapse Photography¹

Chapter Outline

Expand Your Awareness	51
The Intervalometer	
Understand Your Subject	
Contrast	
Shutter Speeds	
Time-Lapse Rates and Formulas	
Time-Lapse Photography and Pixilation	
Motion Control	

Expand Your Awareness

Time-lapse photography has been practiced for decades and it never seems to grow old. From the early work of Dr. John Ott in the 1930s to the phenomenal motion photography of Ron Fricke in films like *Koyaanisqatsi* to Baraka in the 1980s and 1990s, time-lapse photography has allowed us to see the world with a fresh point of view. This technique of stopping the

¹Opening image is a close-up of a time-lapse rig, created by Ken Murphy, History of the Sky project. © Ken Murphy 2009.

camera and shooting frames at an even and given rate allows viewers to see events sped up in time. It is the complement to slow-motion photography, and it reveals the movement in the world around us in a way that we could never experience from normal observation. Ott's early experiments showed the blossoming of flowers, and Fricke's work captured the flow of clouds like turbulent water and the flow of human urban movement like blood pulsing in our veins.

Time is often considered the fourth dimension, and time-lapse filming steps into this arena. This kind of stop motion allows us to observe nature in the forms and textures that we understand as natural, since we are using photographic images, but it delivers the added dimension of an expanded view of time. As a result of these properties, scientists have turned to time-lapse photography to help understand our universe and our place in it. Astronomers observe the skies and stars at night using time-lapse sequences. It allows them to see the patterns of movement and development around us. When John Ott started using time-lapse photography, he became fixated on the blossoming of flowers. This observation led him to become an expert on the effects of light, and he used that information to improve our lives through a better understanding of ultraviolet and infrared rays.

In San Francisco, an experiment is taking place on the roof of the Exploratorium. Ken Murphy, an artist with a background in electronics, mounted a stationary camera on the roof and is capturing the moving sky above the building. His project is called *A History of the Sky*. He shoots one 1024×768 high-resolution frame on a digital camera every 10 seconds each

FIG 4.1 A sequence of time-lapse frames from Ken Murphy's A History of the Sky, © 2009.

day, so one movie is the evolution of that day compressed into a short 6 minute sequence. He then places all of the movies for each day of the year next to each other in a grid formation synchronized to the second, and it is easy to see the changing patterns of light and weather over a year and how the ebb and flow of these patterns work. It is both scientific and aesthetic in nature.

"I've found that A History of the Sky elicits a wide range of emotional responses in viewers. By presenting a visual representation of an entire year in just a few minutes, one gets the sense of the fleeting nature of time, which can have a powerful emotional impact."

Ken Murphy

The Intervalometer

The only way to observe the natural evolution and timing of any event is to record that event at an even rate or interval of shooting. In pixilation, the camera operator can shoot frames at random times, depending on what is going on between frames. Pure time-lapse filming must be shot at equal intervals, so the regular or irregular timing of an event can be observed. This can be a tedious shooting process unless the shutter of the camera is hooked up to a clock that releases the shutter at a particular rate. This clock is called the *intervalometer*. Some digital still cameras,

FIG 4.2 A remote shutter release that has an intervalometer option.

Frame-by-Frame Stop Motion

FIG 4.3 A film camera intervalometer that controls its time shutter release.

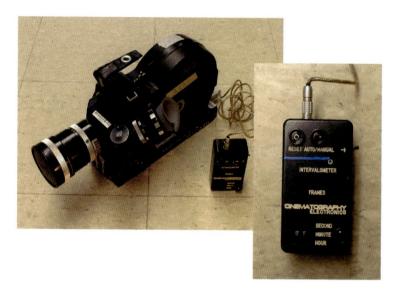

FIG 4.4 The control panel for the time-lapse option in Dragon Stop Motion software.

like Nikon, have an intervalometer built in, but most require a special remote shutter-release component that has the ability to program in time-lapse events. Film cameras also require special intervalometer timers to be attached to them for shutter-release capabilities. The other option for digital video or still cameras is to hook them up to capture software programs, like Dragon, Stop Motion Pro, or Framethief. They all have intervalometers as an option for shooting.

This idea of an expanded awareness of the world around us can easily be demonstrated in the following exercise.

Take a single-frame digital still camera and power it from the adapter that you plug into the wall. Hook up the camera to a computer that has a capture software program with an intervalometer (time-lapse) option. Mount the camera high on a tripod over the bed where you sleep at night. Stabilize the camera with sand bags or tape down the tripod to the hard floor. Set the shutter, iris, and focus to "manual" mode. Have a small nightlight in the bedroom that gives off a small amount of light, enough to give the room a low exposure with all the other lights off. Leave this light on as you go to sleep. Set the iris to f 5.6 or wider (i.e., f 2.8) and adjust the shutter to whatever is required to get a decent exposure with just the nightlight on. Just before you go to bed, set the intervalometer to shoot every 15 seconds at your optimum exposure. The daylight may overexpose the frame when morning light comes through the window, but do not be concerned with this. Set the camera maximum frame count to 2000. If you shoot a frame every 15 seconds, there will be 4 frames for every minute of sleep. There will be 60 (60 minutes to an hour) times 4 frames for every hour of sleep (240 frames), and if you sleep 8 hours, then you will have 1920 frames available (8×240). You will see what your sleeping habits are and have a greater understanding of a part of your life of which you were never aware. For a little extra fun, you can mount a clock near the lens with a small light on it so you can associate your sleeping patterns with a specific time. This is the power of time-lapse photography.

Understand Your Subject

To make a successful time-lapse film, you must choose an appropriate subject and study it carefully before shooting the first frame. Some events cannot be controlled or predicted, but making initial observations will tell you the length of the event, the extremes of the potential transformation in the event, the way light and exposures change during the event, and the external conditions that need to be accounted for to set a stable camera. Companies like Harbortronics build special housing and controls for time-lapse cameras that allow you to shoot outdoors in most any condition. As Eric Hanson, a veteran effects artist and associate professor at USC, states,

"We shoot primarily during trips to remote wilderness areas, thus there is some preplanning using Google Earth and the like, but much is reserved for serendipity, as weather and geography are always an unknown. We did some elaborate preplanning once when shooting from the lower 'Diving Board' of Half Dome in Yosemite Valley, where we wanted to pay homage to Ansel Adams's 'Black Monolith' shot. We found the exact time of the terminator shadow sweeping across the face in his shot by writing a script to download time-lapse frames of a webcam of Half Dome, studying it over many months and determining when the best time of year and day would be to shoot. Of course our work is dwarfed by Ansel's, but it was an interesting and fun process."

A wonderful tool can help you plan the path of the sun when you are scouting out a potential time-lapse location: an iPhone application called *Sun Seeker*. It shows you the path of the sun with a superimposed line over any live camera view from your iPhone. It calculates the path from day to night any time of the year, so you can plan ahead knowing where the sun will be if you scout a location months in advance.

When you choose a subject for time-lapse filming, think about the environments that you go through every day. These are the environments you understand from constant observation and might make the best subjects. You will know where you want to set the camera, what occurs during any period of time, and where any movement is concentrated. It is important to have dramatic transformation in the environment or find an action that is too slow to perceive. The dramatic transformation makes for an interesting sequence, and the slow action or transformation sped up with time-lapse film is fascinating to see and potentially revealing from an observational point of view.

Contrast

When filming a piece of time-lapse photography, it is helpful to show contrast within the frame. This use of contrast makes any compositional frame interesting, but it is critical for time-lapse work. Since time-lapse photography speeds actions up, the overall frame becomes highly active. If no stationary elements are in the frame to help set off the action, then the action becomes a blur of activity and your audience loses focus. This kind of contrast can be easily achieved by careful compositional design. If you are shooting people outdoors in a city, then it is important to place some stationary buildings within the frame. The people, cars, and shadows from the moving sun or artificial light move around the solid immobile building and the eye of the viewer can focus on the activity and rest on the stationary elements. It is important to know how the shadows and key source of light shift or whether you might get a light flare. All this adds to the active frame, so making sure there are some stationary elements helps as a stable visual reference in a highly active frame.

In any moving image, the active element in the image usually draws our eye. If we view a still frame and suddenly an eye blinks or plane jets across the composition, then that is what we look at. Time-lapse film is no

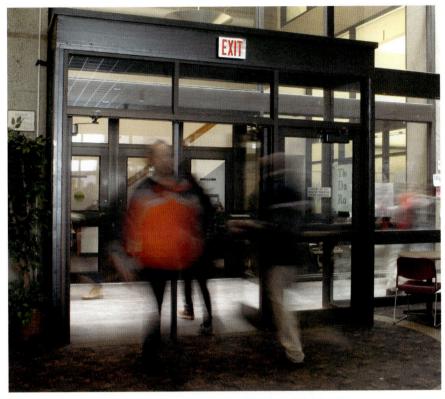

FIG 4.5 Shot of streaking people walking through doorframe.

different, but the opposite can be true in time-lapse filming and pixilation. When a frame is loaded with activity, the eye tends to be drawn to the less active object or area. This contrast can be used to direct the viewer and highlight a particular action that you want to feature in any shot.

Shutter Speeds

One follow-up to the subject of contrast can be found in the simple adjustment of the shutter speed in your camera. We already made a point of the critical element of having manual shutter, iris, and focus control in your stop-motion camera work. You are the one in control not the camera. Since the majority of stop-motion camera work takes place from a tripod, any shutter speed is possible to use. Any handheld camera work requires a fast shutter speed (a quarter second or faster) to avoid soft focus or movement during the exposure. If the camera is moving while the shutter is open, then the frame will smear or elicit a soft focus effect. Stop motion by hand is a rare event, even for an artist like Blu, who is constantly changing the angle of his camera frame to frame. He shoots from a tripod so the camera is steady during the exposure and the focus is clear.

FIG 4.6 Night city scene with a shutter speed of ½ second.

FIG 4.7 Night scene with a shutter speed of 1 second.

FIG 4.8 Night scene with a shutter speed of 5 seconds.

Since we are on a tripod, the shutter speed can be quite long because the camera is stable. Any movement in front of a long shutter exposure smears across the frame and anything that does not move remains sharp and in focus. This is the same principle used in light painting. So, if you want to heighten the contrast in your time-lapse photography, then shoot at longer shutter speeds on a tripod. The moving images streak and the stable images remain focused, giving the contrast you need. The longer the shutter speed, the longer is the streak effect. This has the effect of smoothing out the action in contrast to the more staccato appearance of most stop-motion images, which are sharp and unblurred frame to frame. You have to close your iris down for the longer shutter speed in daylight or use a neutral density filter or the Big Stopper filter by Lee Filters to darken the image. You have to open up the iris for night events to maintain a good overall exposure in the dark.

Time-Lapse Rates and Formulas

Determining the rate of the interval for a particular event may take some experimentation. This is why it is important to know how long an event occurs like the rising of the moon. How long do you let time lapse before you shoot another frame? The moon may take many hours to rise and if you want to highlight the dramatic rise of the moon then speeding up that progression is more effective. That means that you want to allow more time to lapse between frames giving the moon a chance to rise between shots. If you are shooting people then you may not want to have too much time between shots. People move relatively fast (certainly in comparison to the moon). It may take a person 5 seconds to walk across a large room, so if you shoot a frame every 2 seconds, then you get only two frames for that action. That is not enough to get a sense of the movement or direction of the action. You may want to consider shooting a frame every half second, so you end up with ten frames for that action. This way you can see the action and direction in what will play out as less than a half second of screen time. Since the moon is so slow you may consider a longer lapse, more in the 15 to 30 second range, so the change can be perceived in a dramatic playback. It is important to consider what the main focus of your time-lapse film is and set the interval accordingly. If you want to watch the sun rise at a good steady rate, then your interval will be longer but you will have clouds that streak by at a fast pace. If the clouds are your main focus, then the interval will be faster and the sun will not rise that fast in the sky.

If there are restrictions on the length of the playback and you need to squeeze a time-lapse event into that length, then there is a formula to help figure out the interval between shots.

If, through observation, you have determined that the event you want to make a time-lapse film of is 3 hours long and you have to compress that 3-hour period into a 15-second piece of film, then you can work out the interval of the shutter exposure through simple math.

H = Length of event in hours S = Length of time-lapse film in seconds F = Frame rate I = Interval rate $60 \times (H \times 60)/(S \times F) = I$ $60 \times (3 \times 60)/(15 \times 30) = 24$

So, to shoot a 3-hour time-lapse event with a playback frame rate of 30 frames per second in 15 seconds of playback time, you must shoot a frame every 24 seconds.

Time-Lapse Photography and Pixilation

We noted earlier that it is difficult to be the person behind and in front of the camera simultaneously when creating a pixilated film. One way to accomplish this approach is to use time-lapse photography while animating yourself or other people in front of the camera. This is not an easy task and takes a lot of concentration, but here is an exercise that allows you to try this out for yourself:

This exercise tests your knowledge of the animation principles of easing, momentum, and secondary motion. Contrast is another element we discussed, and it is integral to the success of this exercise. First, you must put your camera on a tripod and place it in an area where there is a high level of human activity, like a busy downtown street or a university campus. Be aware that anytime you shoot pictures in public, you must obey any posted notices that would prevent you from photographing people. You will find these notices in subways, airports, hospitals, and other such places. If your camera does not have an intervalometer built into it, then you must bring a laptop computer with a capture software program that has the timelapse option or, if you are using a dslr camera, consider buying and using a remote cable connection that has an intervalometer built into it. Set your time-lapse interval to 3 seconds and make sure that the sound option is on, so you can hear a "click" every time a picture is taken. Make sure that the total amount of frames to take is above 1000 on your computer, or, if you do not have a computer, that you have enough frames on your flash card. Set up a place for you to be in the frame that is stable and supported, like a chair or at a table or against a wall. You are going to move increment by increment every 3 seconds (as the camera shoots). You will hold your position for extended periods and this can be physically challenging, therefore, having some support helps. This requires moving extremely slowly or actually posing bit by bit every 3 seconds, including your eases and normal animation principles. Shoot for about an hour then stop. When you play back your film, you will appear to be moving in a normal pace as the world frantically zips by you. The contrast draws our eye to your slower action, and you have had a chance to practice some animation as the actual animated subject.

Motion Control

We touched on the moving camera in the last chapter, where I mentioned that a whole new world of motion control is now available. Again, because of the lightweight quality of digital SLR cameras, the heavy expensive machines of the past have become dinosaurs. Artists and designers like Chris Church are sharing their information about off-theshelf hardware and common-use software, available to anyone who has the time, patience, and curiosity to explore. Chris has an "open-source" site called openmoco.org, where contributors and viewers can share experiences, resources, software, and reviews to help build their own systems. Aluminum rails are bought off the shelf or can be custom made to "specs," and astronomical mounts can be placed on the rails for pan or tilt capability. All of this is run by Arduino circuit boards. According to Arduino's site,

"Arduino is an open-source electronics prototyping platform based on flexible, easy-to-use hardware and software. It's intended for artists, designers, hobbyists, and anyone interested in creating interactive objects or environments."

Now you may think "this is beyond my capability," but you might be surprised and find some already fabricated hardware and software setups.

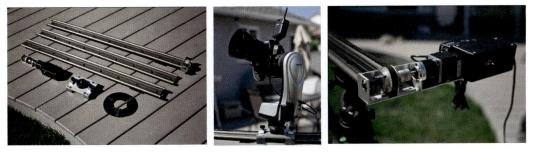

FIG 4.9 Three views of motion control rigs. Courtesy of Eric Hanson, © 2010.

Camera motion is not absolutely critical to making a successful timelapse film, but it certainly is what the experts are using for greater depth perception; and it adds a whole other quality and control to the output. You can create your own camera rigs with guides, rails (wood or metal), and geared heads mounted on the track. This all must be controlled by hand, but it takes some very exacting, demanding concentration and work to add this element. Camera movement should not be used just for the sake of movement. Take advantage of the changing perspective that a camera move might offer. A camera move might reveal new and important visual information. Constant use of camera movement starts to become tedious, and the lack of contrast in shots can diminish your film. Use these techniques sparingly and create an interesting dynamic in your fillmmaking.

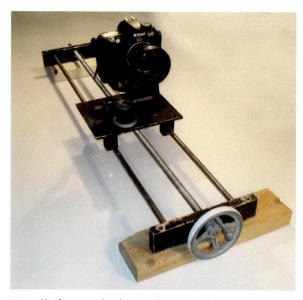

FIG 4.10 Manfrotto gear head mounted on a track that is operated by hand.

The final word on time-lapse filming in this chapter should be given to Tom Lowe who is a time-lapse master and creator of Timescapes.org. A time-lapse forum on his site has an incredibly in-depth conversation about the state of time-lapse photography today. Lowe is in the middle of producing a feature film utilizing time-lapse photography, and many of his shots can be viewed and shared on his site.

FIG 4.11 Tom Lowe shooting a compound motion control camera move with time-lapse at Manzanar. *Courtesy of Tome Lowe and Timescapes.org,* © 2010.

"I have no background in photography or filmmaking at all. I'm just totally self-taught, by trial and error. Back when I started, I had nowhere I could ask questions, no one to seek advice from. I felt like I was re-inventing the wheel with every small step of progress. This was the main impetus for me to start the Timescapes.org time-lapse discussion forum. Today, we have over 1800 members sharing advice and techniques related to time-lapse. This is a great resource for beginners, because it allows them to skip all the painful trial and error to a large degree!"

Cinematography, Lighting, and Composition¹

Chapter Outline

Cameras and Lenses	65
Camera Controls	71
Lighting for Animation	75
Compositional Beginnings and Ends	

Cameras and Lenses

We have already established that, at the moment of this writing, digital single-lens reflex still cameras are the standard for shooting alternative stop-motion techniques. Their light weight and small size offer convenience and quality in the shooting environment. They are relatively affordable, with prices that range from \$400 to \$9000 with the average price around \$1500 for a high-quality "pro-sumer" camera. Although Canon and Nikon are

¹Opening image is a squash and stretch image superimposed on a camera lens. © Tom Gasek 2011.

leaders in this area, many of the other brands, like Olympus, Pentax, Leica, Ricoh, and Sony, offer equally effective products. Some features are better on some cameras than others. The critical feature we touched on already is that the camera must have manual shutter, iris, focus, and white balance options. These options should be available by switching a control on the camera and not by having to constantly hold down a particular control to achieve the effect. Another important feature that is not absolutely critical but a great option for these cameras is the "live-view" mode. This allows you to hook up your dslr to a computer with stop-motion software and see a live image from the camera. The ability to compare live and previously captured frames through live view make this option a real plus. Advanced stop-motion capture programs like Dragon and Stop Motion Pro pick up live view if your camera has this feature, which is included in most new cameras. This makes your life much easier. The only other options are to hook up a small digital camera to your viewfinder or set up a digital camera that is operated at a parallax point of view or alongside your dslr.

The reason manual controls are critical is because the images that move in front of the camera vary in color and light reflectance, depending on how dominant they are in the frame. An automatic camera is programmed to constantly adjust and average for the best exposure for each individual frame. This is very convenient for still photography, where each photograph exists on its own when it is viewed. In animation, we often look at hundreds of images together; and if the automatic exposures are changing from one frame to the next, as the imagery changes in front of the camera, then there are wild fluctuations in the exposure as a movie plays. This is highly distracting. Controlling the exposure, white balance, focus, and image stabilizer and locking them in with a manual setting helps to eliminate this fluctuation.

FIG 5.1 A shot of a video tap camera looking through the viewfinder of the dslr.

There is another reason why exposure fluctuation occurs: Most digital still cameras have automated lenses that often come with the camera. When an iris is set on a camera, in manual or automatic mode, the iris shuts down to that f-stop when the shutter exposes then opens back up so the viewer can see through the viewfinder. The open iris allows more light in for better viewing. If an animator is shooting hundreds of frames, there can be a slight variation in the iris aperture when it shuts down and opens up over those numerous frames, and that can account for the slightly varying exposures. There are a couple of solutions to this issue. One is to use manual lenses that lack the capability to open and close for viewing every frame. They stay in their set position all the time. Another solution, which I do not recommend, is filing down the pin in the lens that triggers this action in an automatic lens. Some camera operators use tape to hold down the pin on the back of the lens that engages these automatic functions. These are not elegant solutions but are practiced in the field. One advantage to using a Canon camera with Nikon lenses is that the adaptor that allows the Nikon lens to work with the Canon camera depresses that control pin, eliminating any unwanted functions. Finally, postproduction solutions can help reduce this fluttering. We get into this last option later in the book.

Iris open

Iris closed

There is always a preference for "prime" lenses, which are single focal range lenses. They have less glass in the lens, theoretically making for sharper images with less distortion. Zoom lenses, which often come with new cameras, are quite well made these days. Their image quality is excellent. They also have a larger set of options for focal range for the price of the matching prime lenses. Having a set of prime lenses, including 18 mm, 24 mm, 35 mm, 55 mm, 85 mm, and 105 mm/macro, gives you everything you need for making a successful film, but if you cannot afford them, a zoom that ranges from 18 mm to 135 mm should work quite well. If you buy a certain brand of lens and decide to use another brand of camera, there are lens adapters so you can mix and match. Many professionals, these days, use Canon cameras and Nikon lenses, but other combinations work as well. Canon, Nikon, and Carl Zeiss are considered excellent brands for lenses, but as usual, there are many more. FIG 5.2 Drawing of an open and a semi-closed iris.

FIG 5.3 A lens adapter (Nikon lens/Canon camera).

One technique that the manual lens allows the cinematographer to practice is the "rack focus." This is a classic live-action effect that allows the filmmaker to direct the eye of the viewer from one object or person to another object or person when they are separated by depth in the frame. A foreground element can be in sharp focus and a background element in soft focus. The story suddenly requires the background element to be seen so the camera lens can be shifted to move the focus and attention from the front to the back of the compositional frame. This is usually executed by using gentle ease-in and accelerated turns of the focus ring on the lens including an ease-out over a short number of frames (i.e., 10 to 20 frames). The move can be done by hand with a measuring device on the lens (like a piece of tape with marked increments) or achieved through a motion control setup.

Depth of field is an important element to consider when shooting with a dslr camera. The basic principle is that the lower the number on the f-stop (e.g., f-1.4, f-2.8), the more narrow the depth of field or range of the focus. The audience automatically looks at focused objects in a composition, because people seek information that they can understand. That is why the rack focus or shifting focus is so effective in directing the viewer. The narrow focus also allows the focused object in the frame to stand out in contrast to its soft-focused surroundings. If you have a relatively busy background over which you have no control, then you might consider opening up the iris to create a shallow depth of field to help your subject stand out from the background. The danger with this is that, if your subject is moving in the "z axis" or toward and away from the camera, then that subject may fall out of focus in the action. It is also worth noting that every lens has a different range of focus. The wider the lens is, like 14 mm to 35 mm, the deeper the range of focus or depth of field. Longer lens and macro (or close-up) lenses have a much narrower depth of field. So, a 24 mm lens at f-8 has a broader depth of field than a 85 mm lens at f-8. Using this knowledge can increase your sense of composition, narrative, and atmospheric quality and is one more tool to give your film a sense of style and purpose. If you view any of the films of the Brothers Quay, like the 1986 Street of Crocodiles, you will see a mastery of this use of depth of field.

FIG 5.4 The "rack focus" effect on cutouts from JibJab Media Inc © 2010. (Barack Obama and Joe Wilson.)

Another type of lens I want to mention is the "tilt-shift" lens. The tilt-shift lens, made by most of these companies, is highly sophisticated in design and, as a result, is very expensive. This concept has been around for a while in copycamera equipment or with bellows cameras. Basically, the lenses can be tilted so the glass of the lens is not parallel to the film or image sensor plane. This changes the plane of focus, which can be highly effective, especially with a shallow depth of field.

FIG 5.5 A diagram of the camera lens with a normal parallel depth of field and a camera lens with a diagonal depth of field that corresponds to the angle of the titled lens.

FIG 5.6 Examples of the tilt focus effect photographed by Monica Garrison, printed with permission from Monica Garrison, © 2010.

This effect has had a comeback recently and can be seen in still photography as well as pixilation or time-lapse photography. Since there is this tilt of the lens and focal plane, the effect almost mimics the effect of a macro lens used on very small subjects and with a shallow depth of field. Life-scale images, like people, buildings, cars, or anything you shoot with this effect looks like a miniature. This is especially true if the camera is placed above the subject, further enhancing the illusion of being a miniature.

The *shift* in *tilt-shift* refers to moving the lens plane up and down or side to side, and that movement is parallel to the image plane. This allows tall or wide objects to be photographed without tilting the camera and lens (which normally forces diverging perspective lines in the object). Architects often use this technique to get straight and undistorted photographs of buildings. This effect is not used as much as the tilt effect, which also can be simulated in postproduction with more control.

The technology of digital cameras and devices is continuing to expand. Recently, Aardman Animations had a team of creative people use a Nokia N8 cell phone that can shoot high-definition video and stills through its Carl Zeiss lens. The team attached a custom cell scope with an adjustable depth of field, which is basically a microscope, to the Nokia N8, and they animated tiny natural objects and models the size of a pencil lead created through 3-D printing.

FIG 5.7 A shot of a camera with the tilt adjusted in a tilt-shift lens setup.

FIG 5.8 The making of Dot for The World's Smallest Character Animation, Aardman Animations and Nokia © 2010.

Camera Controls

When I first started using digital still cameras, about 10 years ago, I knew very little about the way they worked. I certainly understood film camera technology and soon discovered that digital still camera technology was based on film technology. Even though no film was involved, the principles are the same. There is a sensor chip instead of film but the 45° mirror that sends the image to the viewfinder and shuts out the light from the film/chip plane when it is not being exposed was the same. This is why it is called a *single-lens reflex* camera. Some newer technologies are eliminating the mirror all together. I ordered about seven different cameras, tested them, and returned all but one for my shoot. What I learned was that all the cameras operate in the same basic way, so once you learn how one works, the rest are easy to figure out.

One of the newer technologies is the 4/3 camera, which eliminates the mirror in the camera housing and allows for a constant monitoring of the image without having to set up the live-view feature. The 4/3 refers to the size of the image sensor inside the camera.

FIG 5.9 A diagram of the 45° mirror on the single-lens reflex camera.

All dslr cameras come with battery and power adapter options. Usually, when you buy a camera the power adapter does not come with the camera. You get a battery and battery charger. You might have to buy the power adapter separately. I feel that this is a worthwhile investment. Many of these frameby-frame techniques require shooting in locations that are not near power sources, so the batteries are critical to operating the camera. The risk is, of course, that the camera will run out of power before a shot is complete. Yes, you can change the battery in mid-shot if you have a spare charged battery on hand and if you can get to the battery without disturbing the camera. The issue is that you may risk bumping the locked-down camera in midshot, compromising your image stability. You might potentially get a color shift in the digital camera once you change the battery (although this can be corrected in postproduction, because these shifts are usually minimal). Many cameras have their batteries located on the bottom of the camera body, and if you have mounted your camera on a tripod or a solid flat surface, then you have to move the camera to change the battery. Ultimately, using a power adapter from the beginning of each shot eliminates this problem and allows you to shoot for longer periods of time uninterrupted.

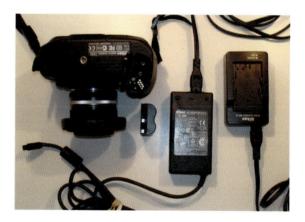

The settings for manual controls are easy to find. A dial for the iris and shutter changes is located on an area near the read-out panel, usually located on the top of the camera. There may be a switch along the side of the lens to put it in manual focus mode. You have to spend a little time with the camera to understand how it works, but that time is well worth it.

A "menu" button on the back allows you to program your camera. Many features are offered in this area, including viewing options, white balance, formatting (erasing all of your images on the camera), and image and file sizes. The image size of your picture is an important choice. New cameras usually have three sizes of jpeg files and what is known as *raw*. The raw image is all the information that the image sensor can give you with no

FIG 5.10 A shot of the open camera bottom, battery, power adapter, and charger.

compression and it gives you the most capabilities for image manipulation in postproduction. The raw file size varies from camera to camera. This is the best-quality image and is much bigger in size than you would need for high-definition playback (which is 1920 pixels wide and 1080 pixels high). Shooting jpeg files (high or medium quality) provides plenty of image to work with later on. It is great having nice-looking images and you can enlarge both the jpeg and the raw images and create more detailed postproduction work on them because of the added data information. The great advantage to raw images is that they carry a lot more metadata on each image, so if you happen to have the wrong color balance setting during a shoot you can still correct it in postproduction color correction. This is much more difficult with jpeg compression. There is one drawback to using these kinds of larger picture files.

That drawback has to do with the time it takes for larger files to be processed in the camera. It can take from 1 to 15 seconds to allow each frame to be processed and placed on the flash card or computer control system, depending on how old your camera and flash card are. Now 15 seconds does not seem long, but when you are animating a person holding unusual and demanding positions, that 15 seconds times several hundred shots can make all the difference in the successful completion of a shot. If you are shooting objects that can remain stable and unmoving between shots, then the digital still camera processing issue is not a problem, except it may slightly throw off the rhythm of the animator. Humans are not immobile objects. The larger the file format, the longer it takes to process each frame. At this point, you want to consider what kind of camera to use when animating humans or anything that requires a faster shooting pace. The newer compact flash cards, like the Lexar 300X series, have greatly improved this lag time and are often a little more expensive but worth the price. This technology is improving every day, and most of the brand new dslr cameras can capture one frame per second continuously. Digital video cameras capture frames much faster and allow for a faster shooting pace than digital still cameras, because the frames are small in size. High-definition frames take longer than standarddefinition frames, but that is rapidly changing. Standard definition frames can look great if you have a good camera. They can be projected well with a good system, but you cannot enlarge those frames very much and any postproduction work will not be as accurate as working with a file with more data and definition. The high-definition files will eventually put all standard-definition images to rest.

A final note regarding dslr cameras has to do with the basic maintenance of these sensitive pieces of equipment. Dirt, lint, and all sorts of fine particles can get into your camera and sit on the low-pass filter in front of your image sensor. Sometimes static electricity makes this happen. Changing lenses is the main way that dust can get onto the filter and sensor. Try to keep lens

changes to a minimum and change only in a clean, interior room. If you need to change lenses on location or outside, try to do it inside a car or out of the wind to avoid windblown particles entering the camera. You *can* clean the filter, but it is very delicate work. Some of the newer pro-sumer grade cameras have ultrasonic auto-sensor-cleaning as an option. But, often, the dirt has to be swabbed out by hand. Most dslr cameras have a sensorcleaning mode, which requires you to lift and hold the mirror open revealing the low-pass filter in front of the sensor. This can be carefully cleaned with a proper swab, like the Sensor Wand, and proper cleaning fluid, which you can get at a photography store. Also, you can blow antistatic pressured air on the filter to remove dirt. You might seriously consider having a reputable camera store clean your image sensor. Cleaning it yourself can result in a scratch on the low-pass filter, which is costly to replace.

These cameras were made for single-frame shooting and not really for movie making or multihour use of multiframe exposures. Sensors can overheat when they are in live view for long periods of time. So the cameras get what I call *pixel burnout* (also referred to as *hot pixels* or *stuck pixels*). This is usually apparent when shooting into a darker compositional field or during long exposures. When you throw the individual picture files onto a large screen you can see bright little spots that are the burned pixels. Blue seems to be the first color that appears in these pixels. Eventually, you have to have your image sensor replaced, but in the meantime, there are postproduction solutions like pixel sampling. This basically identifies the burned out bright pixel and replaces it with the color of the pixel next to it.

Burned pixels and dust on the sensor or low-pass filter are especially noticeable on moving shots. They are also much more difficult to clean up on a moving camera shot over locked-down shots. It is better to address the issue (of potentially replacing the sensor) than trying to fix each problem in postproduction. You should include sensor cleaning as a standard part of your camera maintenance plan.

FIG 5.11 A shot of an open camera with the mirror and mirror lifted to expose the low-pass filter.

FIG 5.12 An example of dirt on the low-pass filter and examples of pixel burnout.

Lighting for Animation

Lighting is a real strength in photographic animation. One of the worst mistakes to make in any stop-motion technique is to light an image with flat, overall lighting. Lighting should give form, dimension, atmosphere, drama, and life to any object or person. Selective lighting can make the composition in stop motion feel larger, adding mystery and drama. Side or underlighting can add tension and weight. This is a huge area to explore and experiment in, but it is important to understand the basics first. The simple formula for basic lighting is to use key, rim, and fill lighting to get the best result. This is known as *three-point lighting*.

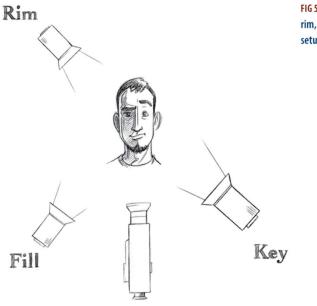

FIG 5.13 A diagram of the key, rim, and fill three-point lighting setup. Simplicity can also be very effective. Single-source studio lighting has a very dramatic look and you use only one light.

FIG 5.14 An example of single-source lighting with no bounce card.

There are all sorts of lighting combinations, but trying to maintain one main shadow with a key light is the best place to start. When you light a person or object, start with the key and see what it lights, then start building with rims or fill, turning each light on and off to see if you really need it and what its effect is on the person or object. The use of reflector boards and foam core can be very effective as fill light and can be illuminated from the spill of a key light. These lighting techniques have been simulated in painting for centuries. Sfumato is the technique of blending colors with similar mid-tones and creating gentle gradients of color and light, and chiaroscuro is the much more dramatic use of single-source lighting that creates high-contrast lights and darks. Leonardo da Vinci was a master of the former and Rembrandt mastered the latter.

Moving or animating the lights in a shot is another element to consider when preparing your preproduction. We have moved light sources with the light painting technique discussed earlier. You can also move lights on stands frame by frame with guides for smoother effects. Use your software capture program to gauge the light movement. Professionals often use computeroperated motion control to move lights around a set. It is virtually impossible to achieve the same lighting effect in postproduction. Rheostats or dimmers are another way to fade lights in and out of shots. If you are turning lights on and off constantly, then consider using rheostats to help extend the life of the bulbs. Switching bulbs on and off can be very hard on the filaments in the bulb, and they burn out a lot faster.

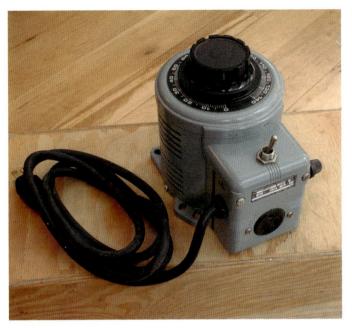

FIG 5.15 Shot of a professional rheostat.

What size lights should you use? Generally, the same rules that apply for live-action lighting apply to stop motion but on a smaller scale. Instead of using a 650 watt bulb for a key light, you might consider a 150 watt bulb. Most stop motion is on a smaller scale, so overlighting can be a problem. The only real exception might be shooting done in a studio with pixilation of people or additional lighting needed for "out in the field." Since the subject matter is larger, you need to cover more ground. It is logical. Lamps that have Fresnel lenses for focusing and softening the light are very helpful. There are many brands, and it is not necessary to pay high prices for these lamps. You can find lamp housing with barndoors, which are used for stage lighting, and the cost is less than the traditional movie lighting brands. LEDs (light-emitting-diodes) are another wonderful, if slightly expensive, alternative to miniature lighting of objects. They are bright, often colored, cool in temperature, and highly efficient. The color temperature of lights used to be an issue when shooting film, because the film labs would develop the film based on daylight temperatures. If your lights were warmer than 3200 foot candles (the lighting measurement standard for daylight), then the film would come out yellow and red. Now, when you shoot a dslr camera with any light, you can see what the final image is immediately and adjust any number of controls, like white balance (in manual mode), to correct for the color imbalance. There is also the postproduction color correction option (especially if you have raw files).

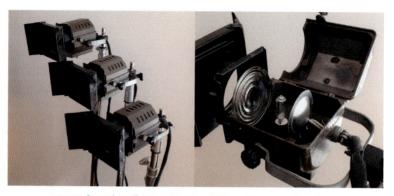

FIG 5.16 Several small 150 watt lamps with Fresnel lenses and barndoors.

Finally, I want to mention indoor and outdoor lighting and the effects of shadows. Indoor shooting has much more control because you are the one setting the lights. Outside, the *big* key light in the sky, otherwise known as the *sun*, is in control. If your shadows are too dark on an inside shoot, then you need to add fill light for a bit of definition on the subject. The shadows are stable or move only when your animated subject moves, but outside the story is different. Since the earth is constantly moving, the relationship to the sun changes and shadows move in an even fashion. We can see this quite clearly in an extended piece of time-lapse photography outdoors. Exterior fill lights have to move or shooting times have to be very short. So, if you are shooting pixilation outdoors, then you want to think about the rate of shooting you need to maintain to have even shadow movement. Erratic shadow movement can be very distracting, unless it is part of the overall effect.

Compositional Beginnings and Ends

Like time-lapse filming, any of these stop-motion techniques can use camera movement to enhance a shot. We explored motion control, geared heads, and even moving the camera itself by hand with a guide. The important point to keep in mind is the beginning and end positions of your camera and the continuously changing composition. It is absolutely critical to practice a run-through of the movement before you commit to shooting frames. In more traditional puppet stop-motion film, animators perform what is known as a *pop-through*. This is a run-through of the move that records camera and subject movement every 5 to 10 frames. Any issues that arise are revealed with the changing lights, shadows, focus, and other difficulties that you will encounter. Once you have addressed these problems, you can adjust for them and the choreography of your shot flows smoothly. Know where you are going, so the camera and subject matter can stay in sync with the camera. This is the equivalent of the cue mark for liveaction actors. One wonderful resource to consider is Joseph Mascelli's *The Five C's of Cinematography: Motion Picture Filming Techniques*. Camera angles, continuity, cutting, close-ups, and composition are all important elements to any film production, including frame-by-frame animation. Many consider this text a classic for filmmakers. The next area that we investigate is the actual subject to be animated. What or who will be put in front of the camera and manipulated in a slow and arduous process? Are there any ways to make this work easier or does the term *no pain, no gain* apply? This is what we explore next.

CHAPTER 6

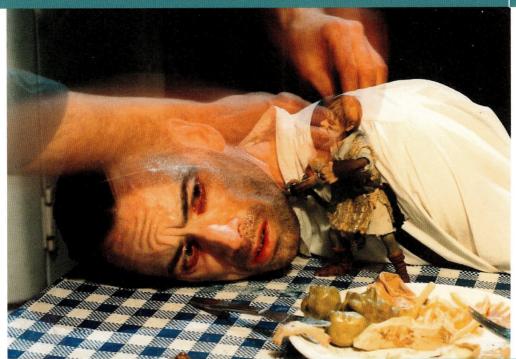

Objects, People, and Places¹

Chapter Outline

People, Objects, and Rigging	
Organic and Nonorganic Objects	
Shooting Safe Zones	85

People, Objects, and Rigging

Often with pixilation, whether you shoot the subject on a downshooter or horizontally, people and objects are treated in the same way. This can be difficult on the person, especially when everything is treated like an object. It is almost inhumane to animate a human in pixilation for long periods of time with no support or breaks. As Nick Upton, the pixilated star in the 1986 Bolex Brothers film *The Secret Adventures of Tom Thumb* states:

¹Opening image is of an animator moving Frank Passingham and Tom Thumb model. By Bolex Brothers, used with permission from Dave Borthwick © 1986.

"Masochists only need apply. It's not for the fainthearted or weak of spirit.

"In all but the wide (full-figure) shots, make sure there are 'rock-solid' supports/guides/reference points, wherever possible, just beyond the edge of the frame, from which you can anchor and thus minimise any unwanted body movement. With regards to breathing, always capture the frame after breathing out, *not* in, as varying levels of stress, fatigue, or physical exertion can cause irregular intakes of air which can cause a 'boiling' of the chest."

Adam Fisher, an independent animator from Maine, animated himself cutting his long beard and hair frame by frame as a metaphor for environmental devastation and overexploitation of natural resources in his 2010 film *Timber*. He needed assistance and support in the cutting of his hair while he placed himself correctly in front of the camera for registration. This took some careful planning and more careful execution. It took many, many months to grow his hair and beard and any mistakes in the cutting process could have been disastrous in the shooting process. This is his description of the process:

"To shoot *Timber*, I was seated in front of my computer with Framethief open and a camera pointed at me. Sarah assisted me. I would tell her when to take frames and when to cut hair. I moved as needed, frame by frame, and would get into just the right position. Then I would say something like... 'okay, trim everything above my finger!'

"We shot the sneeze first, with full beard. This gave us a chance to work out the timing. Once everything else was cut off, we simply repeated the animation without the beard. When I assembled all the frames, I just picked a good spot to switch from no beard to full beard!"

FIG 6.1 A sequence of frames from Adam Fishers's 2010 film Timber, © 2010.

Objects and people do need to be treated differently to get the best animated results. In Oren Lavie's music video *Her Morning Elegance*, animated by Yuval and Merav Nathan and in the British directorial group Shynola's "Strawberry Swing" for the band Coldplay, the human subjects were shot lying down on flat surfaces like a bed or a floor. Chris Martin of Coldplay was shot standing and lying down and animated in various positions on the ground with a camera mounted in a stable

position high above the ground plane. He still required support but the supports could be hidden behind Martin, out of sight from the camera. In the 1986 groundbreaking *Sledgehammer* music video, Peter Gabriel was animated with lip movement. He sat upright and was given a head support to steady his head so the focus could be centered on his moving lips.

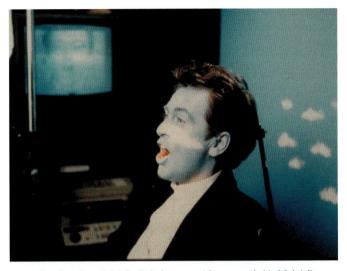

FIG 6.2 Shot from Peter Gabriel's *Sledgehammer*, with a support behind Gabriel's head. Courtesy of Real World Music Ltd., Peter Gabriel Ltd., and Real World Productions Ltd.

The main challenge in any stop-motion technique is how to fight gravity. With full body support, like a floor or bed, the human figure can be animated freely in space with no constraints from gravity. This technique is similar to downshooting on a stand but on a grander scale. There are times when people or objects have to be animated with a visible support rig. This can be erased or cleaned out later in postproduction. We get into more depth on this subject in Chapter 10. Any kind of prefabricated or custom rig can be used, as long as it is strong, as small as possible, and relatively lightweight, so it can be maneuvered easily.

FIG 6.3 A series of rigs that can be used for a variety of situations.

Organic and Nonorganic Objects

I would consider humans to be a kind of organic object. Any object that has water as a base, like humans, animals, and plants and anything that is alive, is a challenge for the stop-motion animator. Over a period of time, these organic objects lose their water to evaporation and change in form and color. Here is a very simple experiment that is worth the effort to punch this point home.

Set up a dslr camera, digital video camera, or webcam on a tripod and sandbag or tape it to the floor. Have the camera point down into a close-up of a pack of frozen peas (with the wrapper removed). Put a 650 watt light about 5 to 6 feet away from the peas and set the time-lapse interval for your camera at a frame every 10 seconds. This may take about 5 to 6 hours but the change is dramatic. You will see the form and color change and that there is no stability in this kind of organic material.

FIG 6.4 Three stages of water-based peas in a time-lapse sequence. Courtesy of Marlee Coulter, © 2010.

Any object that is manufactured and devoid of fluids is a more dependable and stable object to photograph, allowing you longer shoot times or intervals between frames. The conditions of the environment can really effect the composition of your subject matter. Plasticine can get warm under hot lights and start to shine. Certain organic materials, like water-based paint, can stiffen if the environment is too cold. If you decide that you do want to shoot an organic object frame by frame, then the best approach is to work at a fast, even pace with no extended breaks, so that the changes in the object are small, even, and potentially imperceptible over the running time of the film. On the other hand, using organic materials add another kind of movement and layer to your animation, if that is what you seek.

The choice of objects that you use, whether they are organic or not, is critical to the overall effect of your animation. Objects can signify certain meaning and associations. PES, who has created many wonderful films, makes a point to carefully choose what objects he shoots. Here is his description of his intentional use of certain objects:

"There's definitely a language of objects involved. I love playing with the layers of association that come with objects, and I strive to tap into these all the time. Examples abound in all my films. Take, for instance, the boiling water in *Western Spaghetti*: I used bubble wrap to create this effect. It was uncanny how much bubble wrap could be made to look like boiling water. The effect was almost too good—too good because there are people who don't even notice it's bubble wrap until the third or fourth viewing, and that means some people will miss the joke. Plus, bubble wrap has bubbles, just like boiling water. They have that very important detail in common, but you'd never imagine one could stand in for the other, no matter how much weed you smoked.

"Another example in *Western Spaghetti* would be using the Rubik's cube as garlic. This gag is a totally different approach than bubble wrap because Rubik's cubes look absolutely nothing like garlic. I forged the connection by focusing on the act of ripping a clove of garlic from the head of garlic. In real life when you do this, you apply pressure with your thumb until *crack*! The clove comes loose. This action reminded me of when I was a kid and we used to take apart the Rubik's cubes and reassemble them into completed Rubik's cubes. This is something many kids remember from the 1980s. You'd apply extreme pressure, pressure, then *crack*! the piece came off. Your thumb would kill, but it worked. It was then easy to reassemble all the pieces into a completed Rubik's cube. And, interestingly, that action is exactly how you get a garlic clove off. So, the humor lies in the unexpected connection, the logic I found there."

Shooting Safe Zones

Subject matter is critical for a frame-by-frame film. Where you shoot plays an equally important role. As we discovered, protecting and stabilizing your camera is very important to have control in the overall image. Light, shadows, environmental conditions, and power are all elements that have to be addressed in any stop-motion production. Naturally, if you shoot indoors or in a studio space, you have the option to control these elements. Natural light can be blocked out and simulated through staged lighting, if that is desired. Ideally, there are no erratic weather conditions in the studio, but a few issues do need to be addressed in an indoor shooting environment.

The world is constantly changing. It breaths, expands and contracts. Often, this is too subtle for us to see but time-lapse and extended shoots over time reveal this fact. Humidity affects interior spaces, and this can be a problem only if a shoot goes over an extended period of time. Objects get heated and their molecular structure changes under stage lighting for long periods; and if those

lights are turned off for several hours or more, then the cooling and humidifying process can begin. This is influenced by what is going on outside the studio space. If you turn the lights back on and start shooting, you see a shift in the lighting and objects around the shoot. Trying to reduce the temperature and humidity fluctuations with dehumidifiers, air conditioners, and heaters can help stabilize shooting tables, tripods, cameras, flags for lights, reflectors, and objects that are under the camera. This is critical for more detailed and refined stop-motion techniques that require long shoots. Many pixilated films have such dramatic movement and changes in the overall image that they are more forgiving in this area. The changes in exposure and subtle movement of equipment in the scene often cannot be perceived. This reminds me of the practical approach that the Italian graffiti artist Blu uses when he shoots his painted walls around the world. He embraces the wildly fluctuating exposure and intentionally moves his camera frame to frame with slight adjustments so that erratic visual fluttering of the image becomes the norm. This allows Blu to stop and start shooting anytime he wants, because he need not worry about an even, consistent exposure. This approach serves Blu's work very well, because his painting process takes many days if not weeks to complete, and there is no way that one could maintain any consistency with all these wildly fluctuating environmental conditions (which includes human traffic).

Another piece of equipment that many stop-motion filmmakers utilize is the voltage regulator. This helps keep the electrical input into a studio space even. The normal surges or spikes and drops in power can be avoided through these line conditioners and surge suppressors. Sola and Furman are leading brands in this equipment, but there are several others. This could be an important addition to the stability of a controlled time-lapse event that is shot under controlled conditions in a studio. It is important not to have lights and the exposures fluctuating so the natural change of an object in metamorphosis can be observed.

FIG 6.5 A Sola voltage regulator.

Shooting outdoors presents many unique conditions that must be addressed to make the most of the frame-by-frame approach. It is important to know the effects of these elements so that you can attain the effect that you seek. The single most important element, as mentioned previously, is the sun or lack of it. If you use the sun as your key light, then you must utilize the constant movement of light and shadow that naturally occurs. A partly cloudy day has the sun disappearing and reappearing, creating large fluctuations in your exposures. If you shoot over a long period of time, like 2 hours or more, then the lighting changes dramatically from the beginning of the shot to the end. There is nothing wrong with these changes, as long as you are aware of them. As we stated, Blu is not concerned about the light changing because he wants the viewer's focus to be on the dominant drawn figure in the frame. He likes the peripheral movement and distractions, which help focus the eye on the subject. On the other hand, PES shot Roof Sex only on bright, sunny blue-sky days to keep a consistent overall look to all of his exterior shots. In a 2007 Sony Bravia advertisement, called Play-Doh, animation director Darren Walsh directed his animators to move replacement, hopping, model rabbits at exactly every 90 seconds, in Foley Square in New York City. This way the natural shadows, cast by all of the tall buildings surrounding the square, slowly and evenly moved across the frame in an intentional and nondistracting manner. Over 30 animators were equipped with walkie-talkies and given a signal to begin animating with a constant second countdown so they knew when they had to complete their animation and get out of frame to keep that constant 90-second interval shooting pace.

FIG 6.6 This is an example of even shadow movement over parked cars as the result of an even shutter-exposure interval from a dslr camera on Park Street in Bristol, United Kingdom.

Another important issue that must be addressed is the stability of the camera. We mentioned this before, but it is critical that no unwanted camera movement occurs. When setting up a camera on a tripod, it is important to lock down all the pan/tilt options that may be available on the tripod head. Tape the legs to the floor if you are in a studio, or use sand bags to weight down the tripod if there is no even, hard floor. Tripods with mid-leg spreaders offer more stability. It may be convenient to use small pan/tilt heads and lighter tripods, but if you are shooting outside, the wind and other elements, like human traffic, can threaten that critical stability. You may even consider

FIG 6.7 Taped tripod legs and sandbags weighing down the tripod.

a cable release for shooting your camera if you are not hooked up to a computer controller, so you need not physically come in contact with your camera during a shoot.

This kind of anchoring is necessary for motion-control systems, operated by hand or computer, and all lights that need to remain in place, so shadows and lights do not move in the scene. This is true for all frame-by-frame techniques from pixilation to time-lapse work to shooting on a stand. It certainly is possible to shoot without this kind of lock-down approach, but the chances are that your lights or camera will be blown by the wind, bumped by you or someone on the set, since these are physically demanding techniques, or may slip or move on their own over a period of time. After all, it is a wobbly breathing world and nothing is truly static. An accidental bump can be cause for a total reshoot. Although I advocate a controlled and stable shooting space, it is important to note that some of these techniques are being used in a much more uncontrolled manner these days, and that is the intention of the filmmakers. This adds a fresh look to the animation and certainly is very "postmodern" in approach. It is difficult to save a shot with an accidental camera bump in mid-shot. One approach to rectifying a bump in the camera is using a frame-grabber program that has an "onionskin" capability. If the camera moved, then you can try to coax the camera carefully back into place. This may work if your subject is active. It is much more difficult if the image has been static. Naturally, planning a cutaway and other filmic solutions can save a reshoot but you compromised your original intent because you did not take the time to lock everything down.

FIG 6.8 A screen grab of two frames being ghosted or onionskinned one on top of the other for camera and object placement registration.

The next area that we cover all takes place in an interior or studio space. Downshooting, which still requires a camera, takes place on an animation stand housed in a studio with stage lighting. This area of frame-by-frame shooting has a wide range of approaches and materials. Let us examine some of these approaches.

CHAPTER 7

The Multiplane Downshooter¹

Chapter Outline

A Stand of Your Own	
Lighting for the Downshooter	
Clay, Sand, and Three-Dimensional Objects	
Cutouts	
Backgrounds	

A Stand of Your Own

Several elements define the multiplane downshooter. The most distinguishing factor is that this type of shooting requires an animation stand. Immediately, you might think that this can be a very expensive proposition. You would be right if you decided to use a more traditional animation stand like an Oxberry stand. This is a fairly complex piece of machinery with the capability to make compound table moves underneath a camera that can crane up and down. The movement is usually controlled by a computer and requires stepping motors to move the various parts in small increments. This was the preferred method of shooting traditional cel or drawn animation.

¹Opening images are the pre-digital studio set-up and the current digital studio set-up of artist Joan Gratz. Photograph by Joan Gratz, © 2010.

Frame-by-Frame Stop Motion

FIG 7.1 A traditional Oxberry animation stand. Courtesy of Oxberry LLC.

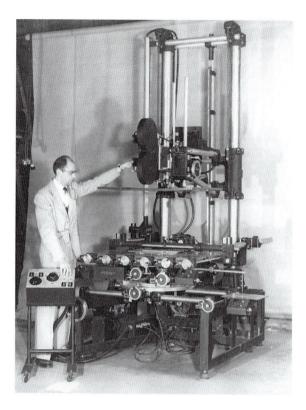

Most independent downshooting artists make custom stands, which can be as simple as a mounted piece of glass placed in front of a camera on a tripod. Many artists cannibalize old stands and cobble together parts, depending on their needs. It is not necessary to have a moving table or camera, especially these days with postproduction options. So, analyzing your needs and building something appropriate is a manageable proposition. When I shot the *Penny Cartoon* for Pee Wee's Playhouse in the early 1990s, I put together a stand out of $2'' \times 4''$ boards of wood with a glass shooting surface and a mount for a camera. It worked beautifully and serviced my needs quite readily. The camera was locked in position, with the lens pointing downward onto a stationary glass surface. All the motion was created by animating the models and materials across the glass. Neither the camera nor the table needed to move.

The table that holds the objects, cutouts, or various materials to be animated can be a hard flat surface of wood or heavy solid plastic, but the great majority of shooting surfaces on downshooters are made of glass. This allows for light to be transmitted from underneath, which can be used for mattes and other silhouetting techniques, like sand animation. The glass also allows for objects on the glass surface to be shot with no shadows falling directly below those objects. This is important for cutout animation and green-screen matting. We get into these approaches a little later in the chapter. The glass itself can be any ordinary glass but there are a few advantages to choosing the right kind of glass. It is important to note that glass is preferable over Plexiglas, because the plastic is less stable under the heat of the lights and it scratches a lot easier. The best glass to use is called *water white glass*. It has no tinting in it, transmits 98% of the light, and usually has an antiglare, antireflective coating. This allows the backdrop to be photographed so that the true colors of the artwork show through. The glass can be an expensive choice and is not absolutely necessary because of the ease of postproduction color correction. All glass slightly changes the look of the background artwork. You just want to minimize that influence.

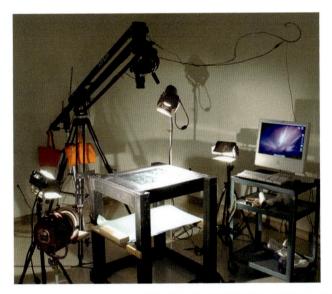

FIG 7.2 A custom-made animation stand with a piece of water white glass used for shooting the *Penny Cartoon*.

Lighting for the Downshooter

The downshooter presents very specific challenges when it comes to lighting. Shadows are the issue. When an object or cutout is placed on the glass shooting surface, it casts a shadow through the glass down on the lower plane, depending on the height of the light and the distance between the shooting planes. This is not a problem unless you are trying to shoot on green screen or do not want large and graphically confusing shadows being cast from one plane to the other.

Many parameters are involved in determining the distance between the shooting planes, including

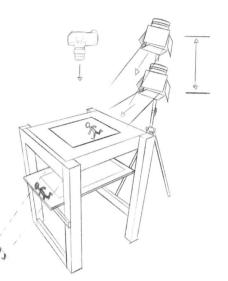

FIG 7.3 Key light position relative to the shooting table and the shadows caused by objects on the top plane.

- How wide can the bottom plane be, based on the shooting range of a 35 mm or longer lens?
- How high above the shooting plane does the key light have to be for a good effect?
- Do you want to shoot horizontally or at a 15–45° angle by tilting the table?
- What kind of depth of field do you need to achieve?
- What is the size of the object you are animating and the distance it needs to move?

The 2" × 4" stand I built has about 16 inches between planes, and the camera is mounted about 2 feet directly above the first shooting plane. As a result, my key light, no matter which side it is on, could rise from 1 to about 20 inches above that plane before objects on the top plane cast visible shadows onto objects on the lower plane. You should think of lighting three-dimensional objects on a stand in a similar fashion to lighting those objects in three-dimensional space. The key or primary light needs to define the object clearly, set a mood, and bring out the three-dimensional form of that object. Your key light can be placed anywhere 360° around the shooting table. It can be placed below the glass shooting up through the glass or anywhere from the glass shooting surface up to the point where the object shadow falls on the lower plane and can be visible to the camera. Ultimately, you must be aware of reflection from the light on the glass and the possibility of lens flare.

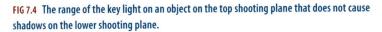

Key lights can create deep shadows, so it is often smart to give some definition to the shadow areas on three-dimensional objects with fill light. This goes back to the three-point lighting topic covered earlier. The range of the fill light is similar to the key light for the same reason: shadows. The fill usually is placed roughly on the opposite side of the key light, so it can complement the stronger key light. This fill light should be diffused and not wash out the shadows the key light creates. Both lights can utilize colored

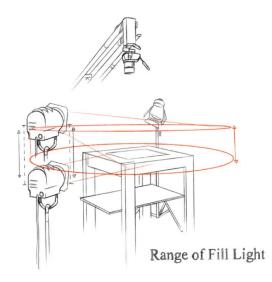

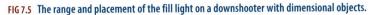

gels to add more atmosphere. Often times directors of photography think about light from nature. In this case, the key light would be warm (yellows and reds) like the sun and the fill light would be cool or in the blue range, which is normally found in the shadow areas and reflects the ambient blue light from the sky.

Cutouts, which are usually flat graphic images, traditionally have a much more restricted range for lights. The lighting has more to do with allowing the artwork to be read clearly and with even lighting. Traditional drawn animation is shot on a stand with two key sources of light set at the sides of the stand at 45° angles to the shooting surface. The lights are set equally above the shooting surface for an even flat lighting effect. Bryan Papciak, a successful director of photography and director, describes his approach to lighting these surfaces:

"Focus each light into a hard 'spotlight' aimed across the table to the opposite side. The light on the left side of the table would be spotfocused to the right side of the artwork, and the light on the right side of the table would be spot-focused on the left side. Once the two spots are balanced, then defocus both lights to 'floodlight.' This will result in the most even coverage across the table."

Since cutouts are flat paper or similar material, they cast no shadows on themselves. On a traditional animation stand, the artwork is placed under a hinged piece of glass that rests on top of the artwork once it is placed on the table. This glass is called a *platen*. The glass platen is more difficult to contend with in cutout animation because it constantly moves or displaces the artwork if the artwork sits loosely on the shooting plane. Tacking down or sticking the cutout artwork to the shooting surface with wax, Blu-Tack, or tape helps eliminate this problem.

The last area in lighting we need to examine is the "underlit" or bottom light setup. This technique is used to gain a silhouette effect for the objects that sit on the top glass shooting plane. Usually, no light emanates from above in this approach, so the objects or cutouts block the lighting that comes from underneath the artwork, creating the silhouette. The light can shine from the lower plane in a couple of ways to achieve this effect. A light box that has florescent tubes and a diffused white milk glass surface can be mounted on the lower plane to radiate an even bright light. The other approach is reflective in nature. Similar to the even lighted top surface approach, two lights can be mounted on either side of the stand focused down at 45° on the lower plane. The light should hit a sheet of white or colored card and reflect up directly under the top glass shooting plane.

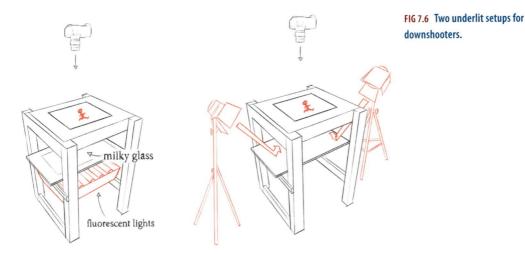

Carolyn Leaf, a master and pioneer in downshooting techniques, describes her own setup:

"I have given many sand workshops and the setup is a single framing camera over a piece of clear glass (plastic builds up static electricity, which can make the sand jump around) with white paper underneath, raised and underlit. I like to put two lights on either side of the glass pointing down onto white paper and bouncing back up to the glass surface. This gives even lighting and isn't too hard on the eyes, which shouldn't look directly into lights and can find tiring the contrast of light and dark when working with underlit sand."

Clay, Sand, and Three-Dimensional Objects

Downshooting refers only to the shooting setup. The objects or materials that can be animated are quite varied. This is limited only by the imagination of the animator or designer. Several mediums have been used successfully, and we touch on only a few. My own experience with downshooting primarily focuses on clay figurative subject matter. This is when characters are drawn and sculpted in plasticine (an oil-based clay that never hardens) in relief. This approach to clay animation has a stylized graphic quality that looks like a mixture between two- and three-dimensional animation. The great advantage to this technique is that no armatures or support structures are required to hold up the puppets. They lie on the glass and can move around anywhere in space without the constant struggle with gravity that is a part of most three-dimensional stop motion. It is necessary to fabricate replacement models if the figures need to turn in three-dimensional space.

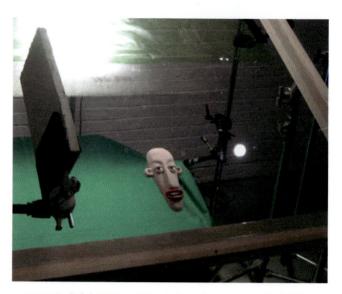

FIG 7.7 A relief plasticine sculpture shot on a downshooter by Wonky Films.

Academy Award winner Joan Gratz works with clay and oil on glass. She paints the plasticine with tools and her hands on the glass, and the images carry great detail and texture constantly metamorphosizing from one image to the next. She explains:

"One of the virtues of painting with plasticine clay is that it has tangible dimension and unlimited textures. It has that handmade quality because it is. Because I am painting and making changes to the same canvas, the images seamlessly flow into each other."

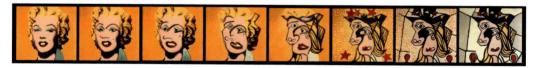

FIG 7.8 An image sequence from the Academy Award-winning Joan Gratz "clay-painting" film, Mona Lisa Descending the Staircase © 1992.

Sand is a very flexible medium to animate on glass. This can be lighted from the bottom or top or both, depending on the effect desired. Many animators use sand to block out bottom lighting. The sand is brushed and stroked with tools or by hand on the glass surface. The thinner the layer of sand, the more light can penetrate the sand, giving edges a feathered look. The more dense the sand, the more opaque and black the image appears. Caroline Leaf describes her approach to sand animation: "It is very important to me to show the texture of the material I am working with. For sand animation, the lighting is adjusted so that a suggestion of the pile of sand within and forming the silhouette of the drawn figure is visible. I want the audience to know sand, but sandiness doesn't dominate the storytelling. Likewise with wet paint, I make sure that my finger-pushing movements show so that everyone knows that it's paint."

It is important to use darker sand if you are trying to achieve a silhouette effect. Some white sands pick up the slightest bit of light, which can reveal the effect. On the other hand, you may want to see some of the sand and show its texture, as Caroline Leaf suggests. It is important to test these effects before committing to an approach. The shooting surface needs to be more horizontal when shooting sand because it sits unattached to the glass and can easily drift down the table due to our old friend, gravity. Plasticine has a bit more adhesion to the glass and the shooting surface can be tilted up to a 45° angle. The great advantage of this is that it is easier on the animator's body. Craning over a horizontal table all day long to see and manipulate the artwork can be much more demanding than sitting and seeing the artwork because it is tilted up for better viewing and access.

Shooting objects under a downshooter has its own challenges. The objects that can be used are limitless. I have seen coffee beans, candy, Barbie dolls, hair, coconut shells, pencils, and so forth. The only restriction is the size of the object and whether the object needs additional support beyond the surface of the glass. These various objects have more flexibility with lighting, as mentioned earlier. It is important to light for the dimension and form of these objects. The higher off the glass the object is, the more possibility there is of a reflection falling from that object back onto the glass. One solution is to polarize the lights and the camera lens. These filters and gels can be found at any decent photography or film store. The polarized filters reduce the reflection but do not always totally eliminate the problem. Polarizing lights and lenses also increase the contrast of the image, which is not always desirable. The background plane also plays a role in how much attention you pay to reflections and smudges on the glass. When you shoot a green screen backdrop, dirt and reflections are less of an issue, because you eventually eliminate them in the keying process. The only potential problem with these smudges and fingerprints can come when they intersect the contour of the object to be keyed. We discuss the role of backgrounds shortly.

Cutouts

The most popular largest technique in downshooting is cutouts. This area could warrant a book on its own because of its deep history and varied applications. The cutouts can be original illustrated artwork, photographic in nature, figurative, or abstract. The technique is fairly direct and inexpensive, so early on in filmmaking, designers, directors, and animators explored the

form. We mentioned Lotte Reiniger, whose 1926 *The Adventures of Prince Achmed* was the first cutout feature animated film ever made. Countless other cutout animated films were made in many countries around the world. This technique was utilized because it was direct and inexpensive in approach. This includes the 1983 film *Twice upon a Time* by American directors John Korty and Charles Swenson.

Most cutouts are animated on a traditional animation stand or a custom downshooting stand, but we will discuss some other approaches as well. The majority of cutout films tend to be on the figurative side, with a certain narrative involved. This is because images can be drawn or cut out of magazines and pieced together in a collage technique. Reiniger used cutouts with a backlit approach, creating very detailed silhouettes. But more contemporary artists, like Terry Gilliam from *Monty Python's Flying Circus* and Evan Spiridellis, one of the founders of the successful Internet entertainment company JibJab, use top-lighted original artwork and photographic images. Figurative images are cut apart appendage by appendage (legs, arms, heads, etc.) and reassembled under the camera with the ability to be manipulated frame by frame. Finally, Yuri Norstein's *Hedgehog in the Fog* is an example of an elaborate and beautifully executed use of this technique.

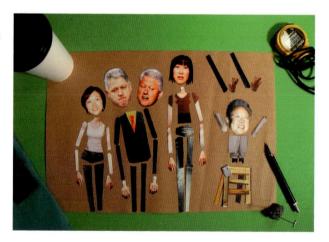

Animating these small pieces of card, plastic, or paper can be delicate work under the camera. There are so many free-floating parts that can be bumped or accidentally moved. Various techniques are practiced to gain a little control in this form of animation. The two issues are stabilization of the cutouts on the shooting (glass) surface and the movement of appendages like arms and legs and their consistent relationship to each other. The issue of cutout stability on the glass shooting surface can be addressed by the weight of the paper, plastic, or card being used. The heavier the drawn or clipped image, the more it stays put on the glass. Tacking down the heavier paper with tape or wax can make a huge difference. Lotte Reiniger used thin lead sheets with her silhouette cutouts. I am not suggesting this approach, but thinner paper can be mounted on Bristol card or lightweight board, which helps the image

FIG 7.9 Cutout body parts from "2009 Year in Review" from JibJab. Courtesy of JibJab Media Inc. © 2009. from being easily brushed aside. Artists even use double-stick tape or small pieces of sticky wax under the cutout. The glass releases the adhesion of the tape or wax quite easily but residue may remain on the glass. The animator has to be vigilant about these cutout footprints, cleaning them up during the shooting process when necessary. Many cutout artists use a tacky material called Blu-Tack that leaves less residue.

The second challenge with cutouts, especially cutouts that are figurative in nature, is the consistent relationship of one cutout to the next. For example, if you create a cutout character that walks, the relationship of the legs to the hip have to be jointed or pivoted from the same point for each movement or frame. Hinging these elements together is the solution for this kind of relationship. There are many different approaches to hinging cutouts. The most effective approach is to purchase a hand rivet set. The rivets are slightly visible and so must be integrated into the design of the animation. Another approach that is a bit less intrusive is to use small holes in the cutouts and hold the cutouts together with very thin wire strung between the holes. The last technique is the use of sticky microcrystalline wax between the cutouts. This technique requires a little more scrutiny on the animator's part, because the pivot point can drift over several moves, but this technique is quick and less visually intrusive. Blu-Tack can be used in place of the wax. Many times, cutout artists tack down only larger cutout sections of the body like the torso and leave the arms untacked so they can be easily moved. Usually, the head and arms move a fair amount compared to the torso, so this approach makes the animation go faster, although it does require a delicate touch. This last tack-down technique of hinging has the added benefit of allowing the animator to incorporate the classic "squash-and-stretch" animation technique to the character. Since the cutout puppet has no fixed positions for hinging, the animator can compress and stretch the placement of the various parts, making the animation a little more dynamic.

FIG 7.10 Three versions of cutout hinging (rivets, wire, and wax).

There are many more techniques for gaining control and hinging cutouts. It all depends on your ability to work at the animation stand, how patient you are, and your style of work and animation. As Evan Spiridellis puts it,

"For cut paper animation, we don't use any hinges. It's a bit more frustrating and time consuming to work this way but it allows a lot more flexibility in the poses and keeps the animators from tightening up. If we are working with paper puppets we'll use anything we can twist into a circle as a hinge. Sometimes it's wire, sometimes it's a paperclip. It's typically whatever is lying closest on the desk."

A final piece of advice from director and animator Terry Gilliam regarding cutouts:

"The most important equipment was a sharp scalpel" and "Make sure you blacken the edges" of the cutouts.

Cutouts can be shot vertically as opposed to in a downshooting mode. Pictures can be mounted on glass or mounted sliders that hold the cardboardbacked cutouts upright. The camera is mounted on a tripod in this case. The lighting arrangement is a little more flexible, and tracking the cutouts becomes very manageable. Jim Blashfield, a comtemporary independent artist and American Animation Master from Portland, Oregon, was a pioneer in this area. Here he describes his approach to a music video he directed, *And She Was*, for Dave Byrne and the Talking Heads in 1986. The music video was produced for Jim Blashfield by Melissa Marsland.

"All scenes were animated to the frame-by-frame log we had made of the song. That log was the backbone to the video, whether scenes were preplanned or improvised. Also central were the boxes of color Xeroxes that resulted from our guerrilla photo shoots all over Portland. We drove around looking for garage sales, secondhand stores, interesting neighborhoody things, and photographing them on site, along with personal items that seemed to fit in: a mailbox that looked just the right way, etc. For one overhead scene, Don [Merkt] sent Melissa [Marsland] off to snatch a couple of pairs of my underwear from our house, the patterns of which appeared floating across the scene. We chose ordinary things that either we thought would be amusing, or/and which seemed to have embedded metaphorical power, or which we otherwise thought should be honored for their long and unappreciated contribution to our lives. Spatula, reclining chair, purse, party hat—icons from the less appreciated heights of our culture. We also carefully photographed our pixilated moving leg sequences, and others, one frame at a time, onto color slides, and these were cut out by a herd of our friends with Xacto knives, and put into the boxes in folders. The live action of David singing was 16 mm footage which we shot in Dallas in our very minimal live-action shootcamera balanced on some videotape boxes in David's office in the back of an old house they were renting—which we then turned into paper prints at the Portland State Library microfiche department.

We rented two 35 mm Mitchell animation cameras, which we mounted on homemade animation stands made from 4×4 lumber, plastic gutters, threaded rods, conveniently sized 8×10 glass plucked from picture frames from a local store and hinged with duct tape, etc. Looking around for someone who shared our aesthetic to go off and shoot slide sequences of the other band members, who were scattered around elsewhere, we found that our friend (like us, usually underemployed) Gus Van Sant was willing to hop on a plane and returned a few days later with more slides for the Xerox machine. Many others, most of whom went on to work in our next videos, participated in the making of this video. We had 28 days from the day we got the go ahead until it appeared on MTV. We had no idea of the huge impact it would have. There was no significant postproduction in And She Was-maybe an hour to clean up something or other. It was all shot under the camera, images stacked up in layers, one frame at a time. All the lateral 'pan' effects were done either on threaded rod with runners attached or on repurposed slide rules, as I had done with Suspicious Circumstance."

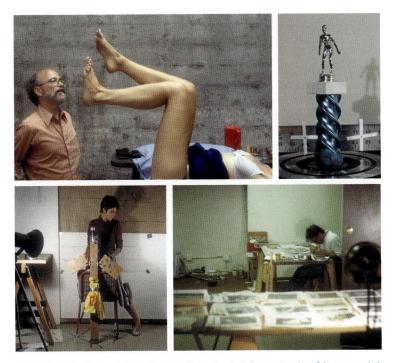

FIG 7.11 (Clockwise from top left) Jim Blashfield directs the single frame animation of the protagonist's levitating legs in Talking Heads' *And She Was* music video; a trophy, soon to be surrounded by party hats and bowling balls, awaits frame-by-frame rotation on one of the many improvised animation rigs used in the production of *And She Was*; a cutter, X-Acto knife in hand, separates one of hundreds of color Xerox images from its background for later registration and re-animation onto 35 mm movie film; producer Melissa Marsland advances the hinged wings of the "flying 2 x 4" as it is animated onto color slide film for later Xeroxing.

Another independent director and animator from the Boston area, Daniel Sousa, also works in this vertical multiplane frame-by-frame technique. His 1998 film *Minotaur* is an example of this approach. Here is how Dan describes his process:

"Most of the character animation was originally hand-drawn on a light table, cut out, and mounted on rigid cardboard. This was done so that each replacement could stand up vertically within a three-dimensional set. The set was then lit with fiber-optic lights and shot in stop-motion, using a 16 mm Bolex camera. Some of the animation was done as hinged cutout puppets on glass, using a multiplane rig."

FIG 7.12 A still from Daniel Sousa's 1998 film Minotaur. Courtesy Daniel Sousa © 1998.

Backgrounds

The final subject to cover is the background or bottom shooting planes on a downshooter. There have been downshooters and traditional animation stands with many more than two shooting planes. The same issue of shadows cast on one plane from the object on the shooting plane above it still exists. This means that multiplane downshooters need to be pretty tall and are often cumbersome to operate. Depth of field becomes an issue with multiple planes. As a result, the lights need to be brighter, so a deep depth of field can be achieved on a lens like f-22. Most stands use two planes with dimensional objects stacked on top of each other on the top shooting plane. Many times, three-dimensional objects, like candy, coffee beans, or a sculpture, are shot on top of a green screen or chroma background, which allows the object to be pulled off that background in postproduction. The object may be composited onto another image later with proper planning. The downshooter is ideal for green screen work because

- The image on the top plane usually gets very little green spill light from the layer below. (This is the light that reflects back up onto the model from below and tints the edges of that model, making it hard to pull a clean chroma matte in postproduction.)
- There are no shadows on the lower level from the object. (This is because your lights have been set to prevent shadows from top plane objects from falling on the lower plane background.)
- The lower level is lighted evenly, which is perfect for pulling the matte in postproduction. (Evenly lit chroma-key green background layers are easier to matte out in postproduction)

Practical backgrounds on the lower shooting plane of color, illustration, light, or any other form are equally effective with the downshooter. When I shot The Insideout Boy for Nickelodeon and the Penny Cartoon for the CBS television series Pee Wee's Playhouse, the figures were made out of plasticine on the top plane but the backgrounds on the lower plane were either cutout paper or pastel drawings. The lighting can be altered below to create any kind of atmosphere, but cutouts and slightly elevated objects or paper on the background have immediate shadows that are cast directly down on that plane under the artwork. Cutout artwork on the background layer should be glued down to avoid shadows. The shadows distract from the crisp, graphic, refined edges of the artwork and diminish the quality of the overall picture, so they must be addressed. If you want to have animated backgrounds, then consider drawing them or shooting the background animation on a second sheet of glass with color on a level below that. Joanna Priestly, another successful independent artist and animator from Portland, Oregon, describes her setup:

"I shot *Surface Dive* on my homemade, multiplane animation stand to add depth to the compositions. I had the replacement sculptures on the top level, a huge variety of clear glass pieces on the middle level, and large, animated pastel drawings on the bottom level."

Many practitioners of these art forms are working across the globe. Independent filmmakers often still utilize these techniques because they are affordable, conceptually appropriate to their style, and stand out in today's computer-driven industry. Programs like After Effects and Flash have been mastered to elicit a very refined cutout style with more control and efficiency. The "photo puppetry," drawn two-dimensional computer and composite

FIG 7.13 Joanna Priestly shooting Candyjam with pieces of candy placed on a glass plate over a drawing. Photo by Joanna Priestly (Priestly Motion Pictures) © 2011.

approach of these programs have dominated this form of animation for over a decade in the commercial world, but there are still many "holdouts" who like to dabble in the "old school" approach to cutouts, like Evan Spiridellis and his team at JibJab.

As you can see, there are many different ways to build or cobble together a downshooter stand, and many artists put together their own version of this piece of equipment. Many years ago, when I was working for Art Clokey, the creator of Gumby, my partner and I took on a job in the evenings. The "clay-on-glass" technique was required, and I had to put together a stand for this night-owl production. Figure 7.15 shows the final stand I put together. It is very rudimentary in construction but solid and still operating 24 years later.

FIG 7.14 A shot of animator Kevin Elam at JibJab on their custom downshooter. Courtesy of JibJab Media Inc. © 2010.

FIG 7.15 A diagram of a rudimentary $2'' \times 4''$ downshooter stand.

It was inexpensive to build because I used $2^{"} \times 4^{"}$ pine lumber, $5^{"}$ long $\times \frac{5}{6^{"}}$ diameter carriage bolts, two $30^{"} \times 24^{"}$ plywood quarter sheets, and a piece of glass. The bolts allow you to take this stand apart, so it can be moved or adjusted. At the time, I was shooting with a 16 mm Bolex camera, but these days the camera mount holds a Canon dslr with a zoom lens. There are better designs for a downshooter stand, and there are adjustments that can be made to this stand to improve it (like mounting a simple track on the back column that would hold a camera and allow for tracking zooms), but this simple stand will suit most of your needs in the downshooting realm. Good luck with your downshooting. It can be a lot of fun!

CHAPTER 8

A Sense of Drama¹

Chapter Outline

Live Action and Single Framing	109
Subtle and Broad Performance	
Reference Film and the Cartoon	
Look in the Eyes	115

Live Action and Single Framing

We already mentioned how important it is to exaggerate images and actions with some of the alternative stop-motion techniques. Time-lapse photography usually does not include acting or contrived scenarios, but it still requires a sense of drama if you want to capture an audience's attention. Choosing the right subject matter that reveals real transformation over time makes this technique effective. Setting the camera so that the composition is dynamic becomes important to a time-lapse study or any form of filnmaking. This can be done by utilizing foreground and background elements in the same shot, thinking about

¹Opening image is a still from *Jidlo (Food)*, directed by Jan Svankmajer. Photo © 1992 Athanor Ltd. Film Production Company, Jaromir Kallista and Jan Svankmajer. Courtesy of Jan Svankmajer. the use of diagonal lines in the composition to lead the viewer deeper into the composition, placing the camera in an unusual point of view, playing with scale, and including an interesting color and lighting palette. An artist also has to consider how a composition changes over the course of a shot. Knowing where your camera will move and what will transform in front of the camera is critical to

FIG 8.1 A series of shots showing dynamic composition elements (foreground/background, diagonal lines, unusual POV, and color palette).

FIG 8.2 Using scale for a dramatic effect in Alice by Jan Svankmajer, 1987. Courtesy of Jan Svankmajer. Photo © Athanor Ltd. Film Production Company, Jarmoir Kallista, and Jan Svankmajer.

maintaining great dynamic compositions. It is usually more interesting to have a subject enter the camera composition from a diagonal direction than directly in from the side. There are many ways to build interest in your animation, and many of these principles apply equally to live-action filmmaking.

Good art direction is critical to any film, but two elements are even more important. The first element and the one that everything rotates around is the idea. We touched on this in preproduction, and Focal Press has several books that cover this immense subject. The next element is performance. Having good actors can make or break any film, and the same is true with animation. When it comes to animation, you, the animator, are really the actor and what you do with your inanimate object, person, or artwork in terms of performance is pivotal to the success of your film. Live-action filmmakers know that there are two kinds of realities. First, there is the way life unfolds from one event to the next. We live this reality every day here on Earth. Sometimes, it is exciting and usually it is not. Life is full of dull tasks and activities that are necessary to our survival. When we go to see a film or a stage production, we do not want to be reminded of these mundane tasks and realities. We are interested in the compressed, interpreted high and low points and emotional expressions of an event. We want the icing without the cake. This is true for animation as much as any other sequential art form. One example of this reality in animation is the use of the everyday walk. Walks can be very revealing about an individual. When we observe a walk, we take cues about the energy level, determination, and attitude of an individual. If this is essential to understanding that character, then animating a walk is an important element in the storytelling process. Normally we do not need to see a character walk from point A to point B. We want the filmmaker just to get us to point B and move the story along. We are interested in the emotion and highlights of the story, not the everyday realities like a long walk. There are some exceptions to this premise, but for the most part, this is the dramatic reality that animation should consider.

PES describes his approach to his 2003 pixilated film *Roof Sex*. Even though he is approaching this film in a documentary form, there is still a great sense of drama and compressed and interpreted shot sequences.

"Would the idea of two chairs having sex conceptually work as a drawn animation? Yes, definitely. In CGI? Yes, definitely. But, in my opinion, the execution gains power when using real objects on a real location ... it's much, much closer to real life and it hits a more absurdist note. I believed that stop-motion was the best technique for *Roof Sex* because my intention was to treat the idea like a documentary. I fancied myself spying on these two specific chairs that escaped from their owner's apartment one day, and almost as a voyeur, I recorded what they had done for posterity. There are no cartoony sound effects; everything was done with an eye to being as believable as possible. As in much of my work, there is humor to be found in the earnest—almost documentarian—approach to the fantastic. For me, photographic images combined with absurdist, yet oddly logical, ideas are like rubbing two rocks together to create a spark."

Subtle and Broad Performance

Time-lapse filming usually does not include performance, except by the natural occurrence of an event. So, this single-frame technique is not included in this subchapter. There can be some subtlety in performance in some of the downshooting techniques, like sand animation. This more refined movement can be achieved with small controlled moves in the sand or clay and can even be attained by the use of dissolves from one frame to the next. Yet, on the whole, these alternative frame-by-frame techniques are broader and less refined than other forms of animation, like drawn and computer-generated animation. These last techniques allow more control, and they are often used in this way.

Generally, like action on the stage and in early film, broad acting is assigned to the wide shot. The figures or objects are smaller in the frame (like seeing the stage from the back of the theater), so the action has to be bold and broad. Close-ups are usually reserved for the more subtle and refined movements of an individual or object. In pixilation, these more subtle forms of acting are more difficult to achieve because of the constant movement of a human that is caught frame by frame. The constant moving in and out of registration or exact placement of the person in the frame makes this technique broader and less subtle. Broad exaggerated expressions help distract the viewer from the constant vibration even in the close-ups. Using "freeze frames" is not a solution to the constant vibration of pixilation. This approach kills the continuity of a pixilated shot and pulls the audience right out of their suspended reality. You can repeat two or three similar frames to keep the vibration going although if this is done for too long the viewer can see the cycle of frames. Extreme control on the subject/actor's part is the only way to achieve some sort of subtlety in pixilation. It recalls Lindsay Berkebile's term "chaotic life amongst silence." Controlled breathing and eye movements along with rig support for heads and hands help maintain stability and potential subtlety without breaking the special energy prevalent in pixilation.

There is the potential for more subtlety in object animation and downshooting, because the objects are inanimate and do not live and breathe (at least not until they are projected). The subtle or broad approach, style, and

FIG 8.3 Image from *The Deep***.** *Courtesy of PES* © *2010.*

purpose is up to the director. If we examine the work of PES again we see a lot of wonderful and controlled movement, like in the underwater world of *The Deep*. Chains are moved with gentle S-curve gestures that mimic a piece of kelp waving underwater and calipers bob up and down like jellyfish as pliers (fish) surge forward, all underwater (or so it appears). These beautifully animated tools create that illusion because of the subtle yet dynamic choices the animators make in the movement.

Joan Gratz produces beautiful full-detail paintings and uses metamorphosis to move from one to the next, frame by frame. These can be dissolved from one image to the next or they can be step printed. *Step printing* means that each frame has a low-opacity layer of the previous and following frames on it. Step printing is also referred to as *step weaving*. This adds to the flow and subtlety in her animation. As Joan puts it,

"In Mona Lisa Descending a Staircase, images of the human face are subtly transformed to communicate the graphic style and emotional content of key artworks of the 20th century."

We covered broad facial exaggerations that many artists like McLaren and Kounen utilize, but it is important to remember that dynamic movement also makes a huge difference in the performance. Certainly by using "eases" you build in acceleration and deceleration, but there is much more to movement than this single dynamic principle. This is the essence of animation. There is so much to discover in this area that even veteran animators like me are constantly trying new combinations of movement for their dramatic effect. Here is an exercise that helps illustrate two types of movement and their effect.

You need a digital camera (still or video) and a tripod. If you have a laptop to control the camera, then bring that along, but this exercise can be done without the capture software. You need a flash card in your digital still camera to capture frames that you will download into a computer after the exercise, if you have no computer on the set. You also need a person, but an object will work. You can shoot this exercise outdoors or indoors, but you need about 20 feet of space to move in. Try to find a background with very little visual detail, like a wall. If you are outdoors then try to execute this exercise where the light is as even as possible. If you are indoors you need broad soft light, like overhead lights. Set the camera slightly off-center from your subject, which will stand 20 feet away from the camera (frame left) near the wall. Mark off 15 forward positions for your subject to move toward the camera, ending frame right. Try to include some simple ease-ins and ease-outs. Remember that

(Continued)

these are the increasing and decreasing increment movements that are a natural part of the physics of any movement. Shoot 15 still frames of your subject in the far position, then have the person move up to the next forward mark (toward the camera) and shoot 2 frames. Continue this pattern until the subject rests near the camera (including those easeouts), then shoot 15 frames of hold at the end. That is the first reference.

Try this again but this time hold for 15 frames at the front, lean your subject back a bit in anticipation (shoot 2 frames), then one small move forward (shoot 2 frames), then move your subject all the way up to the last position (close to the camera), leaning forward (2 frames), then 1 frame leaning back, 1 frame leaning forward (not as far as the first time), and so forth. Settle your character out and shoot 8 frames of hold. The playback should be 30 frames per second. This is the "snap" effect and makes your subject look like a vertical diving board. It is very dramatic and adds a fun dynamic to your shot.

FIG 8.4 A shot of the first ease movement animation setup.

FIG 8.5 A shot of the "snap" animation setup.

Reference Film and the Cartoon

One of my first jobs was working for the "claymation" studios of Will Vinton. A small crew of us spent many years animating characters for an animated feature. Many of us were relatively new to animation, so one of the techniques that Vinton incorporated was making a live-action reference film of all the voice actors as they read their lines in the sound studio. All of the animators would take the appropriate clip of live-action reference film into our set and view it on a 16 mm viewer as we animated. It was a great way to learn how movement works, and there were actions that the voice actors incorporated in their performance under the direction of Vinton that we were able to translate into stop motion animation. This gave the director more unified control over the performance of the animation. The more successful animators used this reference only as a bouncing board for animating, incorporating more dramatic expressions, holds, and actions in their puppets. We used this same technique using digital video cameras more recently when I animated on Aardman Animation's *Creature Comforts America*.

The important point is that even the most experienced animators can rely on reference footage. It is a wonderful learning tool, but one that is to be interpreted. Animation is best when it does something that live action cannot do. Pixilation has the look of live action when you view the individual frames, but it is the relationship of those frames, one to the next, that makes this art form interesting. When you start playing with the incrementation and variation of the placement of the human subject in the frame, you enter into the realm of the moving cartoon. This approach is exemplified in the pixilation work of McLaren, Kounen, Jittlov, and PES and can be realized by trying out the exercise just mentioned.

One technique that many pixilation filmmakers promote is the use of the wide-angle lens. This can add dramatic effect to a cartoon that can be humourous. These lenses range from 12 mm to 35 mm in focal length and usually are best when they are prime, or single focal length, lenses. The wider lenses are most effective, but are also expensive to purchase. Using an 18 mm lens on human faces can be very dramatic, humorous, and even bordering on the grotesque. When you use a wide lens like a 24 mm, 28 mm, or 35 mm focal length on animated objects, it helps bring you down into that object's world and scale. Using a wide-angle lens for close-ups when the lens is set at eye level to the object helps make the image appear larger than it actually is, because the lens makes the background recede faster than a longer lens. The foreground subject looks larger than the background, giving it a grand appearance. This close proximity of the lens and camera to the object can make it difficult for an animator to get to the animated objects, but the effect can be worth it. The only area where wide-angle lenses can be a problem is in the downshooting mode. Wider lenses require wider background shooting planes, and this can be impractical. Most downshooting stands are made for 35 mm and longer lenses, like 50 mm, 85 mm, 105 mm, etc. Any dramatic quality like distortion has to be incorporated into the artwork. As mentioned previously, longer lenses like 85 mm, 105 mm, and 135 mm have an inherent shallower depth of field than wider lenses, so it is important to consider this if you have artwork on a downshooter background that needs to be in focus. Oftentimes, a lens in the 35 mm to 50 mm range works well on downshooters.

Look in the Eyes

Audiences have to care about your characters. Whether your performance is broad or subtle, stylized or naturalistic, photographic in nature or fabricated from nuts and bolts (literally), the characters have to have a humanity to them.

It is critical that the audience has empathy and a vested interest in what your character will do next. If you do not explore these emotional avenues, then you will lose your audience. Allowing your characters to appear to think, have an emotional response, and react with action gives them a kind of life that we understand. So much of that thinking and emotion can be read in the eves. It is critical to bring the camera close and allow enough time for your character to think. This makes them real in the eyes of the audience. The close-up is certainly the animator's friend. These shots can have a huge impact on the story and require the least amount of work. A few blinks, the darting of the eyes or a slight squint can carry a scene with great emotional power. We do understand the attitude of a person from his or her body language. Is this individual energetic, depressed, or nervous? We can read this immediately, because the body is large and consistent in its form, but the eyes confirm the true emotional state. Since we cannot hear the character think, we become more involved in the film by starting to project our thoughts on that individual, based on the situation and our understanding of the character. We may be right or wrong. It does not matter. What is important is that we participate in the storytelling through our projections and caring, and that is good filmmaking. This focus on the eyes explains why early film actors and stage actors would wear heavy eye makeup to highlight their eye expressions. The audience in the auditoriums needed to see what their eyes were saving. Two sources to study regarding the use of eyes are Chuck Jones's book Chuck Amuck, where Jones writes about eyes and timing being at the heart of a thinking animated performance. The other source is a wonderful 1928 silent film by Danish-born Carl Dryer, The Passion of Joan of Arc, where the whole emotional storyline is expressed through the actors' eyes.

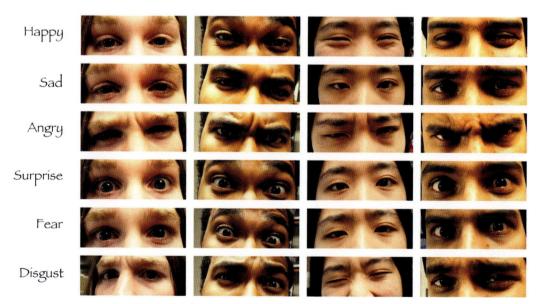

FIG 8.6 A shot of a series of eyes in the six universal emotional expressions.

Paul Ekman, a prominent psychologist, showed and proved that there are several universal emotional displays across all cultures. These include happiness, sadness, anger, surprise, fear, and disgust. All audiences understand these expressions and displays of emotion immediately, because we all share them, and they are revealed through the eyes as much as any other means. These expressions and emotions should be used and exaggerated in frame-by-frame animation for a greater dramatic effect.

CHAPTER 9

Rhythm and Flow¹

Chapter Outline

Let the Music Lead	119
Patterns of Movement	123
The Beat Goes On	126

"We really like to base our animation on music. Usually what we do is, first Merav edits the drawn animatic over the sound track, creating a general tempo for the whole piece. Then, while doing the 3D animatic, we fit the more subtle movements and gestures to the bits."

Yuval Nathan

Let the Music Lead

When I first started studying film, I had a wonderful teacher by the name of Martin Reynolds. His love and passion for filmmaking was immeasurable and his high regard for music and sound left an impression on me. He would say;

¹Opening image is Ed McMahon, Farrah Fawcett, and Walter Cronkite. JibJab Media Inc., © 2010, courtesy of Evan Spiridellis.

"Mr. Gasek, the sound that you create for your film should have as much weight as the picture itself. Sound must be half of the film and no less." I never gave this much thought until Martin brought this to my attention. As I started to analyze the films that I followed, I realized that this statement rang true. I am a very visual person, like many filmmakers, and since I am creating visuals for my film, the sound would often fall into the shadow of the pictures. One day I decided to give a live musical performance for one of the film exercises I was screening for Martin's class. I brought in and played a guiro, which is a hollow, ribbed cylinder of wood played by rubbing a stick across the ribs. This sound, along with the rigging of the sailing ships that I filmed, made an unusual combination that somehow worked and garnered high praise from Martin. From that point on, I promised that my sound tracks would play prominent roles in all of my films, and I have never regretted that commitment.

Ever since the early days of animation, music has played a key role. Some animators follow music and sound effects to the frame, and others have let

Frame	Dialogue	Sound	Actio	Camera	
#		(Music and SFX)	1	Directions	
1					
2					
3					
4					
5					
6					
7					
8			open mouth		
9					
10	Н				
11	~	ŧ			
12	e	*			
13	~	業			
14	1	1			
15		*			
16	~	Ŧ			
17	~	Ŧ			
18	~	ŧ			
19	~	1			
20	0	+			
21	~	*			
22	~	-			
23	~		peak of "o"		
24	~	Ŧ			
25	~	*			
26	~	Ŧ	taper out		
27	~				
28	~				
29					
30					
31					
32					
33					
34					
35					
36					

FIG 9.1 Log sheet with sound wave and frame count.

the sound track become more interpretive and less connected directly to the images. Both approaches have strengths and different effects on the audience. When the music is synchronized directly to the picture, the music drives the picture. If the sound track is interpretative, then the visuals tend to lead the meaning and effect of the film. This is also reflected in the way these two approaches are produced. With synchronized music, the music is created first and broken down in length to the frame. The animator takes those sounds and accounts for them on a log sheet or "dope sheet" so every single frame has an associated sound. This is also the way lip-sync dialog is created. The pictures or mouth shapes follow what the sound dictates. In an interpretive approach, a composer or sound designer is given the moving image, even if it is not completely finished, and starts to create a track based on the general movement and mood of the pictures. Sound effects are usually created this way but require very specific placement on the timeline, so they are synced up to a specific image. Occasionally, original sound effects can be created first and the picture actions follow the broken down analysis of that sound on a log sheet.

William Kentridge, the South African artist and animator, describes his approach to sound tracks:

"Work with the composer starts after about the first two weeks of filming. We look at the rushes, listen to different kinds of music played alongside the images. From here, the film and music go back and forth between the composer's studio and mine, in an ever-tightening observation."

The great majority of films are produced in this fashion; and a lot of interpretation, spontaneity, and creative flow comes with this production protocol. It is important to work with a composer or sound designer who has experience with moving image sound tracks and understands the rhythm and flow of a narrative or experimental production. Working with a pre-existing sound track and following that track to the frame is a lot more work but the results can be very potent. Here is an exercise to give you a taste of this exacting marriage of sound and picture.

This exercise starts with a music track. I recommend creating an original music track from a program like GarageBand. You certainly can use a composer or make a music track in any other fashion that is easy and effective. The key to this music track is that it needs to be simple, short (10 to 30 seconds long), rhythmic, and feature only one or two instruments (preferably no lyrics). Get that music track into digital form, like an AIFF file or a WAV file. Investing in a program like Quicktime Pro can make a

(Continued)

big difference in creating picture and sound tracks. It is also important to note that you need to record the sound track at a rate that you will use for animating, so the picture and sound do not lose synchronization. If you are shooting at 30 frames per second (fps), then you must record at that rate. If you chose to stick to a film rate of 24 fps, then record at 24 fps. Import that sound track into a program, like Dragon or even Final Cut, that allows you to import sound tracks, shows a waveform for the sound, and has the ability to count every frame and its associated sound in the whole timeline. Our website lists several programs that are good for sound breakdown.

Create a log sheet (illustrated in Figure 9.1). Start stepping through the music track with the forward arrow key frame by frame and locate each sound and the beat or rhythm of your composition. I find wearing headphones really enhances this activity. Write down the sounds and their placement by their associated frame number on the log sheet. The waveform helps you see the dynamics in the music and the regular patterns like the beat. Some sound reading programs, like Magpie Pro, print out a waveform right on their existing log sheet format. This is convenient but not necessary. Once you have your whole music track broken down into frames and recorded on your log sheet, you are ready to animate.

You can use any of the alternative stop-motion techniques, but one of the easiest approaches is to work on a flat surface with objects. Similar to other exercises, you need a digital video or still camera, a tripod, a few small lights, and a solid, stable tabletop. If you use a program like Dragon, then you need to import or load your sound file into the audio timeline. The nice thing about using Dragon is that you have your sound file on the desktop with a total frame count and waveform. The sound automatically syncs up with your picture frame, and you can proceed to animate to your sound track.

Try to choose objects that are related thematically or visually to the style of the music you are using. For example, if your music has a Japanese flavor, then you might consider animating chop sticks and ningyo dolls; if your music leans toward hip-hop, then you might animate sneakers and baseball caps; if your music is light and floating, you might animate feathers and paper. I think you get the idea. Keep in mind the things that you are interested in animating and let them influence your choice of music when you create the track. The objects can be pulled in and out of frame based on the beat and sound of the music. You can move and place your objects around the frame in a way similar to the look of the waveform, with lots of activity when the waveform is large and less movement when the form is small. I find it is helpful to assign a particular object to a particular sound or instrument for clarity. Have fun with this exercise. It takes more time to animate this way because of the constant reference to the sound track. I am sure you will be pleased with the results.

FIG 9.2 A waveform from sound in Dragon Stop Motion.

Patterns of Movement

One can consider frames of animation like musical notes on a scale. This is especially true when visuals are closely linked to sound tracks. Generally, when a waveform rises in size on the audio track, the corresponding visual frame is active or more detailed, reflecting more energy and dynamic. If the sound recedes, then the corresponding image may remain static with little dynamic change. One master of this approach to visual music was Norman McLaren and his many film experiments, including his 1959 *Short and Suite* and the 1971 *Synchromy*. McLaren used many different techniques, including drawing directly on 35 mm film with pen and ink. He also used optical printing techniques in *Synchromy* to create a direct visual link to the sound track.

RT +) 01 00 00.28	01 00:01 06	01000111	01 00 01 15	01 00:01:38	01.00.01.21	01:00:01.24	01.00.01.27	01 00:07 01
	dispositos							
(V2) 2 00								
(vi (vi) a # 1	1 1 1	1 1 4	v - 4		YYY	* + +		• • •
at (At) a B				An also and an an addition of the state				
22 (A2) 2 2			- Constant Anna Anna Anna Anna Anna Anna Anna	an a	Sale and the second second	and the to suggest an and		
(A3) 8 #								
A4 3 8								

FIG 9.3 An active sound track and the corresponding visual timeline.

Similar to music, when an animated sequence is highly active, it can be exhilarating to watch. Too much exhilaration can be exhausting, and the audience can start to drift away. It is critical to let your frame and characters rest for even just a moment, so the audience can catch up and digest what is happening and maybe even get a sense of character and thinking from an animated subject. This is practical and adds dynamic to any composition. Even with the lack of sound tracks, object movement and visual frames can have patterns that create certain effects and illusions to the eye. These patterns become recognizable to us because we know their movement even though the objects are not necessarily related to that movement in real life. We saw this in the work of PES. His candy-corn flames and his pepper heart are great examples of movement that have a distinctive pattern. The Pepper Heart features three or four red peppers in increasing size that are replaced one after the other. The first and smallest pepper is held for about eight frames, then each pepper is replaced with a larger pepper. There is a brief hold (four to six frames) on the largest pepper, then the peppers are replaced with smaller peppers (the same three or four peppers), and the smallest pepper is held for eight frames and so forth. PES uses the loop or a cycle of movement mimicking the repetitive beat of a human heart. This creates a visual music of sorts that can be appealing to the eye. The hold along with the changing pepper movement make this a successful sketch.

FIG 9.4 A series of peppers that simulate a heart, PES. Courtesy and © PES.

William Kentridge follows his own intuitive approach to movement and patterns. In his *Fragments for Georges Melies*, which is part of an exhibit that traveled around the world in major venues, Kentridge gives his artwork a life of its own through the use of stop-motion, drawing, and reverse playback techniques. The artwork of one of his drawings appears to sink to the bottom of the frame, until Kentridge enters the frame, frame by frame, and rescues the slumping image. When I asked Mr. Kentridge about his approach, here is how he responded:

"The morning I decide to make a film, I begin. I may have to pause to find an object or image. Thinking about the film starts while setting up the camera ... I can make a film without having to sell the idea to a producer. I can practice my craft without being dependent on the whims of anyone else—there is no crew, no cast. I like to use a camera like a typewriter.

"In the long term, my approach is based on a year at the Ecole Jacques Lecoq in Paris, where there is an emphasis on the expressiveness of gesture throughout the body. In the short term, I find the trajectory of a movement either by watching myself in the mirror, or filming myself or other people with a video camera; or by making a movement in the air with my hand, while counting.

"Objects and images in the films float between being seen as photographic objects, or the things themselves, and provoking other meanings and associations—for example, a cloth draped around a corkscrew is also a woman lifting her arm."

His animated movement is lyrical and so is the pattern and pace of his animation. It unfolds in a mysterious yet simple pattern that makes us wonder about the life of the created image.

FIG 9.5 William Kentridge rescuing the image in his artwork from 7 Fragments for Georges Melies ("Moveable Assets"), 2003 (video stills from installation). Courtesy of Marian Goodman Gallery in New York and the Goodman Gallery in Johannesburg.

This rhythm and flow of images can be an abstract concept to grasp, but it is often the element that defines a particular piece of animation. It is the artistry. Whether the visuals are tightly matched to a music track or much

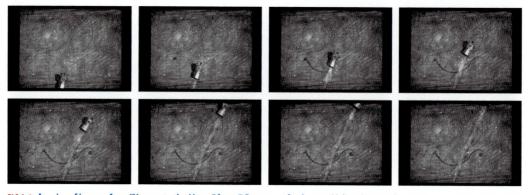

FIG 9.6 A series of images from "Voyage to the Moon," from 7 Fragments for Georges Melies. Courtesy of Marian Goodman Gallery in New York and the Goodman Gallery in Johannesburg.

more interpretive in nature, there does need to be a driving force to carry the film along. Once again we turn to the clay painter, Joan Gratz:

"I am interested in creating a 'visual onomatopoeia' in which line, color, movement, and rhythm create the feeling of a particular experience without illustrating it."

The Beat Goes On

Often these alternative stop-motion techniques can be employed in the marketplace in the world of the music video. Part of the reason that this formula works is because these photographic stop-motion techniques can be produced on lower budgets and in shorter time periods. Ultimately, it requires a great idea, a good piece of music, and sweat equity. These techniques, especially pixilation, can require a lot of hard physical work, as we discovered. More important, this technique allows audiences to see artists in the magical world of animation with a certain rhythm of movement that cannot be recreated in live action. The Peter Gabriel music video Sledgehammer was an early example of this approach. There are many more examples of this music and picture relationship that have been produced in the last twenty years. The one area that makes pixilation more time consuming is if the filmmaker decides that the human subject has to lip-sync or mouth the words of the song. This requires more detailed preparation and production and it can be difficult to get exacting results. The subtleties and in-between movement of the human mouth are something we recognize instantly, since we watch each other speak every day. When it is not done exactly the same way, especially with the photographic image of a human subject, then it does not sit quite right. This stylization of animated speaking can be humorous but difficult to pull off, because the mouth shapes are not exacting and it is difficult to get

human subjects to emote believable expressions that would normally be associated with words.

Always remember to start your work on any sound track from the very beginning of your animated film preproduction. It is totally up to the filmmaker on how to use a sound or music track, interpretative or literally, but it is always important to infuse that sound track with great importance, so that it carries half of the weight of the film. The image itself has its own rhythm and flow on a timeline, and once sound is introduced, there should be a kind of synchronous dance between the two.

CHAPTER 10

Collage (The Digital Advantage)¹

Chapter Outline

Planning a Collage	129
Match Lighting and Rotoscoping	
Clean, Clean, Clean	
The Chroma Key	135

Planning a Collage

Even in the early days of filmmaking, the idea of combining images was compelling and artists like George Melies were fast to practice this approach. Mattes were often used to block out certain areas of the exposed film frame and then the camera re-exposed the film (after it was rewound to the beginning of the first shot) to a new image in the blackened area. Working with film made the process of combining images in collage much more difficult than the present

¹Opening images are a series of the composite Hat Fish, © Tom Gasek 2011.

day digital approach. In film, effects had to be combined directly in the camera or with an optical printer, which was developed in the 1920s and 1930s. Optical printers are rarely used anymore, but they became quite sophisticated in the latter part of the 1980s, just as the dawn of digital compositing came into play. They involve one or more projectors that focus exposed developed film directly into a film camera with great precision and control.

Since the great majority of moving images are created digitally these days, compositing various images and frames together is much more accessible. A good computer and software like Photoshop, After Effects, Shake, Blender, and Nuke make this possible. These programs are not cheap, but they are more affordable to use than optical printers or even high-end professional posthouse programs. Many of these programs offer 30-day free trials and wonderful discounts for educational purposes. We get into some of these techniques but first we need to explore how to prepare for a composite/collage project.

Why would you choose to composite images? Artists can make certain aesthetic decisions that determine whether they composite images or not. This is not something that can be easily pinned down. The combinations of imagery that can be paired together open up a huge area of visual imagination, and many artists are curious to open that door. Quite honestly, any combination of figures and images can be combined to serve any idea. There are also many practical reasons to composite images. A filmmaker may not be able to find two images that can be placed together, like an elephant and the Empire State Building or paper hearts that might surround the heads of lovers. In cutout animation, this juxtaposition of unlikely images can easily be achieved under the camera in one pass. We saw this in the work of JibJab, Terry Gilliam, and Jim Blashfield. Photographs and drawings can be cut out with a scalpel or scissors and prepared for shooting under the camera. Anything is possible with this approach. Ultimately, as mentioned previously, new cutout animation has become the ultimate digital composite form. This new cutout animation, which utilizes programs like Flash, Toon Boom, and After Effects, composites images electronically with layers and lots of fine

FIG 10.1 An optical printer, courtesy of Academy Award winning optical printer artist Eugene Mamut.

control. In any cutout, pixilation, time-lapse, or other animated compositing, the consistent lighting of images is critical to a unified composition. The other important aspect that needs to be considered is how these images interact. If they are figures, will they have to look at each other? Will the eyeballs have to move? Will the objects or figures cross over each other? Do you want to have shadows fall from one object to the other? These and other questions need to be addressed as you prepare for your composite work.

Match Lighting and Rotoscoping

You can start to combine images in a test to make sure that they work together to your satisfaction. But, before we explore that, let us talk about lighting. When you have different objects or people that you want to put together in one frame or image, you need to decide on a unified lighting plan. Your key object or person should be lit to match the atmosphere you want to have in the final collage or composite. This might be the classic three-point lighting we discussed, or it could be a high-noon sun from an outside shot or even single-source lighting in a studio. Once you established that lighting, all of the other objects that you shoot to be combined with your main image must be lit with the same lighting scheme, including any gelling or filtering of lights. This can take a lot of planning and careful coordination. If you cannot control all the lighting with the various objects, then your final composite image looks pieced together and unnatural.

FIG 10.2 A matched-lighting composite image.

FIG 10.3 A composite image where the lighting of the objects does not match.

An adequate solution to uncontrollable lighting is to light all objects with flat overall lighting. This unifies the objects when they are placed together, but flat lighting is dull and does not highlight the dimensional quality of your objects or people. Keep in mind that you can improve these images in color and contrast in a composite program like After Effects. One hint for helping to match images is to shoot your objects in a low-contrast lighting situation, where there is enough fill light in the dark areas. This way you have the important detail from the image that you can color and contrast correct after you have the whole composite image put together.

FIG 10.4 Objects that have been blended together with flat lighting.

The other important element to consider when combining images is the placement and "eyeline" of those images or figures. Once you place various images together in one frame, you want to know if they have a relationship to each other based on their visual connection and image dialog. If you had two people being animated separately and you had to put them together, would it feel like they were addressing each other? One way to gauge this relationship is to take the most difficult element or person to animate of the composite and animate it. You can then import this movie into the rotoscope function of a program like Dragon. When you animate the second element or person for the composite, the rotoscope function allows you to onionskin or ghost each frame from the initial footage to each frame of your new animation. You can see where your new object or person needs to be adjusted, so it has a relationship with the initial image or person for every frame you animate. This makes your final composite much more controllable.

One element that can help sell the composite technique is the shadow of the composited image. It is often difficult to take the shadow of an image, cut it out, and blend in with a new image. This is because the shadow is not solid, and when it is cut out, it brings with it the image of the area that it is shading, which may not blend into your new composite. One solution that many composite artists use is to create a new shadow for the cutout composite image in After Effects or Photoshop. The trick they use is to copy the layer element (of your composite image), flip it, and place it below the original object or element. Turn the copy black and lower the opacity to 20 or 30%. Then you need to transform it and angle it so it looks like it's on the ground or wherever it needs to fall naturally in the new composition.

FIG 10.5 An onionskin rotoscope image.

FIG 10.6 An onionskin comparison in Dragon Stop Motion for eyeline.

You can also take one image into Photoshop then open the second image. You have to do a rough cut out of the key element in the second image with the lasso tool and drag that element onto the first image. This gives you a quick and general idea about how the images might match in lighting and position.

Clean, Clean, Clean

To composite images together requires several steps beyond match lighting and eyeline considerations. You may choose to use visible rigs that need to be cleaned out or removed for final viewing. You may have some unwanted dirt or shadows that somehow crept into your shot. The solution absolutely essential for this kind of cleaning is called the *clean plate*. The clean plate is a shot (often two or three) of the background set or image without the figure or moving object in the foreground of the frame. This clean plate needs to maintain the same lighting and background elements that you use during the animation. It is often shot just before the animation of your figure or object begins. For safety, it is smart to shoot a second clean plate just after you finish the animation (after removing the foreground image or figure).

FIG 10.7 A shot of a clean plate next to the same composition with a foreground element.

Your support rig should have a minimum of junctions with the animated object or person. Ideally, you only want one intersection of the support rig and the animated object. This makes the cleanup go much faster. If your object is near a wall or someplace where the animated object casts a shadow, then you want to make sure that, during the shooting, the rig does not cross the shadow area of the animated object. The shadow is very difficult to replace, because the clean plate does not have the same shadow in it.

FIG 10.8 The ideal rig support placement.

FIG 10.9 Too many junctions with the rig and object, with the rig covering the object shadow.

Several different programs and techniques can be used to clean rig supports, but to get the principle across, I use Photoshop as the demonstration tool. Programs like After Effects are ideal for this kind of work, because they utilize the power of layering from Photoshop, but they do it more efficiently in a timeline. If you captured your animated scene on a flash card or in a program like Dragon, then you have all of your shots in a folder sequentially numbered. Dragon exports these images to a Quicktime movie, but you have to import the images from a flash card to a program like Final Cut or Quicktime Pro, using the image sequence option for exporting to a movie. Before you make your final movie from the scene, you have to remove those cumbersome rigs. This has to be done frame by frame. In Photoshop, you can use some shortcuts, like "batch" processing frames. In the new extended version of Photoshop, you can import Quicktimes and image sequences. A timeline in this Photoshop allows you to work on individual frames in a sequence. Ultimately, this is a slow, meticulous process and requires careful scrutiny on a frame-by-frame basis. No matter what approach you take, the goal is to place the clean plate on every animation frame that has a rig or cleanup issue as a background layer. It can be helpful to use a rig support that has a different color than your model so the delineation of the two elements is easier to distinguish. Carefully erase the rig and rig shadows of the animation frame on the top layer, revealing the clean plate behind it. These should match in placement, color, and light. I often use a small, slightly feathered eraser at the interface point of the rig and animated object being supported. It is possible to use a larger feathered eraser for the rest of the rig, because the rest of the rig is less critical in its placement.

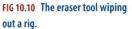

Once all your frames have been cleaned, which should include any camera dirt or burned out pixels from the image sensor, you want to re-export those new frames to a Quicktime movie. Often you do not see some of the more subtle imperfections in a shot until you see it in "running time." You may have to go back and address those problems for the particular frames that need additional work.

The Chroma Key

Chroma keying is becoming more prevalent in stop motion, because it allows an animator to work with individual components or objects separately in any shot. This often saves space and massive set building. There are many uses for chroma keying, so I asked Jeff Sias, who, along with his partner Bryan Papciak, run a small studio in Boston called Handcranked Productions, to create a chroma key exercise that explains the process.

Chroma keying is a compositing term, meaning that anything of a particular color in frame will be eliminated through the process of "keying out" that color. If shooting with a green screen, then anything green in frame will be removed and become transparent. This allows you to

(Continued)

composite your subject onto a new background. For this exercise, let us imagine that your subject is an animated flying saucer and you would like to composite it into a real-life live-action night scene.

The first thing to do when planning a chroma keying shot is to determine what color you will be using as a keyable background. The typical keying colors are pure, saturated, and evenly lit green and blue, because those are the colors least present in human skin tones. It is important to pick a screen color that is not part of your subject, so that your key will be nice and clean. For example, if the flying saucer is silver and has a blue stripe around it, you want to use a green screen background so that you don't lose the blue stripe in the keying process.

The next step is to plan the movement and animation of your subject. Remember that, once you key out the background color, your subject can be moved around the frame freely, scaled and rotated however you like. You can animate the saucer hovering and spinning in center frame, but plan to animate and scale its larger movement as part of the compositing process within After Effects.

Using a two-layer multiplane downshooter, set up the lower plane as the green screen with the saucer animating on the top glass plane. For the green screen background, use a solid tone supersaturated green card or cloth. Focus the camera lens on the saucer; you can let the background go out of focus, which will actually help the green screen key better. Think carefully about the lighting of the flying saucer and the scene it will be compositing into. In this case, the flying saucer might be lit as if with soft blue moonlight.

Once animated, you must bring the frames into your editing program as an image sequence or Quicktime movie. With After Effects, you can import either a Quicktime movie or a folder of sequentially named images. Either way, you end up with your animated saucer as a single clip, ready to key and composite. You want to import your background footage of the night sky at this point, too.

Once you set up a working sequence in After Effects, add your background footage as the bottom layer in your timeline and your saucer footage on top of that. Select the top saucer layer and go to the menu item Effects \rightarrow Keying \rightarrow Color Key. Once the Color Key effect is applied to your saucer layer, you must pick the color it will key. Click on the little eye dropper tool in the Filter window and use it to pick the green color on the saucer layer. Pick a point fairly close to the saucer's edge as this gives you the cleanest key. If you have a nice, evenly lit green screen, you should immediately see most of the green around the saucer disappear, revealing the background night sky layer below. Play with the Color Tolerance parameter until all the green is gone. If you cannot remove all the green, you can always create a simple "garbage matte" to remove the rest. The point is to get the edge of your saucer as clean as possible.

To make the composite of the saucer perfect, there are still a few more steps. First, play with the Edge Thin and Edge Feather parameters. These affect the edges of your saucer matte and clean up any jaggy lines. It is important to soften the edges of the saucer slightly so it marries into the background better. You may also want to apply a "De-spill" effect, which helps remove any green tinge or green reflections on your saucer.

Once you have a nice matte, you will likely want to apply a color correction filter to your saucer layer. In this case, you want to darken the saucer, give it more contrast, and add a dark blue or purple cast to it. This helps it feel integrated into the dark night sky. Key framing these color correction effects as the saucer "flies" through the scene further enhances the illusion.

Let us do a simple animation of the saucer flying into frame, hovering for a few seconds, and then flying off. Use your animation skills to think about how the saucer would move into frame. All you have to do is set a few key frames so the saucer starts small, zooms into the frame, hovers for a few seconds, and zooms off into the distance. All this can be achieved with only a few position and scaling key frames. Because you animated a slight hovering motion on the downshooter, you retain a nice stopmotion feel to the shot.

FIG 10.11 An example of the flying saucer on the green screen and matted onto a background, courtesy of Handcranked Productions, © 2009.

As a last note, you may want to click the motion blur button of the saucer layer. This adds a blur to the frames where your saucer is moving fast, which adds a touch of realism and really helps your saucer feel like it is integrated into the background. As you get more comfortable with the chroma-keying and compositing processes, you can try other keying filters and color effects. Keying and compositing are a whole specialty in and of itself, with many techniques and filters to try. But, understanding the basic concept and keeping your green screen evenly lit gets you great and believable results very quickly.

Massaging Frames in the Edit¹

Chapter Outline

Working the Frames	139
-	
Impossible Perfection	143
•	
File Management	144
Playback	145
Playback	145

Working the Frames

We have finally come to one of the last stages in the filmmaking process: editing. We discovered that, in animation, much of this editing is done early on in the preproduction process. The animatic, which is the moving timeline of the storyboard, should be the guide for the final edit in any animated film. We claimed that animation is so labor-intensive that overshooting scenes is not an option. So, unlike live-action filmmaking, animation has done a good bit of the postproduction decision making before the last process begins. Yet, many fine details need attention at the editing stage, and this is what we will address.

¹Opening image is one of a new digital editing laptop computer attacking an old film Moviola on the run. © Tom Gasek 2011.

Some basic principles of shooting and editing need to be examined before we get into specific frame-by-frame options for editing. When you are shooting out of sequence for a film, which is fairly common in filmmaking, it is critical to always check any already shot footage that might sit on the timeline on either end of the shot you are about to animate. You might want to shoot out of sequence because several shots have the same setup, and shooting those shots together saves a lot of production time in the setup. If you do not examine all the shots already animated on either side of your current shot, then you may miss an opportunity to match the shots for action, lighting, prop consistency, and framing. This could create a lot of trouble in the final edit. A common practice is to work with your animatic as the base edit. Each time you complete a shot, you should replace the corresponding storyboard drawing from the animatic with the final animation. This forces you to keep an eye on the bigger picture and makes sure that your cuts work together.

"If I'm playing with dialogue I have a rough measure of how long I need. I usually shoot the movements (especially the mouths) leaving lots of held frames and then adjust the timings in the editing room."

Terry Gilliam

Terry Gilliam refers to a technique common in these alternative stop-motion techniques: the manipulation of individual frames. Oftentimes, while in the middle of a shoot, you may wonder about the length of a particular hold of an object or person. It is always best to overshoot frames and remove extra frames in the edit process. In this case, Gilliam is overshooting lip-sync frames and adjusting the timing with the sound in the edit. A tendency with novice stop-motion animators is to shoot even increments of the subject, which in the end loses any dynamic in movement. With no variation in the movement from frame to frame, the movement of an object or person is robotic. This ultimately should be addressed in the shooting process, but if you change your mind about a particular movement or action, then the edit room becomes your last chance to improve things without a reshoot. You can remove frames between key positions for speed and snappy actions, and you can repeat frames to make a hold last longer, so the audience can have a brief moment to catch up. The issue with repeating frames, as mentioned earlier, is that it is best to repeat sequential hold frames to keep the movement from freezing in place. Holding a single frame is rarely desirable. Oftentimes, using a technique referred to as rock and rolling is the best way to keep hold frames alive. You would use frame 1 of a sequence, then frame 2 and frame 3, back to 2 and 1, then back up to 2 and 3, and so forth. This way any jumps in the movement can be avoided. But, like Gilliam, you want to make sure to always shoot enough frames of a hold or certain action, if you think you might extend or cut them later in the edit. Having said this about not holding single frames, I have seen some successful short pixilated films that utilize the held single frame, like the Argentinean Juan Pablo Zaramella's Hotcorn. His dramatic facial expressions and good timing works very well with the frozen held frames, and the contrast of movement

and held frames make this animated short fresh and snappy. There are very few hard and fast rules in animation, and it often takes certain creative types to break any existing "rules" to forge new and interesting ground.

FIG 11.1 Sequence of three images from *Hotcorn*, **directed by Juan Pablo Zaramella**. Courtesy of Juan Pablo Zaramella / Can Can Club, © 2011.

FIG 11.2 "Rock and rolling" frames for a hold.

One final solution to holding frames is a postproduction effects solution. If you need a hold in an unexpected area and you only have one frame to hold, then duplicating that frame in postproduction is possible. Later, in After Effects, you can add a "grain and noise" filter to that single frame. These duplicate frames with added grain do not feel quite so static and out of place in running time. But, randomly placing holds in the edit process often does not work, because when the movement begins again, there probably will be no ease-in of the action in the next frame, so the animation will jump. You must examine your sequence and plan carefully when you add holds.

Jeff Sias, from Handcranked Productions, describes another way to deal with making your animation more dynamic in the editing process:

"Editing programs also have the ability to 'ramp' speeds and have variable time changes with an editing graph. This will allow you to really tweak a particular motion if necessary. Also related to this is the idea of 'frame blending,' as in, if you stretch a shot out in time, you can have the program try to create new in-between frames, either by blending frames together or by tracking pixels and actually creating brand new frames. The latter option can create strange and undesirable digital artifacts, but it works well on normal and slow moving objects if you only lengthen the shot by 200–300% or less."

Here is an exercise to give you an idea of the ability you have in the edit to improve your timing in an animated action in a frame-by-frame film. The one important element that you must consider when using this technique is what else is happening in the background of the shot you are frame manipulating. When you pull frames to add dynamic to a foreground object or person, how does the elimination of those frames affect the background or secondary action in the overall animation composition? Complexity in the overall composition with multiple objects or people may prevent you from pulling and adding frames in the editing process.

Chapter 8 has an exercise where you animate a person along a wall frame by frame with eases for approximately 1 second of animation. There are still holds at the head and tail of the shot. You need to create this footage if you have not already shot it. The playback rate is 30 fps. Create an image sequence from these shots and convert it into a Quicktime movie in Quicktime Pro. As mentioned before, Quicktime Pro is an extremely helpful investment. You can also import this footage into an editing program, like Final Cut or Adobe Premiere. You can do this by either creating a Quicktime movie of the footage or importing the individual frames from a folder after setting the "still/freeze duration" to 00:00:00:01 under Editing in the User Preferences area of Final Cut.

Once you have the frames on the timeline, use the filmstrip mode so you can see the individual frames. Then enlarge the timeline, so you can clearly see each frame. In the original exercise, there was a 15-frame hold at the head. I want you to go eight frames into that hold and "rock and roll" frames 9, 10, and 11 three times (i.e., frames 8, 9, 10, 11, 10, 9, 10, 11, 10, 9, 10, 11, 10, 9, 10, 11, 10, 9, 10, 11, 12). Once you have completed this, move into the movement frames. You have 15 forward movements, including eases shot on "twos." Move into those frames and remove the two frames from the fourth movement forward, the sixth movement forward, the eighth movement forward, the ninth movement forward, the eleventh movement forward, and finally the thirteenth movement forward. Remember that you need to remove two frames for each of these movements, because you shot on "twos." Finally, make sure you remove any unwanted gaps between frames by right-clicking on the gap in Final Cut. Once you have completed this, render the footage and export it as a Quicktime movie.

When you compare the two Quicktime movies (the original and edited footage), you will see the effect of the rock and roll hold extension and the ability to change the animation dynamically in editing. This type of edit manipulation goes all the way back to the Cinemagician, Georges Melies.

Impossible Perfection

There is no perfect solution to any one film. Rather, the imperfection gives each piece its unique character, yet we, as artists, have a tendency to keep refining our artistic expression until we run out of time. Each film is a learning experience, even for the more advanced filmmaker, and it is important to take the lessons of each film, close the book on the old film, and move on. This liberating approach allows you to continue to grow and experiment, and that is the essence of this kind of filmmaking. Having said this, you can do much more to refine each filmic experience in the edit.

If you have been shooting with a dslr still camera, the chances are that your images are large enough to scale up in size without losing resolution, even for high definition playback. This means that you can simulate simple camera moves in postproduction either in After Effects or a similar program or in Final Cut. I prefer actual camera moves to simulated moves, because real camera moves give you a genuine perspective change in the image that the postproduction move does not. The postproduction move just moves across the surface of the image, it does not penetrate it like a real camera move. Sometimes, a postproduction simulated move can be effective; for example, if you want a handheld camera feel or are shooting flat images like photographs and you want to push in (and there would be no perspective change anyway), or if you just want to keep a scene alive with a subtle track. A digital move can augment a real physical move but generally postproduction moves done in these programs are effective if they are extreme or subtle but less successful in the ground between.

Mixing live-action elements with single-frame footage takes a lot of planning. We covered match lighting and object/person interaction in the previous chapter, but another element of this kind of composite work is adjusting the colors to match. If your white balance option was not set correctly in the shooting stage, then the edit is the time to correct this oversight. Thinking about an interesting color palette or plan is important in the planning stage, but it is the postproduction work that fine-tunes the differences that may occur in shooting. The bottom line is that you need to have good footage to begin with but there is some latitude in color correction whether you do it in Final Cut Pro, Photoshop, or After Effects. It is best to identify one establishing shot and color correct that shot to the best of your ability. All of the following shots should be matched to that default color-corrected master scene. There is the possibility of changing the overall color palette in the postproduction process, but usually, this should have been explored in the preproduction stage. Your attitude and ideas evolve during a film's development, so allowing yourself a chance to play with the colors in color correction is worth the time. You might change the image to black and white or a sepia tone; or shift the contrast, saturation, brightness, or color scheme; or add filters to view your film in another perspective. Keep track of all the changes and their corresponding filter measurements, so you can duplicate a look you discovered and want to apply to other parts of your film. You can accomplish this by saving your filters and effects settings as "presets." This allows you to reapply the same exact effect to any shot at any time.

File Management

Another important practice that needs to be sorted out in the preproduction stage is the naming convention for all your files. If you establish a good filenaming system and stick with it, then the editing and postproduction work become much more manageable. You can do this in several ways; here is a system I used on my most recent film, *Off-Line*.

```
Title abbreviation = OL
Scene = sc
Take = t
Frame number = f
Effects = e
Final frames = F
```

You must consider the full range of scenes in your film and the maximum amount of frames in any scene; that number, in the tens or hundreds, has to be carried out throughout.

"OLsc09t1f055eF"

This would be a final frame with effects. None of my shots had more the 999 frames in them, and my film had 99 scenes or fewer. This may seem

like a long naming convention, but you can easily identify any frame in or out of place at any time.

There might be several drafts of effects that you apply to your frames, and you might have to consider temporarily adjusting your naming convention to give you an idea where you are in the effects process. For example, if you have color corrected and cleaned out some rigs but have not composited additional images on your frames, then you might put a d after the e in your naming convention. The d would represent a certain "draft" or pass of the effects, so you could write " ... ed1" at the end and leave that in the overall effects folder until you finish the effects of those frames. When you complete the effects, just label the frame " ... e," and perhaps it will be finished at that point, so you can complete the naming convention with an F at the end. The important thing to remember is that you need to set up this naming convention early and keep it consistent for you and any crew working with you. Once again, Jeff Sias weighs in about naming conventions. "It is important for After Effects to 'see' a complete image sequence. If there are any missing numbers in the sequence, AE will assume that the frame is missing and replace it with a warning frame. You can also use a utility program like Automator (on the Mac) to batch rename the files in a sequence. Adobe Bridge also does a good job of batch renaming, but Automator is faster."

Playback

We touched on frame rates when we explored pixilation. It is always best to decide and commit to a frame rate when you animate your material. There are so many things to consider with your playback rate, like how fluid do you want your animation; how much time you have to shoot or animate; and how much finesse and control do you need in the movement of your object, person, or image? I like to shoot 2 frames per move at a playback rate of 30 frames per second. I can also take one picture per movement and have a playback rate of 15 frames per second. It is possible to slow down or speed up playback rates in editing programs like Final Cut Pro but I do not recommend speeding up or slowing down a shot more than 15%, especially slowing down a shot. It often does not look as good and the animation can have a more staccato look, which can be distracting. It is worth experimenting with frame rates to establish the playback pace and feeling that you want. Keep in mind that After Effects can process your frames with "frame blending," which essentially creates in-between frames when you slow down your footage. This can make a big difference in the playback.

One old trick that many filmmakers use effectively is playing footage backwards. It can have a very interesting effect. Images or objects can appear to assemble themselves or perform unnatural movements. If you follow the normal laws of physics like recoil, inertia, and momentum with the idea of playing a scene backwards, then you will have a very successful effect. Another reason for a reverse playback would be if you are animating to a final position or graphic that would very difficult to achieve animating frame by frame forward. In this case, you shoot the final frame in its predetermined and finessed position, then you take it apart frame by frame, then reverse the playback.

FIG 11.3 An animated image that needs art direction and could be animated backwards.

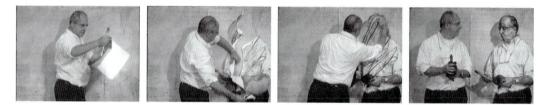

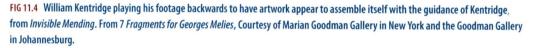

A habit to consider when shooting any animation that will help in the editing process is shooting "handles." This basically means that you should shoot an extra 5 to 10 frames at the head and tail of each shot, even though you might have a very closely timed animatic. These extra frames provide more options on the actual cut point and give you more footage if you have to vary the speed of your playback.

One issue that arises from different sources is flicker or fluctuation in the overall animated image during playback. We discovered in Chapter 5, about cinematography, that small variations in the iris of certain lenses or variations in the power source that powers your lights could cause these minor exposure fluctuations. There are some solutions to this flicker effect. These postproduction solutions do not resolve overall fluctuations due to moving shadows and shifting light sources but even out overall image variation. It is always best to first use appropriate lenses and filtered power if you want a nice even exposure on all your shots, but if you do not get it, then it is time to

turn to a program like After Effects. If you open up Effects \rightarrow Color Correction \rightarrow Color Stabilizer and look for the Set Frame button in the Attributes area, then you can establish the color reference frame. You can set the reference frame through brightness adjustment, levels, or curves. You may have to set a new reference frame, depending on the activity in the frame or if there is a camera move. Breaking up the shot into multiple sections and reassembling the sections can solve any difficulties of having to set a new reference frame. This is not a perfect solution but can help. More effective After Effects plug-ins do the job, but they are more expensive as solutions to overall image flutter. Filters and names change with each upgrade so I advise searching "flicker" or "fluctuation" in the Help or Search menu of any forum or program that deals with these kinds of issues.

FIGE 11.5 The Color Stabilizer menu in After Effects.

Editing is an important and deep art form in the filmmaking process. Many books are written on the subject, including Michael Ondaatje's *The Conversations: Walter Murch and the Art of Editing Film*, Murch's *In The Blink of an Eye*, and *On Film Editing* by Edward Dmytyrk. Animation is one form of filmmaking, and it should be treated in a manner similar to live-action editing when it comes to cutting pace and flow. Using techniques like "cutting on the action," dissolves for a passage of time, "jump cutting" for a jarring effect, and dynamic pacing in the overall cut are critical to all filmmaking, even frame-byframe animation.

CHAPTER 12

Exposure to the Market¹

Chapter Outline

Now What?	
Record and Archive the Process	
Websites and the Internet	
Film Festivals	
Ownership	
A Few Thoughts	

"The resources I use to implement my plan are determined by the subject. Never vice versa.

I would advise young filmmakers that they not copy or follow anyone but go their own way ..."

Jan Svankmajer

¹Opening image is a portrait of Jan Svankmajer, © Athanor Ltd. Film Production Company, Jaromir Kallista, and Jan Svankmajer 2010. Courtesy of Jan Svankmajer.

Now What?

Once your project is complete, you will mostly likely want to share it with others and let the film develop a life of its own. It is rare to sit back and let the film capture its own audience. You have to promote it and expose it, then the snowball can start to roll. If you had a particular audience in mind when you created your film idea, then that starts to focus your postproduction marketing. There are many venues these days and lots of competition for those venues, so it is important to be more targeted about where you want your film to flourish. Many filmmakers are more than happy to immediately post their original work to the web. The exposure they get on the web can be far better than any other approach. Film festivals are another means of exposure. They are not always easy to get into, and they often have application fees. European festivals tend not to have fees, but festivals in the United States usually have fees. They can elevate the perception of your film, because they are juried. Taking this route requires some research and good choices. Commissioned work already has its audience and special requirements, but there can be some wonderful creativity and freedom in this form. This might include commercials, informational and educational formats, or even music videos. Finally, some filmmakers are creating and producing strictly for themselves, often in an experimental mode; and they may not care if many people see these experiments. Since they are filmmakers, I imagine that they do want an audience, but it may be in a more untraditional film venue, like a gallery, a nightclub, or an exclusive screening at an event.

The bottom line is that you do whatever you can to help your film find an audience, and sometimes, that approach takes unexpected turns and directions. Several of the artists I cited in this book made the comments that follow:

"The BBC brought Monty Python to the world—we never thought of an intended audience—and I tagged along. Now we just market recycled Python. People still buy."

Terry Gilliam

"Mostly, when I create a short or an independent work I'm not trying to market it. I make it because I want to or I want to share a story or a feeling. Or honestly, I often want to try a new technique or am bored and want to create."

Lindsay Berkebile

"We choose a song that we like and inspires us with visual ideas or a story. We believe that if you do something that you like, other people will like it, too. Then, the profitable work will come."

Yuval Nathan

"The films are sold through art galleries, and are seen primarily in art exhibitions. They are almost never shown on TV, and very occasionally in film festivals. Mostly, they are shown in art galleries or museums."

William Kentridge

"My films reached an audience of people like me and my friends, probably in an educational setting or via TV broadcast. The beauty of the National Film Board is that it doesn't aim for a mass market though it does have a responsibility to the Canadian taxpayers who fund it."

Carolyn Leaf

"We don't really put a lot of energy into marketing our work. We believe, if we create something of value, the audience will spread it for us. On the flip side, if we don't create something of value, it will die a silent death online. Even though we try really hard, we recognize that not everything we produce will be brilliant. The audience is the best judge of what works and our goal is just to help them share some laughs."

Evan Spiridellis

Record and Archive the Process

It has become more critical these days to document each frame-by-frame project you produce. Even for short experiments, documentation can be very helpful as a record or notebook of the details of each experience. There are many very good reasons to record your process. I find when I am in the heat of a shoot I really do not want to break to take pictures of what I am doing, but it is important to include this activity in your preproduction schedule. If you ever publish your work on a DVD or website, then including some documentation of the process adds depth and interest to your film project. We are visually centered as a culture, and there is a lot of sophistication in our understanding of films. Audiences often have as much interest in the process as they do the final film. Many young filmmakers are keeping blogs that record their progress on a frame-by-frame production. This allows people who might be vested in their project through fund raising programs like Kickstarter to follow the progress of the film and stay involved. It builds a great relationship between the investor and production group. Often, opportunities arise for viewers to comment on the production progress, giving filmmakers a larger perspective on their creation. These blogs should be updated on a regular basis with photographs, short animated clips, and written notes, potentially with an opportunity for feedback.

The other advantage of documenting your work is having a deeper and fuller understanding of your own work process. This is a valuable resource for you when it comes to explaining to others how you work. You may have to educate a potential client on the process of your work before a commission is seriously considered. It also can guide you in making a bid for a job that utilizes a similar technique. The more you understand how you work and what process you need to complete that work, the more you can reasonably make a bid for a job that has a certain budget and schedule. You may have to hire help to produce a commissioned work, and you need to be smart about how long you need that help. If you know how long a particular process takes, like drawing out a storyboard, then you know how long you need a storyboard artist and you can multiply that number by the pay rate you offer the storyboard artist. In your documentation of each film, you should not only consider the visual recording process, like stills and video, but keep a notebook with brief notes about where to get certain materials, locations and events that may occur during your shoot, how long you estimated for an event, and how long it actually took. This information and visual record keeping can be a wonderful way to present your independent film work at festivals, lectures, and tours.

Websites and the Internet

Sites like YouTube and Vimeo host most films free of charge, but it is important to understand the rules of how they work. Once you put something on the net it virtually becomes public property. I do not mean this literally. You still own the copyright of your film, although some sites may have some ownership claim as long as you are using their services. Always read the rules of any service that you utilize. The other option is to pay for a service that hosts your particular website, and you can post your own work on your site. Films can be downloadable or not. You make the choice. I have a personal website that hosts my main pages and small commercial clips of animation. Some pages have links to noncommercial work on Vimeo, and I have a link to a free blog service, so I can interact with my site on a regular basis. There are all sorts of combinations, and you have to find something that suits your needs and ability.

Short films have few revenue-making venues, but this does not stop independent animators from producing. If you are interested in making money on your work, then you need to invest in yourself by producing original work that becomes a calling card for your particular services. Once you get your work out into the world (and the Net is great for that kind of low-cost exposure), people see your work and may approach you with commissioned work (that is often similar to the original work that you posted on the Net). It is the offshoots of your original work that make the money, and the original work serves as an promotional investment. Some artists feel that posting their work online (especially on their own sites) fosters an interest in viewers to own a "hard copy" of your film, so DVDs are sold through fee services like PayPal, which can be linked to your site. If you really want the world to see your work, then it helps to have short, clever, and inexpensive ideas that you are willing to produce with little or no payback. Opportunities can arise for exclusive showings of your work for a fee to you, but usually this does not happen when your work is on the web. This is why filmmakers try to get into festivals before posting work on the web. The exposure is limited at these festivals, so showing your film at more festivals or broadcast venues becomes more attractive for distributors.

Film Festivals

The film festival is the traditional way to get your animated film out into the world. You not only show your film at these festivals but you meet people from around the world with similar interests and different approaches to their filmmaking. Both experienced and novice animators and fans attend these festivals, and these people are generally pretty accessible for conversations. Seeing what other filmmakers are producing can be very inspiring. Exchanging ideas with people who are driven to make animated films, with all the struggle related to that, can help your morale when you feel defeated by the big commitment that frame-by-frame filmmaking can be. Sometimes this is where you find commissioned work or even potential distribution of your film.

A lot is involved in this process, and it takes constant research and followthrough. Fortunately, many new tools and websites help make this process much more efficient and easy to navigate. In my experience, one of the most widely accepted sites is Withoutabox. Hundreds of festivals, primarily in the United States but also around the world, accept film submissions through this site. You basically fill out one thorough application form that accompanies every entry submission to any festival in the world. You can even upload your film to this site for festival jury viewing (for a small fee), so that you save lots of time and money. These festivals look at the Withoutabox site generic application and view your online viewing copy of the film through this site. You have the option of sending a screening copy to the festivals directly, even though you have submitted your application through Withoutabox. You are given a reference number,

so the screening copy can be matched to the application when it arrives at the festival. There are other such sites, and our corresponding website lists some of these sites.

The world's largest independent film community

For Filmmakers & Screenwriters

A worldwide audience for your films

- Discover more than 5,000 festivals across six continents
- --- Securely submit films, forms, & fees online to 850 festivals
- Promote your films to over 57 Million fans on IMDb
- --- Upload screenplays, trailers, clips, posters, & photos
- Get the latest on fests, competitions, & exhibition opps
- Self-distribute on DVD, VOD, & streaming video

Start a Free Filmmaker Account >

Filmmaker Frequently Asked Questions

For Film Festivals & Screenplay Competitions

An innovative online submissions system

- ---- Market to 300 000 filmmakers & writers in 200 countries
- Streamline your season with paperless apps & press kits
- --- Search submissions by genre, category, runtime, & more
- --- View DVDs and/or Secure Online Screener submissions
- --- Become IMDb-qualifying to grant legit films a title page
- --- Accept entry fees in one of five currencies, or not at all

Learn More About Becoming a Withoutabox Festival >

Festival Frequently Asked Questions

FIG 12.1 The Withoutabox

home page.

Choosing the appropriate festivals is very important. Most festivals require that you not have your film online if they show it at their festival. This makes their festival appear more exclusive and interesting to attend. For this reason, many filmmakers do not put their complete film (only teaser clips) online until at least one full cycle of festivals has run its course, which is usually about a year. Your best chance of getting into a festival is when you choose to premiere your film at that festival, so it is important to make the right choice. Many frame-by-frame stop-motion productions fall into a few categories, like animation, narrative, experimental, or music video, but do not limit your festival choices to animation festivals. Many festivals have themes and agendas, like "films and technology" or "American documentaries," or "new directors," so it is important to read about these festivals before you enter. Withoutabox puts you on their mailing list once you join up, and you can research these festivals through the site's steady updates. It might be important to submit to a festival that is near where you live, so you can attend the festival; or you might consider a local regional festival, which is to your advantage. Most festivals do not pay your expenses getting to the festival, even when you are a potential winner. They usually give you a free pass but often that is as far as it goes. There are some exceptions, and this is why it is important to do your research. Big festivals, like Sundance, South by Southwest (SXSW), Annecy, and many of the urban international festivals are a good place to try to premiere your film, because other festival programmers go to these festivals and they may see your film and ask you later to submit to their festival (often waiving entry fees).

Getting into a festival means that some experienced and seasoned filmmakers and people associated with the business have chosen your film over dozens and often hundreds or thousands of other films to show at the festival. The juries at the larger festivals have a fair amount of credibility, so that gives your film a thumbs-up as it enters the public arena. Just getting into a festival in today's competitive atmosphere is a great accomplishment. If you do not get in a particular festival, it does not necessarily reflect badly on your film. The competition is very high, since filmmaking is so much more accessible than it used to be; and often your film may not fit the theme, agenda, or style of film that a particular jury is seeking. Keep trying to find a festival venue for your film by starting high and working your way down into the lesser-known festivals. The fees associated with entering a festival can start to drain your account so start and enter early to save money, and consider calling the festival directly if you are broke and ask for an entry fee waiver. You might just get it.

You should not expect to make any money on your short film, but it might get you some recognition that can be translated into revenue in the form of a commission. Some people get lucky and are approached by film distributors and director representatives. There are many possibilities, and if you are approached, remember that it is best to get the information offered and not make any fast decisions. If one distributor approaches you, then most likely more will come. The deals offered range from exclusive screenings on television for a period of time in certain markets to offers to be part of a collection of animated shorts screened and distributed internationally. Numerous opportunities on the web offer some revenue. Remember that you can market and sell your own films, but revenue may be limited by the lack of exposure that some of these commercial opportunities can offer. People involved in promotion and distribution are constantly scanning the web at sites like YouTube and Vimeo looking for new talent. If your short is posted on a site that has a built-in audience and your animated short receives thousands of "hits" or viewings, then you can be sure that your film is being seen by people who may be able to offer you opportunities to make some money. I must say, more unfruitful opportunities appear through this route than really great offers, but you can weigh those out as they come in. People can contact you through sites like Vimeo, so you are sure to see some action.

Ownership

The current copyright laws protect any filmmaker the moment he or she creates and produces any film. It is required that you "publish" your work or just have some way to prove when you produced this film. It is important to print your name with the copyright (©)next to it and the year you completed the film as your final frame.

FIG 12.2 An example of the copyright statement that should be at the end of every film.

This is also true for the preproduction script, drawings, and layouts. Since some sites have restrictions about ownership when you post on them, it might be best to post your film work on your own site, so there is no misunderstanding. You also have other options with this kind of posting. Some filmmakers utilize the "creative commons" option, which allows others to use their work under very specific conditions but for no fee. These conditions might include educational or noncommercial venues that allow their work to be exposed to a greater audience and with the possibility for the work to become part of a larger communal production.

If you feel that you want "rock solid" protection, then you might think of registering your images, script, and branding with the U.S. Copyright Office. This can be done online by visiting the office's site at www.copyright.gov. You can find out everything you need to know about ownership and protection of your creative products on this government site. Legislation seems to hit Congress every so often, called the orphan works, that threatens the protection of all creative ideas and output in a tangible medium like photography and other visual mediums. The advantage to this legislation is that it offers producers access to use artistic tangible mediums that appear to have no copyright holders, like old photographs, recordings, and images. The danger is that this legislation can be applied to more contemporary work that appears to have no copyright owner, mostly because many of these images and tangible mediums have no author/artist identification associated with them. With the advent of the web and the proliferation of images and ideas, this legislation could move down a slippery path to exploitation of ideas and images by producers that do not make intensive efforts to identify and notify authors of the use of their creative work by others. The Library of Congress wants to move the burden of finding authors to private databases in the area of the artwork, which starts to lose the regulation of a central authority. It will be interesting to see where this legislation goes, and it is worth watching. This will affect both national and international use of images and ideas and is a difficult issue to easily resolve.

A Few Thoughts

This book is intended for both the novice and more experienced filmmaker, but I want to address the beginners in these alternative stop-motion techniques. It is important in the early stages of making these kinds of films to keep things fresh and not overly controlled. Each film should be treated like a sketch and not a masterpiece that reflects high craft. Allow yourself to make mistakes and take risks. Although I have cited some specific approaches to these techniques, as I have mentioned, there really are no hard and fast rules. Keep your ideas simple and manageable, so you can accomplish them. Shoot for small goals within your reach. Do not overcomplicate your idea. The process automatically gets complicated with all the problem solving you encounter, so keeping your idea simple works in your favor.

If you are interested in learning more about how stop-motion studios and artists operate, then consider making some short experiments, put together a reel of your best work and start researching who is making these kinds of films and making a living or even just getting publicity for these kinds of productions. The Internet is a wonderful research tool, especially if you follow sites like awn.com and cartoonbrew.com to see what is going on in the industry. Contact these people and ask if you can show your work and get some feedback from them. The issue of internships might enter the conversation but just getting a little of these artists' time and seeing how they operate is worth the effort. You will find that many of these artists are just driven to produce and make these experimental film shorts. Many times, not much money is involved. That displays the passion necessary to work in this area. If you are fortunate enough to get some commissioned work, like a commercial or a short informational film, consider it an opportunity to experiment and push the bounds within reason. Your client wants to know what you will produce, but there should still be a chance to step out a bit and try something fresh and new.

These techniques open up a wide range of possibilities for established and potential new filmmakers. As I mentioned in the Introduction, the moving image is becoming more and more accessible to a larger pool of producers. Live-action filmmakers want to stylize their films, and this is one way that is not totally foreign to them, since the use of photography, lighting, and performance are involved in both approaches. You really don't need to know how to draw or sculpt well, but you do have to have good ideas and some skills, and these frame-by-frame techniques are a great way to add something new and different to live action. This is also true for photographers who are now using dslr still cameras that have the capability to shoot high-definition video. These photographers want to know how to take advantage of these camera assets. I tried to incorporate a few basic animation techniques in these chapters as well as describe what frame-by-frame artists are now producing, without getting too technical. The associated website has many of the technical hints and approaches, which are always changing with technology, but the fundamentals are described in these chapters.

If you start to think about the infinite combinations and possibilities in this area, you can get overwhelmed. Just about anything can be animated to serve an idea. Some things are easier to animate and control than others, and keeping this in mind when you choose an object or person helps determine the result you get. It is important to apply tried and true animation techniques to your movement to elicit a dynamic result. Pixilation that has some snap and punch is more interesting to watch than evenly paced movement. Time-lapse photography that is dynamic in composition and has dynamic transformation can be fascinating. You must understand the subject before you commit it to film. This way, you get the best angle, understand the best part of an event to record, and can be prepared for the change that occurs in front of the camera. Downshooting or using a multiplane animation stand can be a rich art form when used with cutouts, sand, three-dimensional objects, or an infinite range of material. The ability to shoot in a "down and dirty" approach, which can be fast and fresh looking, is really appealing to some filmmakers. This art form also has the ability to be subtle and refined with its multilayered look. It has the advantage of the photographic approach and look, and objects generally need not fight gravity, the eternal bane of stop-motion animators. I hope you consider playing with these techniques. They can be fairly fast to produce

and very satisfying in their results. These techniques can be a sketchbook approach to animation or a refined and beautiful expression of art. Enjoy these techniques and have fun, because that shows in your work. I leave you with a few more statements and advice from some of the filmmakers that we cited throughout the previous chapters. Shoot on.

"If I have any guiding principle regarding the stop-frame process, it's to try and accommodate or embrace any spontaneous ideas that might present themselves during the animation. Stop frame is generally a long, slow process, and unless one is unduly preoccupied with the more laborious requirements of a shot, additional and peripheral ideas are always going to occur."

Dave Borthwick

"Focus on what you have that makes your work unique."

Yuval Nathan

"Start filming immediately. Understand that every part of the work is a self-portrait. This can be either dispiriting or reassuring."

William Kentridge

"My approach to time-lapse is very organic. I don't overthink or overplan my shots. I go 90% by instinct; the other 10% is just making sure the logistics are in place to support the first 90%. The subjects of my timelapse sequences also appeal to me greatly—outdoor and astronomy subjects, which bring me to the most spectacular and inspiring natural locations I can find. For me, this beats sitting in a studio ten hours a day." Tom Lowe

"Embrace the tech, but remember the basics of image making. Technology is the means, not the end!"

Eric Hanson

"I gave up cutout animation because it is easier to achieve emotions with live action filming and I don't have the patience to do beautiful full animation. The fact is, I always wanted to be film director ... animation was an interesting detour."

Terry Gilliam

"Play around with the material and see what kind of images you can make and move. Don't expect the kind of control you can get from computer imagery. Make images that please you to look at, and you will find that you have the patience to move them."

Carolyn Leaf

"Finally, I understood that, like Bob Dylan said, sometime, someplace, 'to live outside the law, you must be honest.' By this, I mean that I intended, finding myself suddenly in this big, intimidating, and typically controlling industry, to continue to 'live outside the law.' I wanted to make the videos my way and to be trusted to look out for the interests that had been entrusted in us and to repay that trust in spades, to 'be honest'—to deliver something more valuable than anyone could have anticipated, including us—not to mention, on schedule at every juncture and on budget."

Jim Blashfield

"Life is too short to make a film that takes two years being unhappy with the result. I'm getting older, I do not have dreams of success, only dreams of films. Sometimes, you miss your goal, but you did your best. That's something I can accept. Don't start a project knowing you are going to get a bad picture."

Jan Kounen

"I like to stay grounded and come from a base of balance and spaciousness when I am working. I have a cozy studio in an old warehouse near the Willamette River. I love my work and I am excited to get to the studio every morning."

Joanna Priestly

"The best advice I could give would be to try *everything*. There is no right or wrong way to do this stuff. People should read and take in whatever advice and information they can find but ultimately they should distill it all and find their own way to do it. The only other advice I could give would be to work your a\$\$ off! If you don't absolutely love this stuff, you are better off finding another career. Look for something that you love so much you can't stop talking, thinking, and dreaming about it. My guess is if you are reading this book you are probably passionate enough to give it a run!"

Evan Spiradellis

Exercise 1 The Traveling Head

Here is an exercise that can be a lot of fun but requires some careful frame-to-frame registration. You need a computer with a program like Dragon on it to work through this exercise. You also need either a digital video camera that feeds into the computer with Dragon or a dslr still camera. The best kind of lens to use is something that is wider than 50 mm. A tripod is critical. You further need one human subject who is patient and has a fair amount of stamina. You can shoot indoors, but this exercise is much more successful if done outdoors in a variety of environments. If you do shoot outdoors, then it would be best to choose an evenly lit day, like an all sunny day or an evenly overcast day, to help reduce an overactive frame due to strong light variations. Shooting "in the field" has its challenges, and the first challenge you encounter will be your computer. A laptop computer on battery power serves this approach. You can execute this exercise without a computer and just a capture card or flash card in your camera, but the results will not be as tightly controlled. This exercise helps demonstrate the contrast required in a pixilated film for it to be viewable and not overly active. The human subject is the constant and the background changes radically throughout.

The idea of this film is to frame-by-frame focus on your human subject in a head and shoulders composition with enough room in the frame around the subject to reveal the environment that your subject is in. The head and shoulders of your subject travel through different environments as though they are floating through space. The subject can and should react to the different people and situations past which he or she travels creating fun expressions and actions.

EXERCISE FIG 1.A A human subject lined up head and shoulders in front of an environment.

Your human subject should stand at a determined distance from the camera, which is mounted on the tripod directly in front of the human with the lens at the eye level to the human. It would be helpful to have a measuring implement like a ruler to help keep the distance between the lens and the human subject consistent frame to frame.

You are going to travel with your camera and human subject from one location to a second location. You might have the human start from the front door of the house out to the mailbox, all the way around the block, or from one side of the city to another. The distance is up to you. The greater the distance, the more interesting the film can be. If you are traveling long distances, then you could actually use a car to get from one frame position to the next. The key element and critical aspect to watch is the consistent relationship of the camera to the human subject. This is where having a computer with frame-to-frame comparison capability can be very helpful. Holding a laptop and controlling the camera and human placement can be a lot for one person to handle, so you might consider having an assistant who can hold your laptop like a portable table. If you cannot find some help then you might not be able to support all those elements, and as a result, you might have to judge the placement of your human subject by other means. For example, you can turn on the internal grid in the camera's viewfinder. Another simple means of reference can be to use a string or measuring device to constantly gauge the distance between the subject and the camera. I used a 24 mm lens on my camera and the subject stood exactly an arm's length from the camera, so he put out his arm every frame to keep his distance constant and I centered him up with the viewfinder grid. Your registration and human placement might not be as tight as it would be if you were comparing each new frame with the previous frame for placement with Dragon. If you have a laptop and Dragon, then you might consider using the "onionskin" option for the most effective human subject placement and registration. I find that shooting one frame per move elicits the best results at 30 fps but you can try 15 fps. If you shoot your composition a little wider, then you can push in on your frames in postproduction using After Effects, and you can use the tracking or stabilization feature to line up the eyes frame to frame for a more rock solid registration.

EXERCISE FIG 1.B A drawing of the subject defining the camera/subject constant relationship (the length of his arm).

The distance from one position to the next, once you get past the ease-ins, is determined by how fast you want your subject to travel and how rapidly you want your backgrounds to change. Naturally, the bigger the position change (i.e., 10 feet), the more rapidly your character travels. Bigger moves are very effective outside, because you have large environments. But I recommend that you move your subject about 3 feet. This works well for going from the house to the mailbox or even around the block, but the longer the distance, the longer your film is based on a 3-foot move per frame. If the background changes too radically frame to frame, then you might start to lose the effect of forward movement. It is most effective if the background displaces itself at an even rate, so we see background elements diminishing in the frame, indicating that we are moving past them.

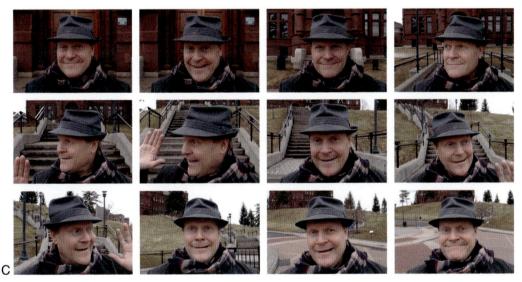

EXERCISE FIG 1.C A series of frames showing how the background changes.

So, you start with your human subject lined up in front of the camera in a still position. I find that it adds a lot to the film if you try to give your human subject some expression of thought or, perhaps, determination. Remember that you have to break down these expressions bit by bit, and the extreme or "key" expression should be strong and slightly exaggerated. Your human subject also needs to be able to hold that expression for long periods of time. Be aware of what the eyes are doing. You can begin by just slightly moving your camera on the tripod backwards by about an inch. Move up your human subject to the camera that same inch distance so the relationship of the camera position and human is always consistent. This is the first ease-in movement of your journey.

Remember to ease out your final movements when your human subject comes to rest or is at the end of the journey. I also want to remind you to think about controlled animated movements that the human subject might display, like looking left and right frame to frame, smiling, maybe waving a hand, or some other expression that might relate directly to the journey be traveled.

The final note I want to relay is that there are endless variations on this exercise. If you refer to Mike Jittlov's Wizard of Speed and Time, you will see a wonderful film partly based on this concept and done in a very inventive way. One more element can be added for a more advanced production: the element of blur. If you can find or build a moving unit (it could be the back of a pickup truck—use extreme caution working in the back of a truck—or a dolly or some sort of rolling platform) that could hold you, your camera/ tripod setup and laptop and your human subject, then you can get the blur you need. Your camera and human subject always are lined up with the proper distance to each other on the moving platform, so you need not constantly monitor that relationship, and you can move them both together by moving the moving platform. To get blur, which might be very effective if your character is supposed to be racing through an environment, you need a longer shutter exposure like 1 second. This may require that you stop down the camera lens to f-22 if you are shooting outside. You can also use ND (neutral density) filters to knock down the exposure. Someone else must concentrate on moving the platform with you and your subject on it as you shoot the camera. You can adjust your human subject; and on a coordinated count, you need to move your platform and simultaneously shoot the camera shutter at 1 second. Your subject stays in focus because he or she moves exactly the same distance and way the camera moves (since they are on the platform together), but the background blurs because the relationship of the camera and background shifts during the 1-second exposure. This takes some practice and careful control, but it can be very effective. It is even more important to give some life to your character with this effect, so it feels like the subject is active and full of energy while racing through the scene.

If you want to shoot a night scene, you can use a flash-pop or a quick on-and-off light on your subject, while keeping your shutter open for a longer period of time, so any moving background elements can blur. This would take a little testing to get the right exposures but could elicit some really exciting results.

Exercise 2 Rotating Human Subjects

This exercise is best when you have the availability of many people, and it can be used as a workshop or class event. You need a single-frame camera, like a digital video camera or a dslr still camera with a 35 mm lens. A tripod is absolutely essential to mount your camera on. It is also important to tape down and bag your camera and tripod, because your human subjects may get close to the camera and bump the tripod, ruining your shoot. There are all sorts of variations on this concept, but I run through one approach and you can take the idea and expand on it. Once again, having a computer near and connected to your camera that is equipped with a capture software program like Dragon makes a huge difference in the success of this exercise. You will frame reference the position of one human subject to the next, so having the onionskin capability allows you to be fairly close in your registration from one person to the next. When I practice this exercise, I also use a projector that is connected to my computer, so that the image and frame I am working on can be viewed by all the other participants in the exercise. This basically means that this exercise should be shot in an interior space protected from the elements and with a steady light source. As I mentioned earlier, you may expand on this idea and take a variation of this exercise outside to see what results you get there.

Here is the setup. Put a chair in the middle of an open interior space and tape down the chair to the hard floor so it is stable. Do not shoot on a soft surface like a carpet. Put your tripod directly in front of the chair with the camera facing the chair. Set the height of the camera at the eye level of someone who might be average height sitting in the chair. Frame it up so that the person in the chair can be seen as only a "head and shoulders" shot. It is helpful to have a table behind the camera, so you can place and operate the computer; the table might also serve as a platform for your projector (if you have one). Your projector projects on the wall behind the camera so the person in the chair sees what is being filmed while looking straight ahead. This is important, so the person in the chair can see where he or she lines up in the frame in relation to the person who was sitting in the chair the frame before.

The number of people involved can be anywhere from 2 to 12. The larger the number, the more interesting the result can be. Let us say you have 12 people. Line up five standing people starting on the right and left sides of the chair. They should start just behind the chair with the rest of the people lined up in a

row. The 11th person sits on the desk with the computer, operates the camera, and directs and works the registration of the 12th person, who is in the chair. The camera is focused on the person in the chair and the people along the sides of the chair are just in on the left and right sides of the camera frame.

EXERCISE FIG 2.A An aerial drawing of the setup.

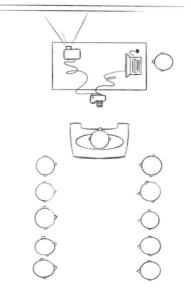

А

The reason this exercise is great for a group is because everyone gets to be the central figure in the animation, a peripheral figure, and the animator. This is because everyone has to rotate positions every frame.

EXERCISE FIG 2.B The same diagram as in exercise Fig 2.A, but with arrows to show the flow of the rotation.

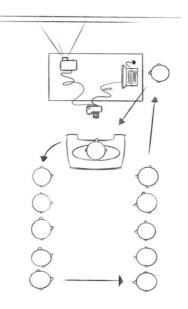

I like to shoot this exercise at 15 frames per second and playback at 15 frames per second. That is the same as shooting two frames for every person in the chair if you were shooting at 30 fps but the process goes a little faster at 15 fps. So the rotation goes this way: Once the person in the chair is photographed, he or she carefully gets up and moves to the front of the line that is "frame right." Everyone moves back one position on the right side line, and the person at the end of the frame-right line moves to the back of the frame-left line. The person at the front of the frame-left line goes to the desk to control the camera via the computer. The person who was at the desk, shooting the previous frame, sits in the chair, and so forth.

This is another example how contrasting visual activity and stationary or focused elements in the overall frame directs the viewer's eye. Imagine what the frame looks like with people changing every two frames. It is highly active, so it becomes very important to find a visual and stable focus for the audience. Since we have people to animate, we acknowledged in Chapter 8 that the eyes are a natural visual focus point. So the element you want to match up in registration (by using the onionskin tool) from person to person is the eyes. When each person sits in the chair, the person behind the camera, working the computer and software, directs the chair person to move so his or her eyes line up as closely as possible with the preceding person in the chair. It is best to line up as much of each person's body (head and shoulders) as possible, but the eyes are the main focus. Everybody has a different body shape, so the registration varies person to person. If you are using a projector, then the person in the chair can see himself or herself on the screen and get the general lineup of his or her own body, if you project the onionskin image of the live and previous frames. Then, the director or animator behind the camera can finesse the chair person's position for a closer registration as the subject looks directly into the camera.

Now comes the fun part. As you change out the chair person and rotate the group, have your animated subjects think about an action they want to carry through from person to person. This is especially important for the person in the chair. This action could include changing expressions, blinking eyes, waving a hand, or even some lip sync. Chapter 9 has some information about breaking down sound. You can record someone saying something at a rate of 15 frames per second, put that on a timeline with a sound wave, and break down the dialog frame by frame on a log sheet. Bring that log sheet to this exercise and the person animating or directing the person in the chair can help adjust the chair person's mouth to mimic the words being said. Or, just import that recording into Dragon and, as you start shooting, line up the poses and actions to the sound wave. The two rows of people behind the chair, who are constantly rotating, can discuss some kind of action(s) they want to follow through on, which could include squatting and standing frame to frame or making a wave pattern or any number of group or individual actions (broken down frame by frame). Remember to use some dynamics in your posed movements, so the movement is uneven in its pacing.

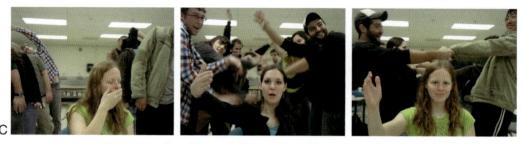

EXERCISE FIG 2.C Several frames of a kissing action in the rotating heads exercise.

What you will find is that certain things help unify this animated exercise. The constant changing of the people in their positions is too active for the audience to register clearly but centering and registering the eyes and mouth (if possible) helps hold the audience's focus. A continuous action, like a wave or having each person go through a sequence of positions for a particular action, holds the audience's focus and attention; and that makes this exercise very interesting. One more element that helps unify the moving image is if the person in the chair always wears the same shirt (like a bright red T-shirt). That adds a sense of stability in this highly active sequence.

One really fun example of something similar to this exercise can be seen on YouTube. A study called *Living My Life Faster* by JK Keller shows an individual shot one frame per day over 8 years and lined up and registered by the eyes (probably with After Effects). The contrast of the locked-in eyes and the rapidly changing elements of clothes and hair make a dynamic and historic account of the evolution of one individual. Although this is one individual and categorized as more of a time-lapse exercise, it gives similar results to the exercise you are trying here.

Exercise 3 2-D/3-D Handball

Mixing techniques can result in some very interesting visuals that can be as fun to plan as they are to produce. Many artists combine approaches successfully, and it gives their work a unique art direction. One artist viewed in previous chapters is the Italian graffiti artist Blu. This stop-motion artist paints graphic two-dimensional images on exterior and interior walls in sequences, while shooting a frame-by-frame camera that is in constant motion. Blu also paints three-dimensional objects as he animates them moving through his composition. This combination of the three-dimensional and twodimensional graphic worlds is seamlessly blended in an organic and practical manner all directly in front of the camera.

Our next exercise plays with this approach. Keep in mind, this exercise can be expanded into an infinite variety of approaches, and I encourage you to try something of your own design once you have gone through this simple process. As always, you need a dslr camera or digital video camera and a tripod on which to mount the camera. If you want to incorporate camera moves (which is not necessary), then you may want to add a Manfrotto geared head (410 Junior tripod head or 400 Deluxe tripod head). The geared head can be cranked or turned in small increments for pans and tilts, allowing for ease-ins and -outs. I recommend that you keep your camera in a fixed, locked position by taping down or sandbagging your tripod and tightening all the control knobs on the tripod once you set your composition. You also need an assistant to operate the camera or a human subject who will sit in front of the camera and have his or her hands animated. I recommend that you have a computer with Dragon or a similar capture software program, so you can compare frames for subject placement and replacement registration. You need to have a table to work on.

We created a simple bouncing ball sequence. You can "rock and roll" this sequence by reversing the cycle once it has completed its forward movement, so the ball appears to bounce up and down and back and forth (once we start moving the cards in the exercise). So, you shoot 1, 2, 3, 4, 5, 6, 7, 6, 5, 4, 3, 2, 1, 2, 3, and so on.

You should be able to take Exercise Figure 3.A and put it on a copying machine or scan it and blow up the sequence so that each frame of the bouncing ball is 4 inches by 4 inches. Print this series out on card stock that is a bit heavier than normal paper. You have a series of seven ball drawings with one ball on each 4-inch piece of card. You need a small block of wood

Exercise 3

EXERCISE FIG 3.A A sequence of a two-dimensional bouncing ball cycle.

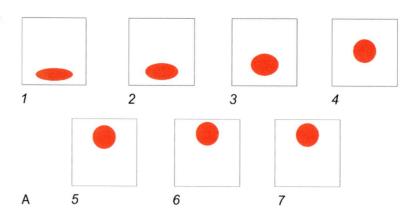

or some sort of simple support with a piece of tape or wax to help support each drawing as you replace each in front of the camera for this exercise. You are bouncing the graphic ball back and forth between your hands as they slowly come together to squash the ball. You should sit behind a simple, clean tabletop, and the camera can point directly at you. It is much easier if you have an assistant or someone else in front of the camera as you operate the computer and change out the drawings.

EXERCISE FIG 3.C The composition of the handball exercise.

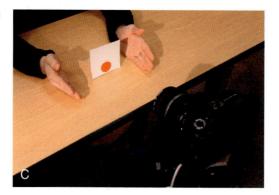

As the animated subject sits at the table across from the camera, place the hands of the subject together.

EXERCISE FIG 3.D The opening position for the exercise (hands together) from the camera's POV.

You open the hands to about 15 inches apart from each other in seven moves and reveal the ball cards between the hands. You need to have one card that is only 2 inches wide as an in-between to reveal the cards. This exercise should be shot at 15 frames per second.

You should always start with a ten-frame hold then slightly part your hands (a quarter to half inch) for an ease-in for the first move. The hands should move apart more on the next frame, allowing the animator to put the 2-inch-wide card between the hands.

EXERCISE FIG 3.E A shot of the hands starting to ease in to their movement apart with a 2-inch card between the hands.

On the third frame, move the hands apart so you can place the first full 4-inch ball cycle card between them and start the replacement ball/card cycle going frame right. Continue to move your hands apart to complete the seven-move sequence until they are about 15 inches from each other. Make sure to ease out from the movement. Each card should be attached to the small support stand that sits behind the card to hold it upright and should be replaced every frame. The cards and hidden stand should be shifted frame right for each replacement until the card comes up against the frame-right hand. That hand should slightly anticipate the ball's arrival by slight shifting EXERCISE FIG 3.F The middle position of the animation.

away from the ball as if getting ready to hit the card with the ball on it. The hand then moves about an inch or two forward (frame left) in one frame then stops and holds, appearing to hit the ball. The ball and card direction and replacement lineup are reversed, and they start moving frame left. The overall effect is that the hands are bouncing the ball on the cards back and forth.

Each time a hand hits the ball and card, it should move closer to the other hand, as if to squash the ball and card. As a matter of fact, that is exactly what you do. This merging of the hands on a frame-by-frame basis can happen fairly fast (perhaps over 40 frames). When the hands get close to touching the card on either side, close the hands completely in one move (removing the card completely) and hold the closed hands with no card for about eight frames. Open the hands and reveal a dimensional red ball (if you can find one) or any other object that you want. When you open the hands include one ease-in movement, slightly revealing the ball or object of your choice, shoot a frame, then open the hands enough to see the ball or object in full. Hold the hands and object for ten frames.

You have successfully mixed techniques in front of the camera and practiced some of the "trick" techniques the early filmmakers like Melies used. Two other great references for this mixing of techniques are the film *Door* by the English

artist and director David Anderson and the American independent filmmaker David Russo's film *Pan with Us*. The mixture of two- and three-dimensional elements is explored with models, objects, and photographic sequences shot frame by frame in front of the camera in a fascinating blend of imagery that is both unique and poetic. Once you start to think about the principles here, it should become apparent that there is a vast area to explore in this approach to frame-by-frame filmmaking.

Exercise 4 Animated Light Loop: The Bursting Star

This frame-by-frame exercise and technique is very popular in Japan. The Japanese refer to it as *pika pika*. They also call it *lightning doodle projects*. Often, large numbers of people get together to create wonderful, fresh, and vibrant images of light painting in front of the camera frame by frame. So, I would like to dedicate this exercise to the people of Japan for their great sense of unity, community, and creativity.

This particular exercise requires a few small props, a dark room or environment, and a dslr camera, like a Canon 5D or a Nikon D-7000. It is important to have one of these digital still cameras because you have a lot of control of the iris, focus, and most important, the shutter speed. The shutter speed of the camera is the critical element in this process. As we saw in previous chapters, the longer the shutter speed, the more you can "smear" images and make moving objects leave a trail of light and color behind them. This is how pika pika works. The camera cannot be hand held or have the possibility of being bumped during this process, because your whole image will be smeared and impossible to read. A tripod is, once again, the anchor to making this exercise work. The use of a cable release or a self-timer from the camera's options might be worth considering. Touching the camera to release the shutter risks a slight movement of the camera during the shooting, and the possibility of smearing the whole image is increased. This is why a remote cable or 2-second shutter time-release option is absolutely critical. If you are confident and have a delicate touch then maybe you can take this risk, but I warn against this approach.

When you shoot an animated light loop, you have to keep in mind that the registration of one frame to the next is difficult to control, because there are no registration guides. Even using a capture software program that has frame-to-frame comparison is impractical, but we consider the possibility of using it in this exercise. You are virtually drawing in three-dimensional space, with only your sense of frame-to-frame placement as your guide. As a result, these light paintings have a very kinetic quality that is similar in appearance to painting or scratching directly on film stock. But, you can do a few things to help with your drawing.

Besides the camera equipment and dark space, the person painting the light has to wear dark clothes. This person is slightly apparent in the image, which adds a special quality to this technique, but we are going to minimize the light painter's image in this exercise. Our goal is to have a star rise in the frame and then burst and disappear in exactly 15 moves. The film then is looped, so there is an unending rise of stars that burst apart. You want to make sure that the looping has a fun quality that can be seen over and over again in an appealing manner. Let us go back to Chapter 3 and use the star guide illustrated in that light painting description. This guide will help keep the star imagery consistent for the first several frames of the exercise.

EXERCISE FIG 4.A The star guide along with two small flashlights.

The star guide should be stabilized and placed very carefully in each frame as it rises into the composition. This is extremely difficult if you hold the guide by hand with the long camera exposure, so we use a stand like a C-stand to hold the star guide. The stand should be "blacked out" by putting black gaffer's tape on it. The C-stand should also be moved to a different position every frame, so that it cannot be seen over a sequence of frames. This can be carefully orchestrated while continuing to raise the star in the frame.

Set up your camera with a wide lens, like 24 mm or 35 mm focal range, on your tripod at about shoulder height. Let us say you chose to be in a dark room that is mostly empty. Make sure all lights are off, although you may want to have a working light that you can turn on and off as you shoot. This light allows you to place the stand in the right place between shooting frames.

EXERCISE FIG 4.B The C-stand holding the star guide and blacked out with tape. This is when you might use your frame grabbing and comparison capability from the computer. You can shoot a frame with the working light on to see where the stand and star are in the frame, turn off the working light, perform and shoot the light painting, turn the working light back on to place the stand and star in the next position, compare the new placement with the old working light stand and star placement, turn off the light to perform and shoot the next light painting, and so forth. The working light has to be off during the shooting. You need only about eight frames of the rising star before it bursts, so that is the only period that you may need the working light setup to measure the placement of the star and stand. If you are using a program like Dragon to control and shoot your frames, then you can eliminate the working-light shots from the sequence later in postproduction. This whole process can be done without the frame comparison capability and no computer. If you choose to just shoot on a flash card in the camera, then think about other means of tracking the star guide placement. This could be by eye or tape on the floor or markings on your stand to guide it as it rises into frame. The problem with the computer is that it emits light in the dark, which can reveal more than you want. This can be resolved by putting a cloth over the screen for each exposure. Programs like Dragon have a "blackout" feature that darkens the screen during the exposure. I leave this option up to you.

When you place the star on the stand in each position for each frame, you need to light paint. You must have a light source, and that should be a small LED flashlight. You can add or tape a colored gel on the front of the flashlight if you want color. Some small LED lights have color built into them, and that might be your best choice for colored light. Each time the shutter is open for the exposure you need to quickly and precisely (as you can) trace the outline of the star from behind the star allowing for some of the light to spill over and shine into the camera. It is worth practicing this a few times to see how long it takes to trace out the star. That time should be your ultimate exposure shutter speed. You need to take some practice shots to find the proper settings for your camera and make sure you have the right overall exposure for the light. I should say that this exercise is best executed by two people, although you could do it yourself using the self-timer option on your camera or a wireless remote. Your shutter speed should end up being somewhere between 3 and 5 seconds long with an adjusted aperture to compensate for the long exposure.

Once the star hits its zenith in the frame, you need to remove the stand and star from the frame for the next shot, which is the beginning of the burst. You need a memory of where in space the star was in its last position (if you are not using a frame grabber). When you are ready to shoot the beginning of the star burst, think about how the light from your LED flashlight should disperse and work from that central point of the last star's placement. The first explosion could be a bright powerful beam that you point directly at the camera, and the sequential frames are the dispersing light trails. You could use different colored lights for a fireworks effect as the lights get farther out in the composition for each shot.

Exercise 4

EXERCISE FIG 4.C An example of options for the beginning of the burst.

This burst can happen over five or six frames, and each sequential frame of the burst should be more spread out from the last position and smaller in size.

Try to finish your small light spots for the end of the burst around Frame 14. That way you have one black frame to complete the 15-frame loop. If you use Dragon, then make a Quicktime movie of the sequence at 15 fps. Once you have this, you may have to remove the working light frames to show only the light painted frames. Set the Quicktime to "loop," and there is your animated light loop. If you are using just a flash card with no frame grabber, then download your files onto a computer. You can place them in a folder and import them into Final Cut by setting the Still/Freeze Duration in Final Cut \rightarrow User Preferences \rightarrow Editing to 00:00:001. You can also put the frames in an "image sequence," if you have Quicktime Pro. Make your loop once you have exported to a self-contained Quicktime movie.

EXERCISE FIG 4.D An image from the end of the burst.

EXERCISE FIG 4.E Five key positions for the animated light loop star burst.

Exercise 5 The Dropping Heads (Cutout)

This exercise requires a little photography, some X-Acto knife work, and a simple downshooter setup. It is not necessary to shoot these cutouts on a downshooter or a piece of glass, but that may add another element for the more advanced animator. You are going to photograph a person (yourself) and print out that photograph on thin card stock that you can run through a printer. You then cut the parts of your body in sections so they can be animated. You also need a few images from the web or magazines that have images of different heads, which you substitute for your own head in the animation. Make sure that these head images are basically in the same scale as your body, although varying the scale a bit can add a lot of humor to this exercise.

Here is how it works. First, set up your dslr camera on a tripod with a wide lens, like a 35 mm or 24 mm focal length. Have the camera facing a blank wall with no detail on it. Frame it so you can stand in front of the camera (using the self-timer) and shoot a shot of yourself that includes your head down to your

EXERCISE FIG 5.A A shot of the camera setup of Exercise 5 for photographing the subject (yourself).

knees. Stretch your arms out away from your body, because they are cut out separately in the cutting phase.

You can take several shots with different expressions on your face or even a four-increment head turn of yourself standing in the same position. You can add these additional head positions to the animation using the heads as replacements if you want to add a little more dynamic range to your animation exercise, but this is not necessary. Once you have your shot(s), download them onto a computer so you can print them out on thin card stock that you can use in your printer. You should size your images so they can be printed out on an $8^{1}/_{2} \times 11$ inch piece of paper or card stock.

Take those color printouts of your self-portrait shot and place them on a cutting surface, like a rubber cutting mat. Since you shot your image in front of a blank background, it should be very easy to see and cut out your contour. It is best to use an X-Acto knife to cut your image from the background. You can use scissors but they need to be smaller and very sharp to get good clean edges. The next step is to cut apart the image of yourself in several areas. You want to separate the head from the shoulders. One way to make this cut is to separate the head from the torso at the neckline where your neck goes into the collar of your clothes. The arms should be separated at the shoulders and need to be cut at the elbows and wrist. Wherever you want to have movement is where you need to make the cut. Remember that, when you reassemble the parts, there must be a slight overlap of the sections so your new cutout portrait may be a little shorter than you are. If you print two copies of your portrait, you can cut the torso out of one copy leaving the shoulder areas a little longer. Then cut the arms from the second copy. This way you have a little overlap, at least from the shoulder to the upper arm.

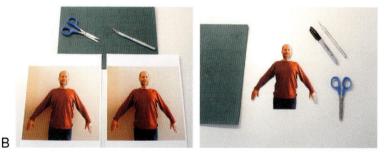

EXERCISE FIG 5.B The setup for cutting, including a mat, knife, scissors, and the final cutout of your body.

The next step is where you can have some fun. You are going to animate your character, throwing off your head, and new heads appear. So, you need to find some different heads that you can photograph yourself, cut out of a magazine, or even find on the Internet and print out. The heads could come from Hollywood stars, politicians, your friends, drawings that you create, insects, or any variety of heads you choose. They can vary in scale as long as they have a believable visual fit to your original body.

Exercise 5

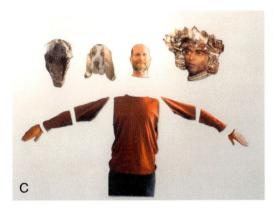

EXERCISE FIG 5.C A series of heads that go on your cutout self-portrait.

If these images are printed on thin paper, they will require some backing. I recommend getting some spray glue and attaching these magazine heads to some of the thin card stock you used for printing your self-portrait. The image can be loosely cut out of a magazine and attached to the card. Once they are bonded then you can do the careful cutting with the X-Acto knife required to pull the head image from the background.

Now that you have all of your cutout elements, you are ready to set up the camera and shooting area. If you have a downshooter available or created a setup with a suspended piece of glass and a lower level background, then place a bright green (ideally a chroma key green) card on that lower level. This way, when you shoot your animation, you can put in any background you desire later in postproduction. Please refer to Chapter 10 regarding this technique. I want to make sure that this exercise can be simply executed, so I continue as though you have no downshooter available. You can shoot these cutouts on a stable, simple, plain tabletop that allows the cutouts to stand out visually. You also need some beeswax, Blu-tack, or thin double-sided tape (this has the sticky material on both sides of the tape). I recommend using the sticky wax often found at miniature and craft stores for holding small objects on shelves. Use this wax to stabilize your cutout parts as you move them on the tabletop. Assemble your portrait of yourself together with the cutout parts on the tabletop. Then, take your dslr camera mounted on your tripod and raise the tripod pretty high up so you can tilt the head and camera down at the cutout on the table. It is ideal to have the angle of the camera perpendicular to the tabletop, but this is not always possible. One way to allow this to happen is if you can slightly tilt the table up toward the camera. Another technique that you can use is to shoot on a clean floor space with the tripod directly above the cutout shooting area. It is important to note that you probably have to change the focal length of the lens to something longer, like a 55 mm or even 85 mm. If you are shooting on the floor and using a zoom lens, then adjust the focal length so you do not see the legs of the tripod but only the cutout model with some room around it. It would be smart to adjust your iris to f-8 or smaller (i.e., f-16) to help maintain a good depth of

field. You have to connect your camera to a computer that is running Dragon Stop Motion or a similar program. Having the frame comparison option to complete this exercise properly makes all the difference.

EXERCISE FIG 5.D An example of the tripod pointing down to a tabletop.

EXERCISE FIG 5.E The composition of the final cutout from the camera's POV.

Now you are ready to shoot. You should always start with a hold. This can be ten frames. I recommend shooting this exercise at 15 fps. The idea is to start with your image, including all the cut sections with the arms down to the side. If you had replacement heads of yourself turning or making an expression this would be a good time to substitute those heads. Shoot one frame per head, turn, and hold the extreme head position for at least eight frames. Then, turn the head back to the camera. Raise the arms so they are placed as though they are holding the head. Remember your eases and increased increments to get to this position. Hold the arm parts in this head-holding position for eight frames then have a one-frame ease-in of the hands with the head between the hands, separating the head from the shoulders. Next, raise the arms and hands above the body as far as you can with the head starting to rise just above the hands and being jettisoned out of the upper frame.

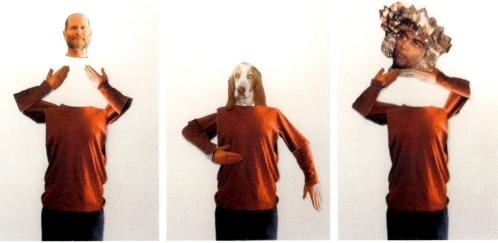

F

EXERCISE FIG 5.F Several different positions in the animation.

Once your head is out of frame, bring the arms back down to the sides of the body, matching the opening position. You can refer to the opening frame and make an onionskin comparison with that frame and your final settled new position of the arms down to the sides of the body. Once the arms are settled, drop in one of your magazine heads from the upper frame. Have it drop pretty fast (about three to five frames) and settle on your headless body. It would be fun to drop your body down about an inch, ease out and then raise the body back up to its beginning default position. The end of the arms (hands) should stay in the same position but keep the shoulder attachment connected to the body so the arms slightly drop down with the body at the shoulders when the body sinks. This gives the new head a bit of weight when it hits the torso. Once the new head is on, hold for 20 to 30 frames, so we see what the new head is, then raise the arms again to jettison the new head, the same way you did with your original head.

You can carry on this way with as many heads as you like. The final head should be your own head dropping into frame once again. Settle out this final position and compare the body, arms, and head with the original first frame to make it as close in position as possible. This way you can loop your dropping head exercise.

Exercise 6 3, 2, 1—Countdown

This next exercise takes inspiration from frame-by-frame artists like PES. We use objects to visually create an opening countdown for your films and other visual mediums. Traditionally, these countdowns were used to help sync up a sound track and picture but they have become part of the filmic language that we know. Each number on a countdown (which can start at 10) should represent a full second including any movement and the number itself. In our countdown, we go with the NTSC video frame count of 30 frames per second. This gives us enough frames to animate any object we choose on single-frame shots and enough time to see the actual number on a hold of 10 frames (or a third of a second). For the sake of ease and simplicity, we start our countdown at 3. You certainly can expand on this exercise, as with all of these exercises, and start at 10 with various objects or even people. You might consider using one person for each second of a countdown and have them swing their arm around in a large circle like the second hand on a clock frame by frame, changing the person every 30 frames. That is another exercise and requires many people and a lot of coordination.

I decided to execute this 3, 2, 1—countdown with some everyday objects around the house. I dug into my childhood trunk and resurrected my old bag of marbles. I also collect coins from various countries, so some of those Polish and British coins were pulled into service. Finally, I got hungry while searching for the first objects, so I made a bag of popcorn. Eureka—there was my final choice for an interesting object or objects to animate in the countdown. I decided to shoot these objects on a table. You need a dslr camera on a taped-down tripod and any lens that gives you enough range or tabletop area in which to work. I used a 24 mm lens. I also added a very simple direct light

EXERCISE FIG 6.A The camera, light, and object setup for the 3, 2, 1—countdown.

with the barndoors pulled together, so it formed two diagonal shadows above and below the numbers.

If you can make your animation production time more efficient in the planning stage, then I encourage you to consider it. For example, once I started working with the marbles on a tabletop. I realized that it was going to take me a fair amount of time to make the number 3 with the marbles. Those marbles seem to have a mind of their own and just rolled out of place when I just looked at them, let alone breathed on them. I felt it was going to make my animation very difficult, animating forward and trying to get the marbles to fall into place and form a nice graphic number 3. So I decided to work backwards. I encourage you to do this with the exercise. Now, you may not choose to use marbles in your countdown, but whatever you use, it will look better if you have plenty of time to set up and form the numbers with those objects without having to reach the perfect placement in a straight-ahead forward piece of animation. You can set up the number and get it perfectly placed in the frame so it reads and looks great. If you need a reference, then import an image of the number into Dragon and use the rotoscope feature to line up your objects.

Because I decided to work in reverse, I first started with the number 1 because that is at the end of my reverse playback. The number 1 is formed by my coin collection. I set up the coins to make a number 1, shot ten frames, then started my animation. Coins are often stacked, so this is how I animated the individual coins. They collected on top of each other in one column, then the column diminished and disappeared.

The popcorn came next. (I was starting to eat the popcorn, so I thought I better use it before it all disappeared.) Without moving the camera or light, I carefully formed a number 2 with the popcorn kernels. I was

EXERCISE FIG 6.B The number 1 coin sequence in key positions.

shooting on a white background so the popcorn, which is light in value, stood out enough due to the shadows from my key light. Once the number 2 was set up, I shot ten frames and decided on the best and most interesting way to introduce the corn from the blank frame left after the number 3 popped off. Popcorn pops and explodes so I decided to randomly pop the corn in a three-object replacement series. This series was a small corn seed for one frame, two or three large popped kernels grouped together for one frame, and then the final replacement was one normal kernel of popped corn.

EXERCISE FIG 6.C A series of popcorn replacements.

The popcorn would disappear after it popped onto the screen when viewed playing forward. Eventually, the corn pops only where the number 2 would be created, and the corn kernels remain on the table forming the final number 2 for ten frames.

EXERCISE FIG 6.D The key positions for the number 2 corn kernel sequence.

Without moving or bumping the camera and light, I proceeded to my last number. The final number in the countdown was 3, formed by my childhood marble collection. The next step is to figure out how to move the marbles in an interesting way (backwards in 20 frames) to form the number 3. Marbles roll, so I wanted to add a little dynamic action to a rolling pattern and have it appear as though the marbles roll in, squeeze together in a pile, then burst out into the number 3 for a ten-frame hold.

Once all the numbers were shot and the animation complete, I cleaned up the tabletop and proceeded to edit. Because the camera and light remained in the exact same position, I had all sorts of freedom in the edit area. As I mentioned earlier, I decided to shoot backwards but I wanted the action to move forward, so I had to apply a reverse playback to the footage to see my final effect. You can view a reverse playback in Dragon, but you need to export your frames to Final Cut or After Effects to kick out a reverse playback Quicktime movie. Your final results are the marbles rolling on to form the number 3 for ten frames; then a blank frame invaded by popping corn kernels, ultimately forming a number 2 for ten frames; and finally a stack of coins that grow and disperse into the number 1. On the end of the exact 3-second count, the animated countdown is complete. There are all sorts of combinations and possibilities for animating a countdown, and this exercise, I hope, will spark some ideas of your own that you can expand upon. For inspiration, you can view the 1987 film Academy Leader Variations, directed by Jane Aaron and Skip Battaglia.

Exercise 7 Love at First Sight

This final exercise combines several elements explored in the book. It has a camera move, human pixilation, downshooting elements, and some composite work. One more challenge that I incorporate in this exercise is the requirement to shoot outside. Not only do you shoot outside, but it will be important to shoot each frame at an even interval so that any shadow and light play throughout the composition moves in an even fashion. The inspiration for this exercise comes from the great designer and animator Tex Avery.

The camera approaches a young man sitting on a bench outside. The subject looks left and right (in pixilation) and suddenly stops turning and looks directly at someone offscreen. The camera cuts to a close-up of a girl batting her eyes at the young man. The film cuts back to a close-up of the young man. He blinks his eyes and vibrating paper hearts grow out of his eyes. His ears blow steam (cotton) and then the young man starts to get up, heading frame left. The couple glide together and spin around each other and glide away from camera into the sunset leaving a trail of hearts (if you can time this right).

I recommend that you shoot the pixilation of the couple first, then go into the studio and create and shoot the hearts and cotton steam on a downshooter with a green screen. For the exterior pixilation work, you need a dslr camera on a tripod with a 24-mm lens. The wider lens gives the shot a sense of drama. This is another situation where it would be nice to have a laptop with a program like Dragon Stop Motion or Stop Motion Pro for capturing the frames and for frame comparison and registration. Having an assistant that carries the laptop makes your life easier. If you cannot get a hold of a laptop, then you have to shoot on a flash card and use practical means of registration, like you did in Exercise 1. This means lining up your subject through the viewfinder. Remember that some cameras have a grid-focusing screen for the viewfinder, if this helps you register your subject. This is not a necessary component to help you locate your subject within the frame.

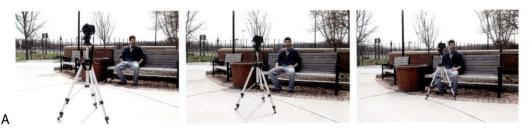

EXERCISE FIG 7.A The setup for the man on the bench and the camera on a tripod.

Line up your young man on the bench with your camera and shoot a 30-frame hold. Pick up your camera and tripod, and ever so slightly move it forward toward the man on the bench. You are easing in on the move toward your subject. Increase your moves forward while trying to keep your subject centered in the frame. You should shoot at 30 fps, because camera moves are always best shot in single frames. This will take some of the strobing out of the move and make it smoother. Remember to ease out your camera move as you approach your subject, keeping him lined up in the center of the frame. It might be best to frame your subject for composition before you start shooting, then move your camera back to find the beginning position. This way you know exactly where you are going before you start.

EXERCISE FIG 7.B The composition of the close-up of the young man on the bench.

Have your young man look frame left then frame right. Do not rush this movement, allowing about 2 seconds for each direction. You can shoot two frames for every movement at this point. Finally, have your subject look slightly to the left of center frame and try to animate him in a "double take." This incorporates a head bob and some blinking. On a second blink, hold his eyes open for 20 frames. This is where you composite the hearts in later. Then, have him blink again (wiping away the hearts). Continue to hold this position for an additional 2 seconds. This is the place that you composite in the cotton steam in postproduction.

EXERCISE FIG 7.C The close-up shot of the girl.

Then, get a close-up shot of the girl. The girl should be on screen for about 3 seconds. She can look rather coy and blink several times. Remember to keep the action exaggerated for dramatic effect.

Cut back to the same close-up of the young man. He should smile and start to get up from the bench. This should be animated at the end of the first shot and can be edited later on. The next shot is a wide shot of the boy approaching the girl. He can slide on one foot (after all, he is in love). Frame-by-frame walking takes too long and breaks the flow of the piece. They should embrace and start to spin in a circle. This can be done at an accelerated pace to add a little dynamic to the scene. You could try having the couple lift their feet off the ground by jumping during the camera exposure when they are in the accelerated spin. This spin is an area to be creative and have fun.

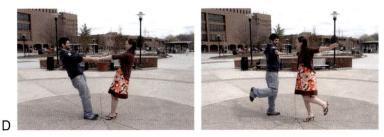

EXERCISE FIG 7.D An example of the wide shot of the couple and the spin.

Finally, the couple should quickly stop the spin, holding hands side by side. Each person lifts one foot and glides away from the camera and toward the sunset (if you have planned your shoot at the right time of day and in the right weather conditions—a sunny day). A trail of hearts is left behind as the couple recede in the distance. These can be the same hearts that you used for the young man's eyes. It is important to remember that each exposure should be shot at an even interval of time, so the shadows and light move evenly throughout each shot. You can achieve this by putting your camera on a time-lapse setting and using a remote cable with a timelapse option or using a connected laptop with capture software. I guess that an interval of about 30 seconds would give you enough time to arrange everything between shots.

EXERCISE FIG 7.E The final composition of the couple gliding away.

Now it is time to head to the downshooting stand. If you do not have a stand, then all you need is a piece of glass and a sheet of green screen material. You must find a way to mount the glass at a distance from the green screen board and light both evenly. You should have a series of five hearts that grow from nothing. These can be cut out from red paper. The fourth heart is your main heart. The fifth heart is bigger than your main, number 4 heart, and you get a slight stretch-and-squash effect by using this sequence. So your shooting sequence is heart 1, 2, 3, 5, 4.

EXERCISE FIG 7.F Hearts and steam in the final product.

Shoot the hearts once on the stand from nothing to heart 1, 2, 3, 5, 4. Hold heart number 4 and slightly move it to give it a subtle vibration for 20 frames.

The next step is to take some cotton (cotton balls from the drug store will work) and fabricate a series of five growing cone-shaped cotton steam shoots.

EXERCISE FIG 7.6 A series of hearts to be used in the young man's eyes and over the final shot of the couple gliding away.

This series gets shot once, starting with cotton 1, 2, 3, 4, and finally cotton 5. Hold on cotton 5 for 20 frames, slightly moving it frame by frame so it vibrates. Try to keep the cotton from having too many see-through areas so it does not become too difficult to pull off the green screen in postproduction. You should consider using a despill filter in After Effects when you pull the cotton off the green screen background. You can also change the cotton color option to black and white to get rid of any green spill on the cotton edges.

Now you are ready to go into composite and edit. The first step is to remove the hearts and the cotton steam shoots from the green screen backgrounds. For the sake of brevity, I refer you to Chapter 10 in the exercise with the flying saucer in After Effects that Jeff Sias described. You need to get the hearts and the cotton shoots onto an alpha channel, so they can be matched up and scaled to the pixilation footage. Placing the hearts in the young man's eyes requires some placement transforming (moving the heart around in the close-up shot of the young man), scaling, and possibly some color correction or opacity adjustments. Once the young man opens his eyes, then start growing hearts. When he closes his eyes, you can reduce the heart series, quickly making sure that the heart looks like it stays behind the eyelid. Then, as the young man continues to look offscreen in that first shot, start the cotton steam effect and let it cycle in the vibration mode. Reverse the cotton growth, then cut to the close-up of the girl. You might reduce the opacity of the cotton layer to help make it look a little more like steam.

EXERCISE FIG 7.H Two shots of the cotton replacements used as a steam effect coming out of the young man's ears.

Once this is complete, you need to go to the final shot of the couple gliding away. This is where a trail of hearts is left behind them as they exit from the camera. These hearts can be the same cycle that you used in the eyes repeated randomly around the frame. They can be scaled and duplicated five or six times. Each heart can grow on and either reverse the growth at the end or dissolve off. This can be done in After Effects or even Photoshop on a frame-by-frame basis. Think about an appropriate sound track. It could add great value to the exercise.

If the camera move at the beginning is too rough for your taste, then you may apply some stabilizing tracking by slightly blowing up the frames and finding some tracking points to lock onto to smooth out the track-in. Once this is complete, the shots need to be exported from After Effects and brought into Final Cut or a comparable editing program. Make your edits (cutting on the action of the young man getting up from the bench). You might consider a fade-up in the beginning and a fade-out at the end. There are many variations that you can make to this exercise. It is just a kicking-off spot for you to consider when trying to mix and match techniques in a unified film. Have fun with *Love at First Sight*!

Index

Note: Page numbers followed by b indicate boxes and f indicate figures.

A

The Adventures of Prince Achmed, 12, 91 Animated light loop camera setup, 164-165 C-stand, 164, 164f digital still cameras, 163 frame registration, 163 LED flashlight, 165 lightening doodle projects, 163 light painter's image, 163-164 star burst ending, 166, 166f positions, 166f shooting, 165, 166f star guide, flashlight, 164f Animatics, 24, 24f Animation stand custom, 84 Oxberry, 83, 84f water white glass, 84-85, 85f Annecy, 142 Attenborough, David, 10, 11f

B

Backlit approach, 91 Big Bang Big Boom, 9, 42f The "Black Maria" studio, 4, 4f Blu-Tack, 92 Borthwick, Dave, 7 Bowers, Charley, 5 The British Oxford Scientific Film Institute, 11

C

Cameras cinematography, 74 controls burned pixels and dust, moving shots, 70 4/3 camera, 67 digital still, 66–67 dslr cameras, 67 flash card/computer, 68–69 hot/stuck pixels, 69–70

image-sensor filter, 69 low-pass filter, 70f manual, 68 "raw", 68 digital, 66 and lenses Aardman Animations and Nokia, 66f adapter, 63f automated, digital still camera, 62-63 Canon and Nikon, 61-62 depth, 65f iris, open and semi-closed, 63f manual controls, 62 "prime", 63-64 "rack focus", 64, 64f "tilt-shift" (see Tilt-shift lens) video tap, 62f open bottom, battery, power adapter and charger, 68f pop-through, 73-74 Candy Jam, 14, 96f Capture software, 27 Carrefour De L'Opera, 10 A Chairy Tale, 38, 39f Chroma keying animation, flying saucer, 125, 125f background and saucer footage, 124-125 colors, 124 compositing, 126 described, 123-124 edge thin and feather parameters, 125 motion blur button, 126 stop motion, 125-126 two-layer multiplane downshooter, 124 "Clay-on-glass" technique, 97-98, 97f Clay-painting, 90f Clean plate described, 121-122, 122f rig wiping, 122-123 Close-up animator's friend, 105-106 subtle and refined movements, 102

Collage chroma keying, 125-126 clean Photoshop, 122-123, 123f plate, 121-122, 122f re-export, frames, 123 rig support, 122, 122f cutouts, 91 match lighting and rotoscoping flat lighting, 119-120, 120f image shadow, 120-121 object/person, 119 Photoshop, 121 placement and eyeline, images, 120, 121f planning composite images, 118-119 mattes and optical printers, 117-118, 118f softwares, 118 Composite images animation, 120 described, 118-119 match lighting, 119, 119f shadow, 120-121 saucer, 125 The Conjuror, 3f, 4f 3, 2, 1-countdown camera, light and object setup, 173f number 1 coin sequence, 174, 174f number 2 corn kernel sequence, 174-175, 175f reverse playback, footage, 176 series of key positions, marbles formation, 175-176, 176f series of popcorn replacements, 175f Custom-made animation stand, 85f Cutout animation Candy Jam, 14 computer-generated images, 14 description, 13 downshooter, 14 Monty Python's Flying Circus, 13-14, 14f Tale of Tales, 13

Index

D

Digital single-lens reflex still cameras, 61-62 Digital still camera, 26f Digital video camera, 26f The Dinosaur and the Missing Link: A Prehistoric Tragedy, 5 "Down and dirty" approach, 145-146 Downshooter, 12, 12f, 13f Dragon stop motion software, 52f, 120, 121f Drama sense eyes thinking, 105-106 universal emotional expressions, 106f, 107 live action and single framing, 99-101 reference film and cartoon Creature Comforts America, 104-105 footage, 105 wide-angle lens, 105 subtle and broad performance ease movement, 103-104, 104f object animation and downshooting, 102-103 pixilation, 102 sand animation, 102 "snap" effect, 104, 104f step printing, 103 Dropping heads animation, 168, 169f camera setup, 167-168, 167f shooting, 169-170 cutout, final, 170f image printing, 169 opening frame and onionskin comparison, 171 self-portrait body cut parts, 168, 168f shooting, 170-171 shots, expression, 168 tabletop tripod, 170f two shots, 171f

Ε

Easing in, 34–35, 34f Easing out, 34–35, 34f Editing books, 135 playback rates, 133 process, 130 program, 130 Eyeline, 120, 121*f*

F

Faust, 39, 39f Filmmakers advice, 146 Frame-grabber program, 82 Frame-to-frame shooting animated movements, human, 152 camera and human distance, 150, 150f human, head and shoulders composition, 149, 149f "key" expression, 151 night scene, 152 registration, 149 subject travel, 151, 151f *Wizard of Speed and Time*, 152 Fricke, Ron, 11

G

Gabriel, Peter, 8, 8f Gilliam, Terry, 13–14 *Gisele Kerozene*, 7, 7f, 32, 39 Greenhalgh, Jordan, 40, 41f Green screen background, 124 chroma keying, 123–124 flying saucer, 125, 125f

Н

Hand-cranked camera, 21f Hold frames postproduction effects solution, 129–130 rock and rolling, 128–129, 129f

Intervalometer shutter release remote, 51*f* time, 52*f* time-lapse filming, 51 *It's a Bird*, 5, 5*f* J

Jabberwocky, 6, 6f JibJab, 97, 97f Jobard ne peut pas voir les femmes travailler, 4

Κ

King Kong, 5 Kounen, Jan, 7, 7f

L

Leaf, Caroline, 14, 15f, 97, 99 Lenses adapter, Nikon lens/Canon camera, 63f manual, rack focus, 64 Nikon, 62-63 "prime", 63-64 "tilt-shift" (see Tilt-shift lens) Light-emitting diodes (LED), 72-73 Lightening doodle projects, 163 Lighting, animation indoor, outdoor and shadow effect, 73 painting technique, 72 professional rheostat, 72f selective, 70 single-source studio, 71, 71f size, 72-73 three-point, 70 150 watt lamps with barndoors, 73f Light painting frame by frame, 43 guide, 43f iPads, 44, 44f painter, 43-44 tools, 43f Live action film making dynamic composition elements, 99-101, 100f PES, 101 reality, 101 reference, 104-105 Living My Life Faster, 156 Log sheet, 110-111, 110f Love at first sight close-up shot, girl and man, 177, 178f "double take," 178 exterior pixilation work, 177 final composition, couple gliding away, 179f, 181

series of cotton replacements, 180, 180*f* series of cutout paper hearts, 180, 180*f* setup, man on the bench and camera on a tripod, 177*f* two shots side by side, composited hearts and cotton steam effect, 181*f* wide shot, couple and the spin, 179*f* Lp sync, 110–111 Lumiere, Louis, 3*f*

Μ

Magic creation pixilation, 2 single-frame filmmaking, 2 stop-motion photography, 2 storytelling, 1 Man with a Movie Camera, 5 Market exposure artists comments, 138 film festivals description, 141 fees, 142 short film, 142-143 themes and agendas, 142 Withoutabox, 141, 141f filmmakers, 138 internet, 144-145 moving image, 145 ownership copyright laws, 143, 143f "creative commons" option, 143 "rock solid" protection, 144 photography, 145 pixilation, 145-146 postproduction marketing, 138 record and process advantage, 139-140 reasons, 139 stop-motion technique beginners, 144 websites and internet DVDs, 140 YouTube and Vimeo, 140 Massaging frames in the edit animation vs. live-action filmmaking, 127 file management naming convention, 133 off-line system, 132 frame blending, 130, 130b

frame-by-frame film, 130, 130b Gilliam, Terry, 128b imperfection cameras and postproduction simulated move, 131 color palette/plan, 132 as learning experience, 131 playback, 133-135 postproduction effects solution, 129-130 rock and rolling technique, 128-129, 129f shoot out of sequence, 127-128 Zaramella's facial expressions, 128-129, 129f Match lighting flat lighting, 119-120, 120f image shadow, 120-121 object/person, 119 Photoshop, 121 placement and eyeline, images, 120, 121f McLaren, Norman, 6, 6f Melies, Georges, 3-4, 3f Mona Lisa Descending the Staircase, 98f Monty Python's Flying Circus, 13-14, 14f, 20, 20f Moving camera dslr, 48 heavy motion-control units, studio shooting, 46, 47f lightweight motion-control unit, outdoor shooting, 47-48, 47f "locking down", 46 35 mm Mitchell camera, 46f single-frame camera, 48 Multiplane downshooter animation stand custom, 84 Oxberry, 83, 84f water white glass, 84-85, 85f backgrounds After Effects and Flash program, 97 Candy Jam, 96f "clay-on-glass" technique, 97-98, 97f field depth, 95 JibJab, 97, 97f lower shooting plane, 96 clay downshooting, 89

Gratz, Joan, 91, 98, 98f

Mona Lisa Descending the Staircase, 89, 90f plasticine sculpture, 89f cutouts The Adventures of Prince Achmed, 91 cut paper animation, 93b figurative, 91 hinging, 91, 93f JibJab, 91, 91f lighting arrangement, 93 Minotaur, 95, 95f relationship, 92 sharp scalpel, 93b And She Was, 93, 94, 94f stabilization and appendages movement, 92 vertical multiplane frame-byframe technique, 95 lighting cutouts, 87-88 fill light, 87, 87f platen glass, 87-88 range, top shooting plane, 86f shadows, 85-86 shooting planes distance, 86 three-dimensional objects, 86 underlit/bottom light setup, 88, 88f sand animation, 90b bottom lighting, 90 darker and white, 90 three-dimensional objects, 90-91 Muto, 9, 42f

Ν

Neighbours, 6, 6f Norshtein, Yuri, 13, 13f

0

Object animation, 44–45 Off-Line, 33, 33f, 47–48, 48f "Onionskin" capability, 82, 82f Organic and nonorganic objects animation, 78 description, 77–78 dslr/digital/web camera, 78b shoot times/intervals, 78 time-lapse sequence, water-based peas, 78f Western Spaghetti, 78b

Index

Orphan works, 144 Ott, John, 10f *The Overcoat*, 13 Oxberry stand, 83

Ρ

Pan/tilt, 81-82 Pan with Us, 161 The Passion of Joan of Arc, 105-106 People, objects and rigging gravity, 77 Her Morning Elegance, 76–77 pixilation, 75 rigs, 77, 77f Sledgehamme, 76–77, 77f Timber, 76, 76b, 76f "Photo puppetry", 97 Pika pika, 163 Pin registration, 25, 26f Pixilation description, 2, 32 director anticipation, 35, 35f "easing", 34-35, 34f hair fly, 36 limitations, 36-37 secondary motion, 35, 35f squash and stretch, 36, 36f dramatic effect, 32-33 extensions, 9 film and animation programs, 8 humor cartoon animation, 38 expression and performance, 38 Gisele Kerozene and Neighbours, 37 Jobard ne peut pas voir les femmes travailler, 4 makeup and expressions, 33 **MEAT!**, 33 moving camera (see Moving camera) Neighbours, 32, 32f Off-Line, 33, 33f saltshaker, 45, 46f The Secret Adventures of Tom Thumb, 7 shooting Faust, 39, 39f frame rate, 40 Gisele Kerozene, 39 live-action photography and, 38 on twos, 40 and time-lapse photography, 57

uniqueness, 34 variations animation, 40, 42 light painting (see Light painting) object animation, 44 PES, 44-45 Process Enacted, 40, 41f replacement animation. 44-45, 45f Platen, 87-88 Playback color stabilizer menu, after effects, 134-135, 135f editing and animation, 135 invisible mending, 134f reverse, 133-134, 134f shooting handles, 134 slow down/speed up rate, 133 Play-Doh, 80-81, 81f Pop-through, 73-74 Preproduction animatics, 24, 24f cutouts/sand on glass, 25 drawing, 23-24 reference material, 23 storyboarding, 22, 22f test footage shooting, 25 testing equipments, 25 "Pro-sumer" camera, 61-62

R

Reggio, Godfrey, 11 Reininger, Lotte, 12f Replacement animation, 44-45, 45f Rhythm and flow beat sound/music track, 116 stop-motion technique, 116 movement patterns active sound track and visual timeline, 113, 113f Gratz, Joan, 113, 113b Kentridge, William, 114, 114b, 115 pepper heart, 113-114, 114f music exercise, sound and picture, 111, 1116 Kentridge, William, 111 log sheet, 110-111 sound effects, 109-110 Rock and rolling, 128-129, 129f Rotating human subjects

actions, 155–156 flow, 154f frame visual activity and stationary, 155 "head and shoulders" shot, 153 heads exercise, 156, 156f *Living My Life Faste*, 156 position, frame, 154–155 setup, 154f single-frame camera and tripod, 153 Rotoscoping, 120, 121f

S

Sand on glass technique, 14, 15f "Screen grab", 27f Secondary motion, 35, 35f The Secret Adventures of Tom Thumb, 7.7f.75 Sfumato, 71 Shooting camera stability, 81-82 downshooting, 82 motion-control systems, 82 outdoors, 80-81 stop-motion production, 79 taped tripod legs and sandbags, 81f time-lapse and extended, 79-80 Shooting frame by frame animation advantage, 18-19 cutout, 20 drawn, 20, 20f technique, 20 audience, 18 cutouts limitations, 20b equipment and setting up capture software, 27 digital technology, 26, 26f "grip", 27-28, 28f Oxberry animation, 27-28, 28f pin registration, 25, 26f Wonky films downshooter, 28f hand-cranked camera, 21f human subjects, 18 MEAT! 19f Off-Line, 19f PES, 19f pixilation, 21, 29 preproduction (see Preproduction)

Svankmajer's approaches, 19 time-lapse photography, 21-22, 21fShooting on twos, 38-40 Shutter speeds night scenes, 55f stop motion, 55 Silent films Auguste and Lumiere, 3, 3f "Black Maria" studio, 4, 4f The Conjuror, 3f, 4, 4f documentary films, 5 Edison, 5 filming and single-frame adjustment, 2 Jobard ne peut pas voir les femmes travailler, 4 Man with a Movie Camera, 5 Melies, Georges, 3-4, 3f Single-lens reflex camera, 66–67, 67f Squash-and-stretch animation technique, 36, 36f, 92 Step printing, 103 Step weaving. See Step printing Stop motion technique cutout animation (see Cutout animation) downshooter, 12, 12f, 13f frame-by-frame films, 15 Gisele Kerozene, 7, 7f Her Morning Elegance, 8, 9f Jabberwocky, 6, 6f multiplane animation, 12 Muto and Big Bang Big Boom, 9 Neighbours, 6, 6f Ott, John, 10f pixilation, 6 sand on glass (see Sand on glass technique) The Secret Adventures of Tom Thumb, 7, 7f Sledgehammer, 8, 8f time-lapse photography (see Time-lapse photography)

Stop-motion technique, 77 Storyboard moving (*see* Animatics) photographic, 23*f* "thumbnail", 22*f* time-lapse, 23–24 Sundance, South by Southwest (SXSW), 142 Sun Seeker, 53 Support rig, 77 Svankmajer, Jan, 6, 6*f*, 19

Ì

Three-point lighting, 70 **Tilt-shift lens** depth, 65f design, 65 focus effect, Monica Garrison, 65,65f setup, 66f shift in, 65-66 Time-lapse photography camera setting, 52-53 Carrefour De L'Opera, 10 contrast, 54-55 description, 9 A History of the Sky, 50, 50f, 51 intervalometer (see Intervalometer) Koyaanisqatsi, 11-12, 11f, 49-50 motion control Arduino, 58b depth perception, 58-59 Lowe, Tom, 59, 59f Manfrotto gear head, 58f off-the-shelf hardware and common-use software, 57-58 rail and track setup, 58f and pixilation, 57 The Private Life of Plants, 10 rates and formulas, 56

shutter speeds, 55 subject description, 53 environments, 53-54 Sun Seeker, 53 time, 50 Timeline audio, 112 visual, 113f "Trick" techniques, 161 Twice upon a Time, 91 Two-dimensional and threedimensional handball animation, middle position, 160f ball/card cycle replacement, 159-160 Blu's paintings, 157 bouncing sequence, 157, 158-159, 158f ease-ins and-outs, 157 exercise composition, 158f frame-by-frame hand merging, 160 hands, easing, 159f opening position, exercise, 159, 159f ten-frame hold, 159 "trick" techniques, 161

V

Vertov, Dziga, 5 Voltage regulator, 80, 80f

W

Water white glass, 84–85, 85f Western Spaghetti, 44–45 Wide shot, 102 Withoutabox site, 141, 141f Wizard of Speed and Time, 7, 152 Wonky films downshooter, 28f